Master Paintings from The Phillips Collection

The Fine Arts Museums of San Francisco, California
July 4—November 1, 1981

Dallas Museum of Fine Arts, Texas
November 22, 1981—February 16, 1982

The Minneapolis Institute of Arts, Minnesota
March 14—May 30, 1982

The High Museum of Art, Atlanta, Georgia
June 24—September 16, 1982

Text by Eleanor Green
with twelve essays by Robert Cafritz

Introduction by Laughlin Phillips

Foreword by Milton Brown

Preface

If we, as representatives of four art museums, were to sit down to plan a major travelling exhibition of European and American painting of the nineteenth and twentieth centuries, and could not borrow from The Phillips Collection, we would soon abandon the project or accept drastic compromises in quality. It is truly remarkable that such an exhibition can be drawn entirely from The Phillips Collection. We are reminded that Duncan Phillips's prophetic modern vision has become a reality.

As these master paintings begin their first national tour, leaving their wonderfully intimate environment in Washington, D.C. for the enjoyment of art lovers across the country, we wish to thank Laughlin Phillips, Marjorie Phillips, and the other trustees of The Phillips Collection for affording us this opportunity. We are also grateful to James McLaughlin, Willem de Looper, Michael Green, Pamela McDonald, and particularly to Martha Carey for their gracious cooperation in helping to organize the exhibition.

Finally, we acknowledge with thanks the generous grant from BATUS, INC., which covered the expenses of the national tour and made this exhibition possible.

Ian McKibbin White, Director
The Fine Arts Museums of San Francisco, California

Harry S. Parker III, Director
Dallas Museum of Fine Arts, Texas

Samuel Sachs II, Director
The Minneapolis Institute of Arts, Minnesota

Gudmund Vigtel, Director
The High Museum of Art, Atlanta, Georgia

Acknowledgements

I would like to thank the following persons
for their assistance and cooperation in the
creation of this exhibition and catalogue:
Thomas P. Lee and Ian White at the Fine
Arts Museums of San Francisco; Marjorie
Phillips, James McLaughlin, Willem de
Looper, John Gernand, Martha Carey,
William J. Koberg, Joseph P. Holbach, Jr.,
Harry Raab, and Robert Cafritz at The
Phillips Collection; Leslie Shore, Alison
de Lima Greene, Sandra Moy, and Anthony
Strianse at Shorewood Fine Art Books.
 —Laughlin Phillips

Edited by Eve Sinaiko

ISBN: 0-9605574-1-5

Library of Congress Card Catalog Number: 81-82024

Created for Penshurst Books and The Phillips Collection by
Shorewood Fine Art Books
475 Tenth Avenue
New York, N.Y. 10018

Foreword

Duncan Phillips: Adventure in Art

Duncan Phillips was one of the most fascinating of that galaxy of collectors of modern art who were so influential in the transformation of taste in the United States in the early years of this century. Among the others were John Quinn, Lizzie P. Bliss, Arthur Jerome Eddy, Albert C. Barnes, Walter Arensberg, Katherine Dreier, the Steins—Gertrude, Leo, Michael, and Sarah—the Cone sisters, Claribel and Etta, A. E. Gallatin, and Ferdinand Howald. Almost all of these were patrons of art in the old sense, rather than collectors of art objects.

American collecting in the late nineteenth century was concerned almost exclusively with the acquisition of art treasures of the past. The great reservoir of artistic tradition that had accrued over the centuries in the old world offered an inviting shortcut to status and culture to those *nouveau riche* American merchant princes who could, discriminately or not, plunder them, with considerable profit to their custodians. To such men and women of wealth, collecting art presented the most desirable form of conspicuous consumption, in the Veblenian sense, indicative of affluence as well as of refinement. Only works of the revered past and established values carried unquestioned cachet; this bias had a great deal to do with the continued dependence of American art on the imported traditions of European art of the past, and the slighting of contemporary art in general. Collectors like J. Pierpont

Morgan, Joseph E. Widener, Henry C. Frick, Henry Walters, and John G. Johnson, to name only the most prodigious, were in their very voracity laying the foundations for the many historically comprehensive museums of this country. Their historic function was as accumulators of treasure, rather than as patrons of contemporary art or artists. On the other hand, the new breed of collectors that surfaced in the early years of this century was more interested in the recent past and the present, in what was then already called "Modern Art." This interest in contemporary manifestations and in living artists led many of them back into patronage. However, these first collectors of modern art were important less as patrons of individual artists than as instruments in the propagation of modernism. Perhaps it was a natural desire to defend the apparent eccentricity of their own taste that led them to proselytizing of modernism that would have been unthinkable to the older generation of collectors. They also differed from their predecessors in a fundamental economic dimension; none of them were rulers of vast financial or industrial empires, nor did they have unlimited funds at their disposal to spend on the expensive treasures of the past. In many cases they were living on income from inherited wealth. Money to them was never an instrument of power. It was simply a condition which permitted a freedom to indulge their intellectual and cultural interests. If not as rich as their

more orthodox brethren, they were more independent and adventurous as collectors and less concerned with the accumulation of art as an expression of wealth, prestige, or power. Of this coterie, only Albert C. Barnes was a throwback to the older acquisitive type, and even he ran true to form in other respects.

The distinctive mark of the group was the urge to proselytize. They seemed to feel that only a public educated to understand and appreciate the revolution occurring in the arts could eventually vindicate their own judgment. Instead of housing their collections in marble palaces and hiring experts to catalogue their works, printing the results in sumptuous private editions as further evidence of affluence, the new collectors were committed to public display and education. They themselves attempted to defend, explain, and justify modernism in the public press, in articles, and in books. Barnes, Eddy, Dreier, Gallatin, and Phillips wrote and lectured; and Barnes, Dreier, Gallatin, and Phillips, as well as Bliss, institutionalized their collections for educational purposes rather than as memorials to themselves. It is truly remarkable that this small group should have harbored such concentrated fervor for the transformation of public taste. It was as if they were driven by a moral compulsion and a belief that the truth about modern art would elevate the spirit. The course of art is changed by artists and not by critics, dealers, collectors, or edicts, but the effects of the concerted efforts of these collectors on the taste of the American public can hardly be overestimated. The Société Anonyme, the Barnes Foundation, the Phillips Memorial Art Gallery, the Gallery of Living Art, the Museum of Modern Art are the institutions that have helped to support the growth of modern art, creating a favorable climate of opinion, and our taste today is in no small measure the product of these efforts.

Only a few of these collectors had begun to collect before the famous Armory Show of 1913. Gertrude and Leo Stein were the earliest, but their activities were confined to Paris and their influence was largely on visiting American artists and collectors. Claribel Cone began to collect early, under the guidance of the Steins, but she too lived abroad a great deal, and her sister Etta's collection, like hers, was private and unknown to the American public. In spite of Albert C. Barnes's vociferous claims of priority, he had probably bought nothing more radical than Cézanne before that time. Quinn, Bliss, Eddy, Dreier, and Arensberg were

directly influenced by the Armory Show, and of these, the first three bought heavily from the exhibition. It was only later, after the First World War, during the prosperity of the 1920s that Duncan Phillips and A. E. Gallatin were converted to modernism and that Ferdinand Howald became interested in contemporary American art. It was then that they began to form their collections. During the 1920s, they were joined by a second wave of less adventurous collectors who reverted to the more traditional concept of collecting, the accumulation of masterpieces. By that time, modernism, if not completely established in public taste, was recognized by a sizeable body of opinion and had become a legitimate field of collecting. By the 1930s it was to become the major field.

Art consciousness grew prodigiously during the prosperity of the 1920s. Almost every fair-sized city in the United States that did not already have an art museum moved to establish one. From 1921 to 1930, sixty new museums were founded and thirteen new buildings erected at an estimated cost of $16 million. There was at the same time a phenomenal expansion of the art market, and record prices were paid for art objects in all fields. American buyers had dominated the international art market since the turn of the century, and it was estimated in 1923 that $350 million had been spent abroad since 1910, but even this pace was accelerated in the next decade. At first, modern art played no appreciable part in the postwar wave of art buying, which was confined almost exclusively to the more traditional fields. There was even an unanticipated boom in American "masters": an Abbott Thayer figure piece sold for $40,000, followed almost immediately by Winslow Homer's *Eight Bells* for $50,000—a new record for a modern American painting—but this was soon eclipsed by the $60,000 paid for George Inness's *Spirit of Autumn*. The academically minded lived for a while in the hope that "solid" and "national" values were finally coming into their own.

But the influx of modern art from abroad increased and before very long the dominant figures in the modern art market became Manet, Monet, Degas, Cézanne, Renoir, Seurat, Van Gogh, and Gauguin, to be joined shortly by Matisse and Picasso. The first evidence that modernism had forced a break in the art market was the Dikran Kelekian sale in 1922 which netted $254,870 for sixty-one pictures from Ingres and Delacroix to Matisse and Picasso,

as well as the Americans Cassatt, Whistler, and Arthur B. Davies—hardly a spectacular total by today's standards. Seurat's *Poudreuse* went to John Quinn for $5,200 and a Van Gogh *Self-Portrait,* now in the Detroit Institute of Arts, was sold for $4,200, but Lizzie Bliss paid the then "sensational" price of $21,000 for a Cézanne *Still Life,* the highest price in the sale. By 1926, the John Quinn sale, half of which went under the hammer in New York, clearly indicated that modernism had won a secure place in the art market.

When Bryson Burroughs, curator of paintings at the Metropolitan Museum of Art, purchased Cézanne's *La Colline des Pauvres* for the museum from the Armory Show in 1913, it was a landmark in museum history. It should also be noted that the Art Institute of Chicago housed the Armory Show, that John Cotton Dana had the courage to give Max Weber a one-man show at the Newark Museum in 1913, and that the Metropolitan Museum of Art had presented an exhibition of modern art in spite of much public opposition in 1921. But the very nature of museums of that day militated against any playing a decisive role in the recognition and dissemination of modernism. Museums were, on the whole, still morgues for masterpieces.

It remained for individuals of courage and foresight, with faith in their own taste and no need to appease either tradition or trustees, to pioneer in the collection of modern art. Just as the country had found men and women of vanity and wealth to seize upon the plastic traditions of Europe and the East, it now found a new generation with the daring and the means to buy living art, and these new collectors were in their own way even more amazing than their colossal predecessors.

Duncan Phillips was no sudden convert to modern art as were Bliss, Eddy, and Arensberg. He came a long way in his lifetime, from detractor from to defender of modernism. Phillips began his career as an amateur collector and critic, with a set of aesthetic values that were, for their time at the turn of the century, essentially conservative, based on what he described as "impressionism," the visual impressionism of Velázquez, whom he then considered the greatest of painters, rather than the optical luminism of Monet. He was profoundly unsettled by the Armory Show and, along with such other conservative critics as Kenyon Cox, Frank Jewett Mather, Jr., and Royal Cortissoz, rushed to attack modern art in "Revolutions and Reactions in Painting," published in December 1913, and "Fallacies of the New Dogmatism in Art," in December 1917. In 1927, however, in the second edition of his *Enchantment in Art,* which had originally been published in 1914, he recognized the extent of the change in his taste. "I am embarrassed by some of the premature judgments of my youth," he wrote. "The book seems to me today the work of another person." He admitted his errors in denigrating the art of Cézanne, Van Gogh, and Gauguin, and in reviling Matisse and Picasso. For my part, when, as a young man some forty years ago, I first did research on this period of American art history, I took a harsh and critical view of Phillips's transformation, emphasizing what seemed to me his aesthetic myopia. Looking back now with the additional perspective of time, I see it more accurately as an unusually frank and courageous statement that was to remain the guiding principle of his life as a collector, writer, and aesthetician.

It may be that the very character of the collection is the result of that sincere search for understanding, that cautious and considered process of refinement. Duncan and his brother had begun to collect art with the help of their parents in 1916, but the paintings acquired before the collection was opened to the public in 1921 were hardly avant garde. Among the early purchases were examples by Chardin, Daumier, Monet, Puvis de Chavannes, and Monticelli; and among the Americans, Inness, Whistler, and Ryder; the American Impressionists, Robinson, Twachtman, and Weir, and all The Eight, except for Shinn. This was already an indication of Duncan's abiding commitment to American art. Of all the early collectors, he was the only one, except for Ferdinand Howald, whose primary focus was on the art of his native land but, unlike Howald, he viewed it not in a parochial sense but in the context of international standards. During the 1920s, when he began to fill in the gaps, the collection expanded in scope as well as depth. The acquisition of the magnificent Renoir *The Luncheon of the Boating Party* in 1923 was perhaps the turning point in his odyssey as a collector, just as Gallatin's purchase of two Cézannes and a Picasso in 1922 had turned his career around. By the early 1930s The Phillips Collection had already taken its basic form and included works by all the major French Impressionists; the Post-Impressionists Cézanne and Van Gogh (though it was not until 1951 that a Gauguin was added); Redon and

Rousseau; Vuillard and Bonnard; the Fauves Matisse, Derain, Rouault, and Dufy; the Cubists Picasso, Braque, and Gris; as well as Jacques Villon, Klee, de Chirico, and Eugene Berman. It was also in the 1930s that Phillips turned from his earlier allegiance to the American Impressionists and Ashcan School realism to the younger American modernists, especially the Stieglitz group, Marin, Dove, and O'Keeffe; as well as Demuth and Sheeler; Weber and Hartley; Stuart Davis and John Graham. A Kandinsky was acquired in 1944 and a Mondrian in 1945. It should be noted that the acquisition of some artists' works may have been planned earlier but was not consummated until later, for financial reasons or quality judgments. With the rise to hegemony of American art in the 1950s, a cautious but clear acceptance of changing directions was signalled in the addition of works of major artists of more recent times, from a Willem de Kooning in 1952 to a Frank Stella in 1974.

Though The Phillips Collection has responded to time and shifting taste with remarkable flexibility, it has managed to retain its basic character over the years because of the personality of Duncan Phillips and his aesthetic vision. That vision was, as already noted, conservative. He really did not believe in revolution in art, and he did not understand extremism. Thus, he eschewed to the end the more intellectual, recondite, or excessive manifestations of the art of the twentieth century, and the collection makes no pretense at being an historical survey of the period, though there is a conscious effort to be representative. Phillips's philosophic posture owed much to Elie Faure, John Dewey, Henri Focillon, and, perhaps, ultimately, Henri Bergson. As Bess Hormats has pointed out, Phillips agreed with Focillon in the "constancy and identity of the human spirit everywhere."* His was a positivist attitude. He saw all art as a continuity of tradition, and one of the guiding principles in the formation of the collection was to demonstrate the interrelatedness and universality of the creative act. It may be that for Duncan Phillips the spiritual value of art transformed collecting from a way of life and even an art form into a moral act, so that he was able to use his wealth for the public good.

Aside from the spirituality and universality of art, Phillips also saw it as individual and particular, apart from the collective unconscious, apart from periods, schools, or doctrines. Art was a one-to-one and personal contact between the artist and the viewer. The Phillips Collection is a projection of this concept, but ultimately it remains a reflection of Duncan Phillips's taste. Though he consciously sought to emphasize the nexus among diverse cultures, between the present and the past, and to leave a door open to the future, to keep an open mind toward the new and constantly to reexamine his own decisions, and never to operate with the egocentric, self-limiting arrogance of an Albert Barnes, the Collection remains colored by the personal predilections of a personal taste, a taste perhaps unconsciously rooted in Impressionism in its broadest historical connotations, in a pervading sensuous delight in color. He admitted this bias toward emotion over intellect, color over form, and it dominates the Collection, from the material splendor of the Renoir to the transcendentalism of the Rothkos, from the earthy tonalities of Dove to the pure geometry of Albers, from the fanciful arabesques of Klee to the chromatic debris of Schwitters.

For some artists Phillips had a special affinity, and their works he collected in quantity—Daumier, Cézanne, Bonnard, Klee, Braque, and de Staël; and, among the Americans, Ryder, Prendergast, Marin, Dove, Augustus Tack, Karl Knaths, and Rothko. Do they all have some aesthetic ingredient in common? It is difficult to say. Perhaps for Duncan Phillips they had. Since he abhorred extremism, perhaps one ought to say that they are compromisers or eclectics. Hardly. Perhaps it is because they do not fit neatly into categories and remain always uniquely themselves, perhaps because they avoid excess, or perhaps because they bridge the irreconcilable. In any case, whether one agrees with all his preferences, these were artists who spoke to him strongly, and he had faith in them. For Duncan Phillips, the commitment to art was a faith. He accepted his vocation as a kind of mission. There is a moral fervor that runs through his belief in art, in the sanctity of its forms, and even its redemptive qualities, and The Phillips Collection became the temple of his conversion.

*"The Critical Writings of Duncan Phillips" in *Duncan Phillips: Retrospective for a Critic.* University of Maryland, Feb. 1–Mar. 16, 1969, p. 5.

Milton W. Brown
The Graduate Center
City University of New York, 1981

Introduction to the Collection

Late in the fall of 1921, two large rooms of an 1897 brownstone house near Dupont Circle were quietly opened to the public of Washington, D.C. On the walls were French paintings by Chardin, Monet, Sisley, Monticelli, and Fantin-Latour. Along with them were paintings by the contemporary Americans Twachtman, Weir, Ryder, Davies, Whistler, Lawson, Luks, and Hassam.

Although there was no press conference, or champagne lunch, or reception, this was the opening of The Phillips Memorial Art Gallery, now known as The Phillips Collection. Incorporated in the District of Columbia in July 1920, as a foundation specializing in the display of art, it was the first museum in the United States to emphasize the work of living artists.

In the other rooms of the Victorian house lived the Gallery's founder, Duncan Phillips, aged thirty-five, his mother, and his wife of just a few weeks, Marjorie Acker Phillips, a painter herself, who had studied at the Art Students League of New York. For the next several years, the exhibition rooms were open to the public from 2 to 6 P.M. on Tuesdays, Saturdays, and Sundays.

Today, as the Collection approaches its sixtieth anniversary, it has grown into one of the world's most loved and respected small museums. With holdings of over two thousand works of art, including some of the finest works of nineteenth- and twentieth-century French and American artists, the Collection now occupies all of the original house, along with an adjoining building erected in 1960. It maintains an active program of exhibitions, concerts, publications, and loans to special exhibitions organized by other museums. During its entire history, however, the Collection has held to its unique philosophy of showing paintings in a comfortable domestic setting, so that "visitors [would] feel at home in the midst of beautiful things and [be] subconsciously stimulated while consciously rested and refreshed."[1]

Any attempt to understand the establishment and growth of this extraordinary museum must focus directly on the background and philosophy of its founder, my father, Duncan Phillips. Though the Collection was assembled for public appreciation, it has a uniquely personal stamp on it. Until his death in 1966, my father made all decisions about purchases and exhibitions without resort to professional advisors or concern for the dictates of contemporary taste. The only person who participated in all aspects of the Collection's development was my mother, Marjorie Phillips, whose opinion was sought before any painting was acquired.

Duncan Phillips was born in Pittsburgh, Pennsylvania, in 1886, the grandson of James Laughlin, a banker and cofounder of the Jones and Laughlin Steel Company. Laughlin's daughter, Eliza, and her husband Major Duncan Clinch Phillips, a businessman, lived in a high-ceilinged house full of academic European and American paintings. As my father wrote after he had founded the Collection:

"Looking back on my childhood in that house, I do not remember the pictures. . . . And yet the long and stately

1. From the Minutes of the First Annual Meeting of Trustees of the Phillips Memorial Art Gallery, 1921.

The entrance to The Phillips Collection

School for Boys. While there, in 1901, Duncan wrote to his mother, "The one study in which my interest, enthusiasm, and ambition is kept alive is English. And as for composition writing, I cannot find out the reason for my passionate fondness for this occupation."[3]

Entering Yale in 1904, Duncan studied English and agitated for more courses on the history of art. In an article entitled "The Need for Art at Yale," in the June 1907 issue of the *Yale Literary Magazine,* he wrote:

"A thing that strikes the outsider as strange in our college curriculum here is that so many splendid courses with celebrated instructors should be offered to the dilettante in literature—while the sister art of painting now receives no attention save in technical instruction to the art students. . . . [A] deplorable ignorance and indifference prevail among the majority, and many graduate without a smattering of art history."

After graduating from Yale in 1908, my father became increasingly involved in writing about art. In a letter to his class of 1908 secretary, he reported: "I have lived in my home in Washington . . . devoting much study to the technique of painting and history of art. . . . At Madrid, London, and Paris as well as New York and other cities, I have met and talked with many artists in their studios and gone the round of exhibitions. [In my writing] I have attempted to act as interpreter and navigator between the public and the pictures, and to emphasize the function of the arts as means for enhancing and enriching living."[4]

This ambition—to act as a sensitive and eloquent interpreter of the painter's language and to share his own delighted understanding of art with an ever-growing audience—became my father's dominant concern, and his life work. In 1918, following a personal bereavement, this interest began to take concrete form in the establishment of the Collection as a place where the public could meet and appreciate great art in a quiet and informal setting. Emerging from a period of deep shock after the death of his father in

drawing-room contained oil paintings and many of them— 'Hudson River School' landscapes and well-drawn story-telling European pictures—in gorgeous gold frames. I was constantly aware of them and more or less fascinated, but none too pleasantly."[2]

In 1896, after the retirement of Duncan's father and the death of his grandmother, the Phillips family moved to Washington, persuaded that it had a better climate than Pittsburgh. They bought property at 21st and Q Streets, Northwest, and commissioned the noted Washington architects Hornblower and Marshall to design a house in the Georgian Revival style. (This building, with additions built in 1907, 1920, 1923, and 1960, now houses The Phillips Collection.)

My father and his brother James, two years older, went to Washington schools, including the Washington

2. Duncan Phillips, *A Collection in the Making* (New York: E. Weyhe, 1926), p. 3.

3. Letter quoted in *Duncan Phillips and His Collection* (Boston: Little, Brown, 1970), p. 34.

4. Letter quoted by Marjorie Phillips in *Duncan Phillips and His Collection*, p. 39.

The Main Gallery in the 1930s.

1917 and his brother James a year later, my father conceived the idea of a memorial gallery: "I would create a Collection of pictures—laying every block in its place with a vision of the whole exactly as the artist builds his monument or decoration a joy-giving, life-enhancing influence, assisting people to see beautifully as true artists see."[5]

The Phillips Memorial Gallery was created at the end of 1918, incorporated as a District of Columbia foundation in 1920, and opened to the public in the fall of 1921. Starting with a small, private family collection, my father had, by the time of the public opening, acquired some 240 paintings.

The paintings originally purchased, and all those to follow, were chosen not necessarily because they were wide-

ly acclaimed, historically significant, or radically innovative, but because they impressed my father as beautiful products of a particular artist's unique vision. His increasingly catholic taste excluded the academic and faddist, but honored "the lonely artist in quest of beauty, the artist backed by no political influence or professional organization."

His collecting proceeded at a wild and wonderful pace during those early years. The Renoir masterpiece *Luncheon of the Boating Party* was acquired in 1923, Daumier's *Uprising* in 1924, Cézanne's *Mont Ste.-Victoire* in 1925. By 1930, there were over 600 paintings in the Col-

5. Duncan Phillips, *A Collection in the Making*, p. 4.

11

Marjorie and Duncan Phillips, ca. 1922
photograph by Clara E. Sippels

lection, indicating a growth of some forty paintings a year. This, however, does not reveal the collector's full activity, since dozens of paintings acquired in those early years were later traded back to various artists and dealers for what he considered better examples of a given artist's work. Other paintings were simply disposed of when they failed to pass muster. As my father wrote in a published 1921 inventory: "It has been my policy, and I recommend it to my successors, to purchase spontaneously and thus to make mistakes, but to correct them as time goes on. All new pictures in the Collection are on trial, and must prove their powers of endurance."

The paintings reproduced in this book represent an excellent sampling of the finest works in the Collection. This selection cannot, however, reveal one of my father's favorite museum techniques—to create "exhibition units" of paintings by each of his favorite artists. Thus, the Collection today includes units of paintings by Bonnard, Cézanne, Braque, Daumier, Rouault, Kokoschka, Klee, Ryder, Prendergast, Tack, Dove, Marin, Knaths, and Rothko. Sometimes these exhibition units have been hung in rooms of their own; more often, they have been mixed with the "really good things of all periods. . .with such a delightful result that we recognize the universality of art and the special affinities of artists."[6]

In some cases major groups of paintings were formed when my father became a friend and patron of contemporary artists whose work he particularly admired. This was especially true of Augustus Tack, Arthur Dove, and Karl Knaths, all of whom received vital support and encouragement from him at crucial periods of their lives.

The Collection also includes a great many works bought by my father to encourage talented but little-known artists. This "encouragement collection" grew at an especially rapid rate during the 1930s, when the museum ran a small art school and when my father served as a regional chairman of the New Deal's Public Works of Art Project.

Inevitably, as the Collection grew, the problem of exhibition space became more acute. In 1930, our family moved out of the 21st Street house so that all of it could be converted to museum use. And in 1960 an extensive wing was added to provide new and safer space in which to present the most important holdings. As of today, the Collection consists of some 2,500 works of art.

By the time Duncan Phillips died in 1966, he had turned the Collection into a magnificent living memorial—not only to his father and brother, but to the independent, creative spirit of the many hundred artists represented there. With its great variety of vital, nonacademic paintings—many of them masterpieces—chosen by a single inspired art lover and exhibited in an unpretentious domestic setting, the Collection became a favorite small museum, a private place to revisit on trips to Washington and to introduce to good friends.

Shortly before his death, my father prepared "A Statement of My Wish for the Future of The Phillips Collection." He wrote that the Collection has "in recent years attained to its essential character as a home for a wide diversity of paintings, with a unity in all the diversity," and that "this intimate, personal creation, this creative conception having been achieved, it must in the future be maintained." However, he went on: "This does not mean that the Collection should be closed. It must be kept vital, as it always has been, as a place for enlightenment, for enjoyment, for rediscovery—by frequent rearrangements of the collection, and by the enrichments of new acquisitions." He went

12

6. Duncan Phillips, *A Collection in the Making*, p. 7.

The Music Room

on to urge the continued display of exhibition units and special loan shows, together with the series of free Sunday afternoon concerts initiated in 1941.

Responding to another of his wishes, my mother became Director in 1966. In addition to carrying on an active program of acquisitions and special exhibitions, she celebrated the Collection's fiftieth anniversary in 1971 by organizing a superb Cézanne loan exhibition and by writing the book *Duncan Phillips and His Collection*, full of personal reminiscences about the museum and its founder.

I took over in 1972, upon my mother's retirement, and have been increasingly preoccupied with devising plans to insure the Collection's physical and financial security. The proper preservation of the paintings now requires extensive renovation of the historic building, a considerably accelerated restoration program, and construction of a new storage and handling facility with temperature and humidity controls. This addition will also include study space and several galleries, so that more of the permanent collection can be on continuous view.

Meanwhile, the endowment left by Duncan Phillips cannot, in today's inflationary economy, cover more than a fraction of the Collection's expenses. Even with a small staff and a modest program, the museum has had to draw on its capital resources. Faced with these difficulties, we are for the first time seeking to broaden the Collection's base of support, while at the same time preserving its essential character. The museum will continue to celebrate adventurous, independent visual expression; to show how art of this sort is always modern; and to present that art in a warm setting for the viewer's pleasure and understanding.

Laughlin Phillips, Director
The Phillips Collection

Plate List

MASTER OF THE PHILLIPS ASTROLOGER

Venetian, active early sixteenth century

The Hour Glass (also known as Allegory of Time; The Astrologer)

Undated
Oil on wood panel
12 x 19 cm. (4¾ x 7½ in.)
Acquired 1939

The Hour Glass, together with two other luminous, Arcadian scenes of the same size now at Padua, was probably intended to decorate a piece of furniture. It is a rare example in the United States of a refined, lyrical style of painting which flourished during the early sixteenth century under the leadership of Giorgione and the private patronage of an exceptional group of Venetian aristocrats.

Several small landscapes with figures have been preserved which, like *The Hour Glass*, attest to a penchant among the collectors of the early sixteenth century for what Duncan Phillips termed "vistas of escape." These works are of problematic attribution, but they evince a strong affinity with the few extant authenticated works by Giorgione. Giorgione used landscapes not as mere backdrops for specific scenes from the Bible or classical literature, but as freely invented, inherently potent images and dynamic compositional devices, essential to the full exposition of the theme of the painting. It was Giorgione's genius for emotional suggestion, conveyed through color and design, that prompted Duncan Phillips, in his book *The Leadership of Giorgione*, to acclaim him as the creator of "pure art" and a predecessor of the lyrical abstractionists of our own century.

The Hour Glass displays a thoroughly balanced arrangement of generalized figural and landscape forms, engendering a sense of contemplative calm in the composition. These balanced forms frame our view of that most evocative image of Time's passing, the setting sun, which is central to the painting, pictorially and thematically. Vanishing beneath the horizon, the soft golden light cast by its parting rays envelops the foreground. This creates an elegiac tone that corresponds to the melancholy scene of an old man contemplating an hourglass—the so-called "Astrologer"—who is a personification of Time, and his companion, a young musician, whose performance affords an audible, aesthetic measure of Time's passing. As in other pastoral scenes ascribed to Giorgione or his followers, nature, that is, the landscape, serves to evoke a particular mood in accordance with the preoccupations of its inhabitants.

R.C.C.

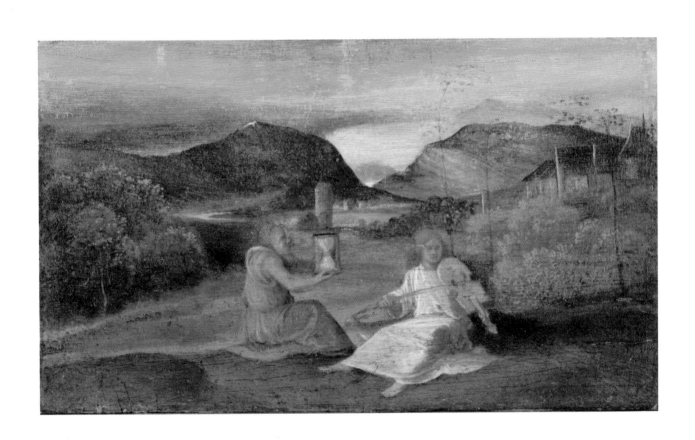

17

EL GRECO

b. Candia, Crete, ca. 1547
d. Toledo, Spain, 1614

The Repentant Peter

Ca. 1600
Oil on canvas
93.6 x 75.2 cm. (36$^7/_8$ x 29$^5/_8$ in.)
Acquired 1922

El Greco's *The Repentant Peter* belongs to a special category of religious image: the devotional picture, whose intended function is for private meditation rather than public ceremony. These pictures were designed to express theological concepts or mysteries of faith in compelling, affective form and, characteristically simple and direct, they played an important role in disseminating basic doctrines. The many pictures of penitent saints by El Greco and his contemporaries evidence the particular popularity of this theme during the Counter-Reformation.

The devotional image was meant to inspire emulation of the holy figure and, drawing on the tradition of icon painting, artists exploited the immediacy inherent in the close-up view to this end. The El Greco affords a dramatic close-up of St. Peter, weeping and praying when, as dawn breaks on the day of the Crucifixion, he realizes that Christ's prophecy at the Last Supper has been fulfilled: "And immediately the cock crew. And Peter remembered the word of Jesus, which said unto him, Before the cock crow, thou shalt deny me thrice. And he went out and wept bitterly." (Matt. 26:74–75.)

In this work, the reality and extent of Peter's psychological isolation, which is only hinted at in the narrative, is conveyed by his remoteness from the background. In the distance, Mary Magdalene is shown en route to the Holy Sepulchre, and on the horizon, a townscape is suggested— Jerusalem—over which dawn breaks with an effect appropriately Manichean in force and scale.

Just as in the background El Greco depicts the onset of the dawn evoked in the narrative—exploiting and exaggerating this feature in order to convey metaphorically the cosmic dimensions of the tragedy in Jerusalem, so too, the light radiated by the figure of St. Peter was probably inspired by biblical imagery. It is Peter, as leader of the Apostles, who in moments of communion with God, is "filled with the Holy Ghost. . . .with the Word," that is, "the light [that] shineth in darkness; and the darkness comprehendeth it not." (John 1:5.) Here, the ascetic and obviously receptive saint is shown as if divinely illuminated, and El Greco's dark field endows the light with a formal strength consonant with its thematic importance.

Ironically, El Greco's seemingly quite literal approach—as in the extravagant exploitation of the biblical imagery of light in *The Repentant Peter*—results in paintings which, when viewed through twentieth-century eyes, are seen to possess an abstract emotive power of overriding significance. Duncan Phillips, fully aware of the passionate, religious inspiration behind El Greco's painting, acclaimed El Greco as "the first great Expressionist in art."

R.C.C.

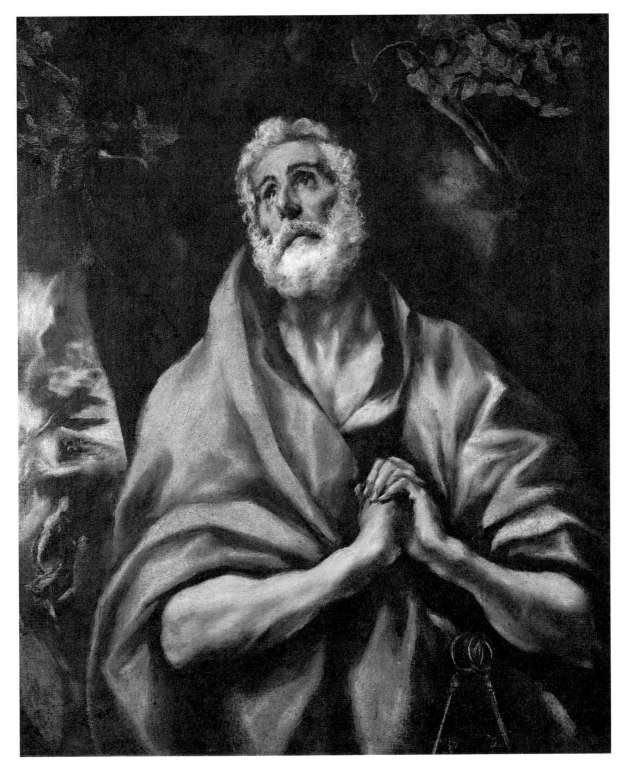

19

FRANCISCO JOSÉ DE GOYA

b. Fuente de Todos, Spain, 1746
d. Bordeaux, 1828

Repentant Peter

Ca. 1820–24
Oil on canvas
73.3 x 64.8 cm. (28⅞ x 25½ in.)
Acquired 1936

In semi-retirement at his home, the Quinta del Sordo, from 1819 to 1824, Goya painted five pictures which can be designated as "religious." Four of them follow the iconographic traditions of church painting. The fifth, *Repentant Peter*, departs radically from the usual depictions of the Saint. Although Peter can be recognized by the keys of the Church, his traditional identifying symbol, they function more effectively as extensions of golden yellow highlights than as artificially incorporated attributes. The emotional intensity of the severely foreshortened head, thrown back in agonized prayer at the moment when Peter realizes he has fulfilled the prophecy of denying Christ three times, is more human than saintly. This is Peter the humble fisherman, corporeal and massive, lamenting his moral frailty.

Peter is described passionately by such hastily brushed modelling that the painting could only have been done toward the end of a prolific career, when the need for meticulous description had been replaced by the shorthand of painterly language. In the context of a largely twentieth-century collection, Goya's *Repentant Peter* transcends all specific narrative references and stands in its pyramidal solidity as a monument of masterful technique.

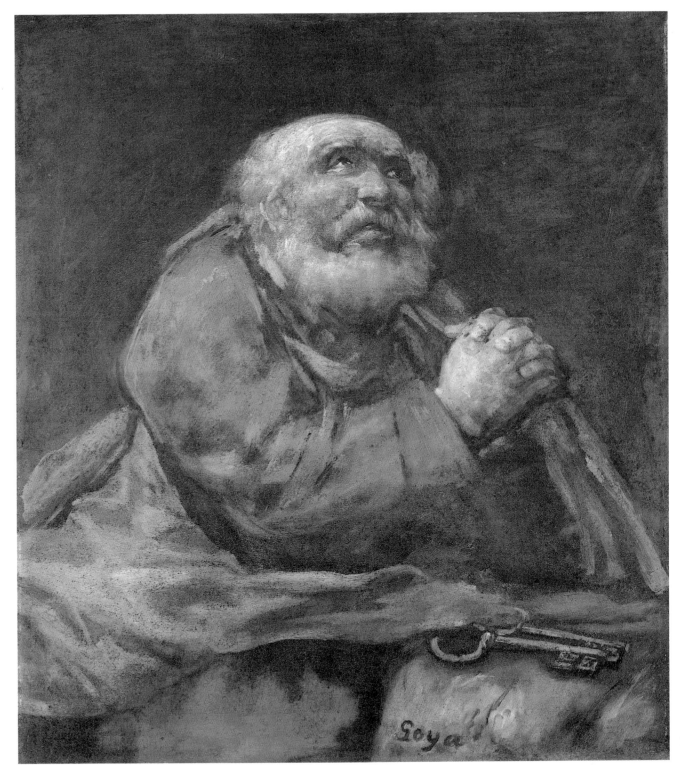

JEAN-BAPTISTE SIMEON CHARDIN

b. Paris, 1699
d. Paris, 1779

Bowl of Plums, a Peach, and Water Pitcher

Ca. 1728
Oil on canvas
45.1 x 56.8 cm. (17¾ x 22⅜ in.)
Acquired 1920

In the 1720s, when Chardin first dedicated himself to the "humble" study of animals and fruit, still-life painting ranked at the lowest level of the official artistic hierarchy. In fact, the Academy recognized Chardin only in the category of painters "skilled in animals and fruits." Higher accords were reserved for artists who relied on imagination, rather than on observation. This prejudice may well have been based not only on the opinion that a painter should concern himself with "noble" subjects, but also on the prevailing inability of still-life painters "to see the forest for the trees." That is to say, they lavished greater care on reproducing texture and local color than on compositional relationships between the objects they represented.

While Chardin never shunned meticulous rendering of the gleam on a plum or the crackled glaze of a pitcher, he first set himself another objective. In a statement which strikingly anticipates Cézanne, he said, "I must place [the object] at a distance where I no longer see the details. Above all, I must strive for proper and utterly faithful imitation of the general masses, the color tones, the roundness of shape, and the effect of light and shadows."

Bowl of Plums, most recently dated circa 1728, is thought to be an early example of Chardin's effort to generalize masses. In his concern with light, color relationships, and the expression of three-dimensionality, he has tilted the tabletop and the silver bowl slightly to emphasize the roundness of the fruit, even to the extent of implying multiple viewpoints. By also observing the pitcher from an elevated angle, Chardin exaggerates the fullness of its body by showing more than the silhouette that would be visible at eye level. The light source seems inconsistent as well: highlights fall illogically where Chardin wanted to stress the voluptuous surface of the fruit or the curved rims of bowl and pitcher.

Cézanne often proclaimed his indebtedness to Chardin. Comparison of *Bowl of Plums* with his *Pomegranate and Pears* (page 79) demonstrates the relationship. Furthermore, looking back from Cézanne, the modern eye sees beyond the seductive tactility of Chardin's painting to the brilliant devices invented by "the first artist," as Duncan Phillips said, "to accept and explore the complexity of visual appearance."

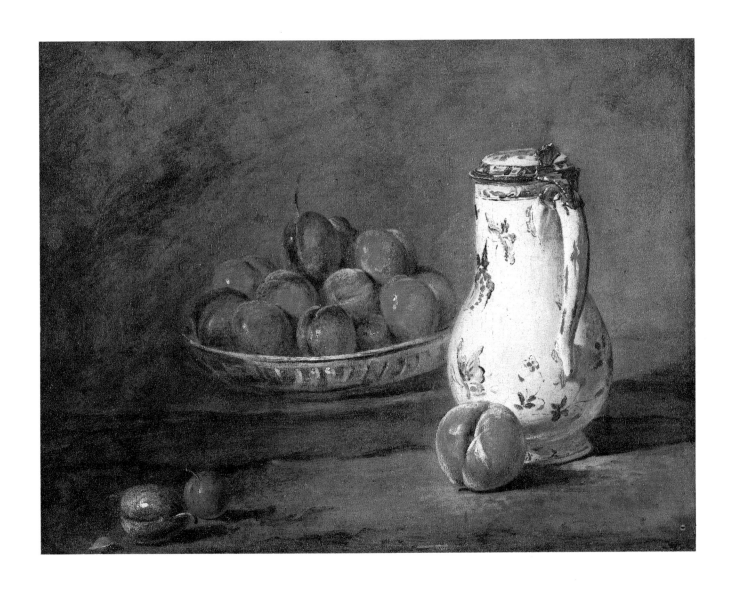

23

JEAN AUGUSTE DOMINIQUE INGRES

b. Montauban, 1780
d. Paris, 1867

The Small Bather

1826
Oil on canvas
32.7 x 25.1 cm. (12⅞ x 9⅞ in.)
Acquired 1948

Having received virulent criticism for his entries in the 1806 Salon, Ingres required considerable courage to send the large *Bather of Valpinçon* (now in the Louvre) from Rome to the Paris Academy in 1808. Perhaps out of pride in the sensuous classical figure, or from the premonition that it would be of further use to him, Ingres made a greatly reduced watercolor copy of *The Bather* (now in the Fogg Art Museum, Cambridge) before it left his studio. Eighteen years later, when he returned to Paris to be "dazzled" by the freely painted romantic canvases in the Salon, he turned again to repetitions of the central figure in different settings. The Phillips *Bather*, identical in proportion and contours to both the Valpinçon and Fogg figures, sits in an idyllic glade rather than the elegant boudoir of the Valpinçon painting, watching over a sleeping figure that does not appear in the earlier versions. In the background, perhaps in deference to the Romanticism Ingres had not yet rejected, flaccidly drawn, androgynous innocents bask and bathe. The scene may illustrate some unidentified mythological legend, a Renaissance tale, or simply nostalgia for a lost Utopia.

Several other variations on the seated bather occur in Ingres's paintings, most notably the musician at the center of the great *Turkish Bath* tondo in the Louvre. Of these works, the immediacy of the delicate Neoclassical figure, contrasted against a vaguely defined background, presents the most tantalizing version of Ingres's brief flirtation with Romanticism. The Phillips painting, in which the monumental, chiselled nude (based on Renaissance prototypes) is juxtaposed with an elegiac background, is unique. At no other time in his career did Ingres so successfully accommodate to the old style and the new.

24

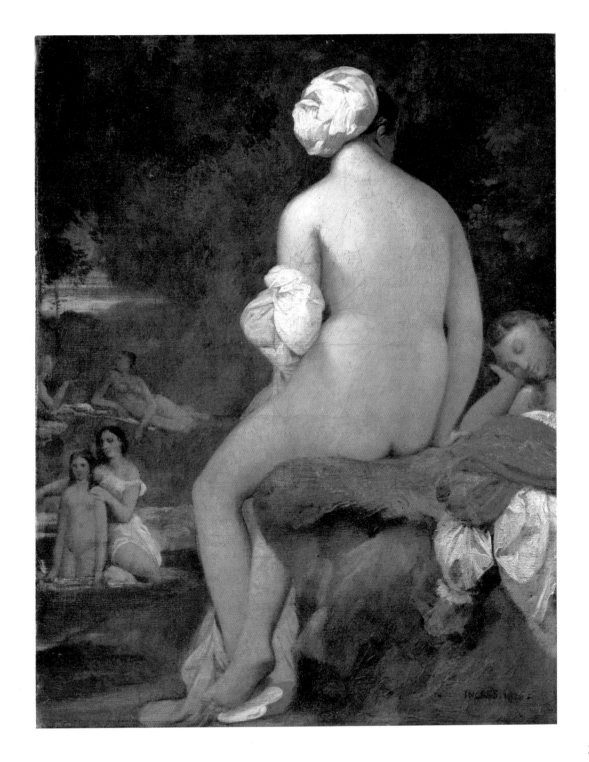

EUGENE DELACROIX

b. Charenton-Saint-Maurice,
 France, 1798
d. Paris, 1863

Paganini

Ca. 1832
Oil on panel
45.1 x 30.5 cm. (17³/₄ x 12 in.)
Acquired 1922

Paganini's Faustian persona excited the imagination of Romantic era audiences so much that they believed his extraordinary virtuosity stemmed from a pact with the Devil. The violinist packed concert halls with crowds anxious to see his frenzied performance transform him into the "incarnation of desire, scorn, madness, and burning pain." His reputation as a wastrel made him all the more an attraction.

Eugène Delacroix painted the legend at the height of its potency. Paganini appears as a shadowy apparition, illuminated only by an arabesque of theatrical light from his forehead to the tips of his unnaturally elongated fingers. The demon-driven figure, subsumed in sound from his "devil's music box," contorts as if beckoned by a danse macabre. The flesh is bloodless, the body boneless; it is a portrait of Paganini's beleaguered soul.

Tubercular, syphilitic, and plagued by gambling losses, Paganini was nevertheless preparing for his first concert tour of England at the time when Delacroix painted this small panel. The furious drawing and paint handling deliberately emulate the bravura of a Paganini recital. As Delacroix explained, in deference to the sister arts of music and painting, Paganini's hypnotic presence could only be caught by another hand as practiced and deftly agile as his own.

This image of Paganini, which was also translated into a print, became a source of caricature and later a symbol of Paganini's tortured genius. Ultimately, it is his epitaph: "To the imperishable memory of Niccolò Paganini, who drew from his violin divine harmonies."

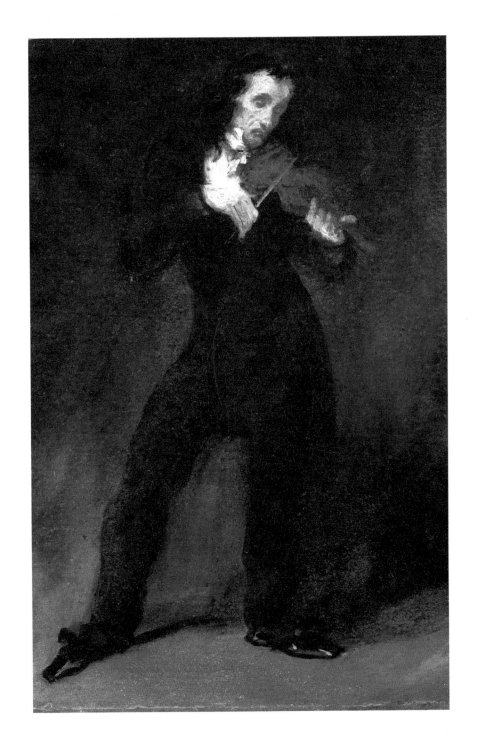

HONORE DAUMIER

b. Marseilles, 1808
d. Valmondois, 1879

The Uprising

Ca. 1860
Oil on canvas
87.6 x 113 cm. (34$\frac{1}{2}$ x 44$\frac{1}{2}$ in.)
Acquired 1925

Although Daumier unwittingly provided the militant Realist movement led by Courbet with its battle cry—"*Il faut être de son temps*"—*The Uprising* manifests a moralizing and ideological point of view, a trait, generally speaking, that often distinguishes Daumier's paintings from Courbet's or Manet's more purely phenomenological Realist works. In *The Uprising*, Daumier adhered to the Realist position insofar as the subject matter of the painting is a scene from contemporary life—a distinctly urban mixture of people marching through Paris, most likely during the anti-monarchical demonstrations of 1848. But Daumier's Republican sympathies are as much in evidence here as they are in the thousands of lithographic caricatures he produced for the anti-establishment journals that thrived in Paris throughout the nineteenth century. A comparison with Manet's strangely distanced, evenly inflected treatment of the *Ballet Espagnol* (page 43) reveals how Daumier's passionate involvement with his subject matter influenced his rendering of *The Uprising*.

Daumier's painting is not simply an unembellished journalistic record of a contemporary scene, but an exhortatory, carefully structured pictorial "symbol of all pent-up frustration . . . of the waves of self rule, of self reliance, the epic movement in the history of freedom." Daumier's vision of *The Uprising* recalls Baudelaire's insistence that there was an epic, heroic side of modern life, as worthy of recognition as the heroism of antiquity.

The "heroism of modern life" is brought home in the subordination of the image to the central figure of the young leader of Daumier's revolution. He stands out, arm stretched and fist clenched, dramatically highlighted—a white-clad, strongly modelled Joshua surrounded by his mesmerized followers, who are depicted as a shadowed, barely differentiated, coalescent mass. The ominous magnitude and intensity of the unleashed strength of the people is conveyed by the impression that the street can barely contain their powerful flow.

In rejecting both the academic, allegorical approach and Courbet's impersonal, photographic realism, Daumier was forced to exploit the expressive potential of purely pictorial means. In Daumier's painting, compositional structure, lighting, and, above all, drawing and modelling come to the fore as conveyers of significance.

R.C.C.

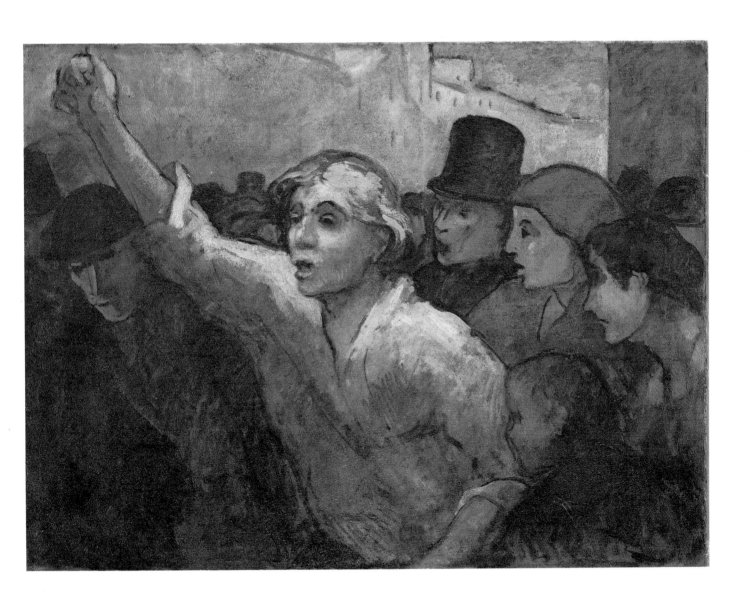

29

HONORE DAUMIER

The Painter Before His Easel

Ca. 1870
Oil on panel
33.3 x 25.7 cm. (13^1/$_8$ x 10^1/$_8$ in.)
Acquired in 1944

In spite of the acclaim accorded to his painting by some of the most perceptive critics of the day, Daumier was forced to depend for most of his life on his graphic work for economic survival. The often unpleasant or depressing subject matter of Daumier's paintings and, by nineteenth-century standards, their lack of "finish" simply did not conform to the taste of the average collector. Nevertheless, Daumier considered himself a painter first and foremost.

The Painter Before His Easel is a distinctly psychological treatment of the self-portrait theme. In contrast to the traditional self-portrait, in which, far from depicting himself at work, the artist asserted his hard-won social or intellectual eminence—as in the case of Titian, Van Dyck, or Poussin—Daumier portrays himself, unabashedly, at work alone in an unpretentious studio environment. Even Courbet's self-image as projected in *The Studio* is high-flown and rhetorical. Although, like Daumier, he allows himself to appear in his working milieu, Courbet emphasizes the abstract social and intellectual concerns that motivated his work, whereas Daumier's image is strictly personal and psychological.

Daumier has been described as working out his compositions directly on the support, in an inspired and assured manner, without models or the usual preparatory studies. He painted rapidly and with the utmost economy of means. "Like a Chinese painter," wrote A. Hyatt Mayor, "Daumier must have had to sit until the clearing of his inner eye discharged an accumulated energy into a few lines flowing deliberate and free." Daumier's characterization of the artist's psychological condition during the act of creation is unequivocal. He is here portrayed, surrounded by a suggestive, glowing light, in a beatific state.

R.C.C.

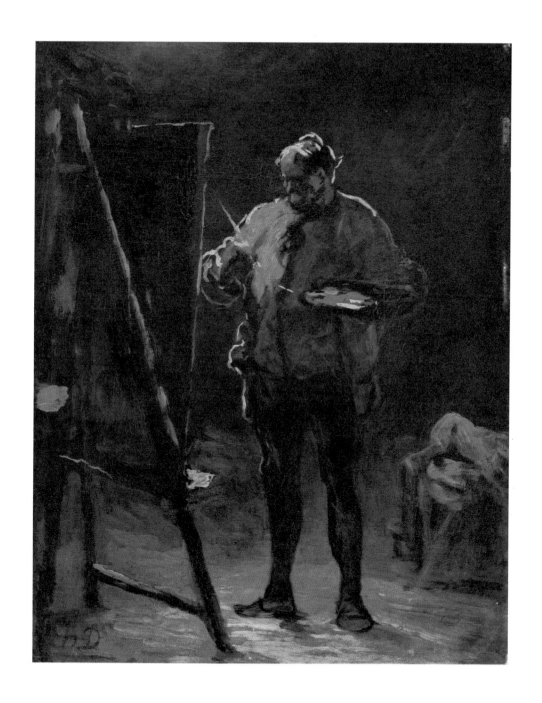

31

JEAN-BAPTISTE CAMILLE COROT

b. Paris, 1796
d. Ville-d'Avray, 1875

View from the Farnese Gardens, Rome

1826
Oil on paper mounted on canvas
25.1 x 40.6 cm. (9⅞ x 16 in.)
Acquired 1942

Jean-Baptiste Camille Corot's long-neglected landscapes from his first visit to Italy of 1825–28 have come to be prized as critical to the transition of landscape painting from the classical to the modern. His formal plein-air pictures bridge the psychological distance between the formidable studio compositions of Poussin and Claude Lorrain and the informal immediacy of Impressionist painting.

View from the Farnese Gardens, along with the Louvre's two equally famous views, *Forum Seen from the Farnese Gardens* and *Colosseum Seen from the Farnese Gardens*, was painted in March of 1826, when Corot visited the Palatine Hill early each day to watch the morning light change on the walled garden and tiled roofs as the sun moved higher. While his observance of light was as keen as any Impressionist's, he painted solid forms as they were illuminated by sun and shade, rather than dissolving them in simulated light sensations.

In this painting, Rome's slanting morning sun hits the top of the wall and east facades, leaving the south sides in sharply defined shade. Shadows mask the shuttered windows and cool the wildflower-covered swale between the trees; it is a fresh southern morning promising mid-day heat.

Corot had only recently left conservative studio tutelage in Paris to see for himself the antique sources of the classical tradition. Once in Italy, however, he spent more time sketching and painting the Campagna than in archeological study. Corot's response to the ambience of his environment gives his Roman paintings an essentially classical feeling without resorting to specific antique architectural references. *View from the Farnese Gardens*, balanced and serene, needs no aqueduct or triumphal arch to identify it with the Eternal City.

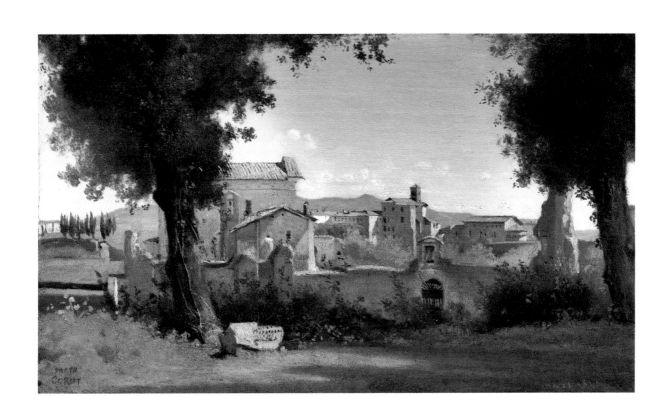

33

GUSTAVE COURBET

b. Ornans, France, 1819
d. La Tour de Peilz, Switzerland,
 1877

Rocks at Mouthiers

Ca. 1850
Oil on canvas
76.2 x 116.2 cm. (30 x 45¾ in.)
Acquired 1925

After the pointless "days of June" street fighting, Gustave Courbet left Paris for his home in Ornans; disillusioned by the outcome of the 1848 revolution and depressed by the failure of his ambitious allegorical paintings, he needed a new locale for a new impetus. Once detached from the artistic and political turmoil of the capital—free of the temptation to follow fashionable trends—he rejected Baudelaire's edict, "Who says Romanticism says modern art." As an alternative, he espoused the newest credo—that the future of painting lay in the simple, unforced presentation of contemporary subject matter. In the belief that the most honest painting must commemorate an everyday event the artist had personally experienced, he recreated an evening at the house of a friend in his next major canvas, *After Dinner at Ornans*.

After this genre painting won a gold medal at the 1849 Salon he chose *Burial at Ornans*, a variation on the scene of his grandfather's funeral, as the theme for his next "*machine*" (as large Salon paintings were called). But while these complex works demanded much of his time in the studio, he still made forays out of town, where he painted the "highway series" of landscapes in the dramatic Franche-Comté countryside. The brooding cliffs of Mouthiers, some fifteen miles from Ornans, appear repeatedly in paintings of this time, and again some twenty years later in another series. The Phillips painting is a severe rendering of the inhospitable rocks rising above a tamed valley. The paint, applied with a palette knife, presaged Monet's "broad principles" in technique; it also imparted a physical roughness equivalent to the feel of granite. An unsympathetic critic of the time, repelled by the blotched surface, remarked, "No one could produce a better blue cheese than Courbet."

While Monet approved of Courbet's handling of paint, he rejected the dark ground in favor of a light one, which would give a painting airiness. Tastes changed with the advent of Impressionism; paintings ceased to have the bite of aged Roquefort; palettes were dominated by pastels; Realist paintings, by comparison, looked graceless. Then, after World War II, when Abstract Expressionist artists aggressively rejected what they called "French tastefulness," conventions and techniques similar to Courbet's became part of their means. A similar toughness of spirit led the New York painters to deliberately build up heavy layers of "unacceptable" color, in order to assert their own definition of Realism.

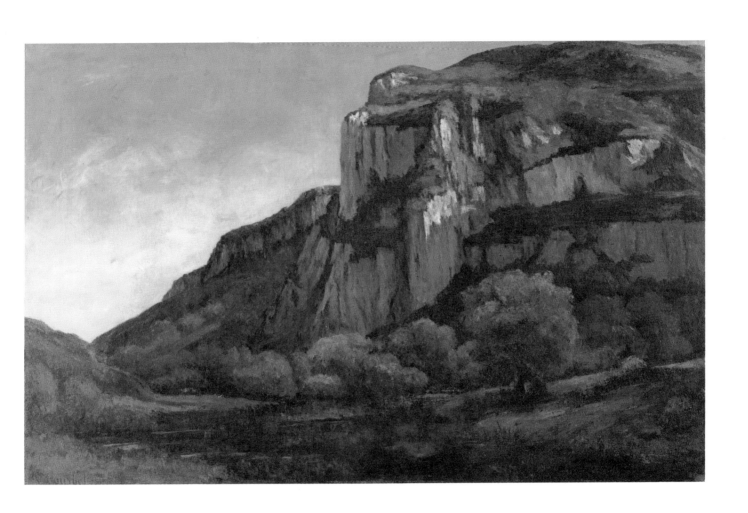

ADOLPHE MONTICELLI

b. Marseilles, 1824
d. Marseilles, 1886

Bouquet

Ca. 1875
Oil on wood panel
69.2 x 49.5 cm. (27^1/$_4$ x 19^1/$_2$ in.)
Acquired 1961

Monticelli was an anachronism in the sense that he made his entrance into the art world at a time when his predilection for elegant opulence was out of fashion. While Courbet and Flaubert elevated petit bourgeois subject matter to heroic proportions, Monticelli celebrated aristocratic *fêtes galantes*. In the 1870s, when the Impressionists were obsessed with natural light and painting *en plein air,* Monticelli worked in his studio, encrusting dark canvases with colors like glowing coals.

Actually, Monticelli was neither ahead of nor behind contemporary art developments; he was, instead, off to one side, following a minor tradition of *la belle peinture*—an artist whose pleasure in the craft, materials, and technique of making a painting far exceeded any preoccupation with external considerations. Other painters of the same sensibility, from Chardin to Braque, frequently turned to still lifes because rendering the textures and colors of flowers and fruits provided an excuse for the most exquisite manipulation of paint. Toward the end of Monticelli's life, surrounded by the often exotic and pungent sights and smells of Marseilles, he indulged himself in painterly equivalents of the city's riches. For this artist, the intrinsic properties of the oil medium became as important as the pigments they bound, as, for example, when a shiny glossiness made a red more vibrant or a black more mysterious. To construct *Bouquet,* Monticelli appears to have applied juicy full-strength colors directly from the tube in order to simulate flower petals. Then, in a tour de force of mixing without muddying primary colors, he softened and greyed them without the addition of black. The mélange, applied with a flat, horizontal stroke, corresponds to the waxed sheen of a tabletop diffusely reflecting the bouquet.

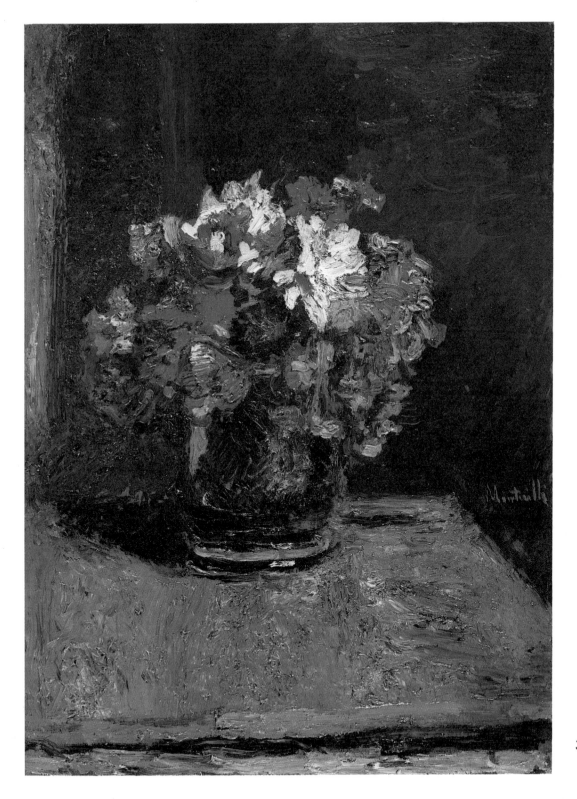

37

JOHN CONSTABLE

b. East Bergholt, Suffolk, 1776
d. London, 1837

On the River Stour

Ca. 1834–37
Oil on canvas
61.2 x 79.3 cm. (24⅛ x 31¼ in.)
Acquired 1925

Contrary to its specific title, *On the River Stour* is an imaginary landscape synthesized from memories and sketches to distill the essence of the Bergholt countryside. Painted during the last three years of Constable's life, when he frequently summarized form and light in bold strokes of paint, this is the kind of canvas most emulated by forgers shortly after his death. Altogether too many academic hacks believed that "in order to manufacture an authentic Constable, it is only needful to load . . . old canvas with unmeaning daubs of paint." (Robert Leslie, in his introduction to the 1896 edition of C.R. Leslie's *Life of Constable*.)

Because a plethora of Constable forgeries exists and his earlier best-known works are painted with more exactitude, nearly all the late canvases have been questioned at one time or another. Even recent exhibitions have focused largely on more tightly painted versions of his often repeated subjects. However, *On the River Stour* can be seen as a logical variant—so typical of Constable's way of working—on the Victoria and Albert Museum's *Farmhouse near the Water's Edge* and a similar watercolor in the British Museum. The same intelligent structure pervades all three paintings and, although they vary greatly in medium and degree of finish, the handling of paint is peculiarly autographic. Future scholarship is likely to establish *On the River Stour* as a key to authenticating even looser versions which have long been questioned.

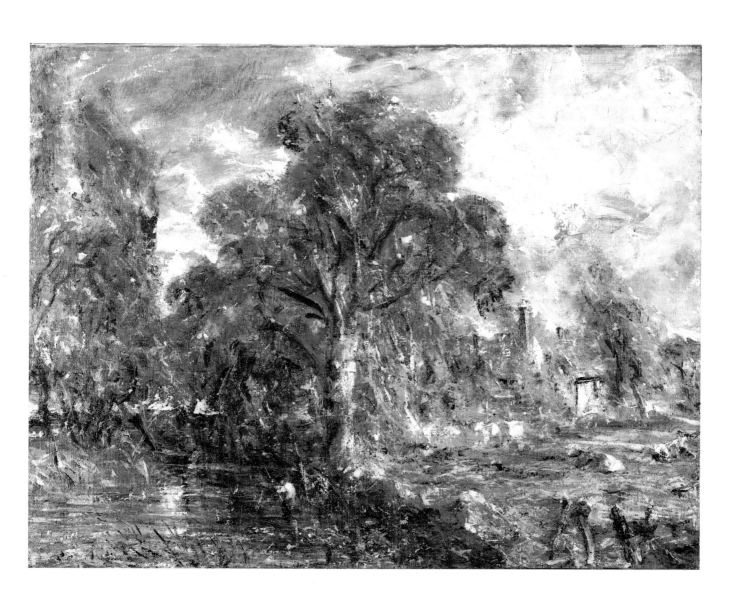

PIERRE PUVIS DE CHAVANNES

b. Lyon, 1824
d. Paris, 1898

Marseilles, Gateway to the Orient

1868
Oil on canvas
98.1 x 146.4 cm. (38⅝ x 57⅝ in.)
Acquired 1923

Trained in the grand tradition of classical mural painting, Puvis simplified forms and colors to conform to the essential flatness of the wall and to enliven the usually drab stone surroundings. As a result, without intending to be deliberately modern himself (he firmly denied any association with Symbolism, for example), he became almost an idol to avant-garde artists of the late nineteenth and early twentieth centuries.

Marseilles, Gateway to the Orient was not conceived as an easel painting; rather it is a finished sketch for a Musée de Marseilles mural commission that was to be installed in the Palais Longchamp; it is a preparatory painting which required simplification according to the principles of wall decoration. Invited to dramatize the port as a gateway for Western trade, Puvis unsuccessfully tried several views looking out to sea before finally hitting upon the idea of painting the city from the deck of an arriving ship. He presents the city as the immigrant or merchant would first see it—blanched white in the midday Mediterranean sun beyond an intensely blue harbor.

Marseilles, Gateway to the Orient and its companion piece, *Massilia, Greek Colony*, have been cornerstones of this Collection devoted to modern art and its sources almost since the founding of the museum. Augustus Tack, who later wrote about the "breadth of handling and wealth of suggestion" in the painting, especially admired the canvases. Many other artists have re-evaluated Puvis after seeing these atypical and brilliantly colorful studies. Most Puvis paintings, at least those in American collections, tend to be monochromatic, Neoclassical drawings. *Gateway to the Orient* explains the great enthusiasm of Seurat, Degas, and Gauguin for Puvis as a major force in revolutionary painting.

41

EDOUARD MANET

b. Paris, 1832
d. Paris, 1883

Ballet Espagnol

1862
Oil on canvas
61 x 90.5 cm. (24 x 35⁵/₈ in.)
Acquired 1928

Baudelaire spoke of "the strangest Spanish savor" in Edouard Manet's paintings of the early 1860s. It was a strangeness born of exoticism—a ubiquitous French fascination with Hispanic culture that became a true craze during the 1862 Paris appearances of Don Mariano Camprube's Ballet Espagnol. Baudelaire is said to have attended every performance; Manet went frequently to see them at the Hippodrome and persuaded Camprube, his star, Lola de Valence, and other dancers to pose for him in the studio.

For Manet, flamenco models and theatrical lighting offered the opportunity to make a dramatic departure from French rules of style and composition. As a friend of his remarked, Manet "despised all the tricks" and "deliberately defied all conventions." After making two sketches and a watercolor of *Ballet Espagnol,* Manet discarded all principles of perspective and optics to paint a picture so radical that it is still difficult to comprehend.

The horizontal division of the canvas into light and dark halves, the arbitrary placement of figures without relating elements, and the distracting bouquet set squarely in the center of the painting leave the eye without guidance. It is further confused by the four dancers, whose equal size and presence contradict their placement in space. Manet may have intended his pictorial rhythms to be equivalent to the staccato beat of castanets and clicking heels and, if he worked from photographs, as he did a few years later to paint *The Execution of Maximilian,* the technique would explain both the stop-action clarity of outline and parity of size and focus. Nothing, however, fully explains Manet's perverse point of view, unless we see it as his intuited foresight of twentieth-century aesthetics.

It would seem to be more than coincidence that after the Manet retrospective at the same 1905 Salon d'Automne where the Fauves were exhibited for the first time, Matisse purged his art of its last Impressionist vestiges. By 1911, in his *Red Studio* and later in *Studio, Quai St. Michel* (page 83), Matisse was taking the same calculated compositional risks that are so disquieting in *Ballet Espagnol* by throwing the space out of perspective and scattering unrelated forms across the face of the canvas. Matisse further distorted his drawing and expanded areas of local color to broad planes, but at his most inventive he could not surpass Manet in the use of sonorous black as a fourth primary color.

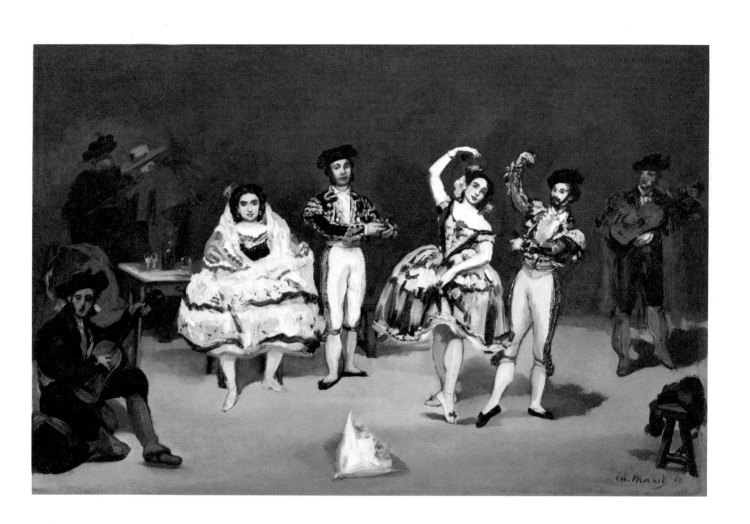

43

EUGENE-LOUIS BOUDIN

b. Honfleur, 1824
d. Deauville, 1898

Beach at Trouville

1863
Oil on wood panel
18.4 x 34.9 cm. (7¼ x 13¾ in.)
Acquired 1923

Eugène-Louis Boudin's many small landscapes are metaphoric self-portraits of the artist: gentle, unassuming, engaging. As a man and painter he avoided bombast and pretention, but his softly spoken criticisms and beautifully crafted little paintings were heard and seen with all the more attention because of their quietness. Initially a craftsman and a frame maker, Boudin's two years spent at the Ecole des Beaux-Arts in Paris had little effect on his predilection for recording his native Le Havre. He returned from Paris convinced that Romanticism was finished and that "we must seek the simple beauties of nature . . . seen in all its variety, its freshness." When he met Monet, then a teenager arrogant over his success as a caricaturist, Boudin praised his work, then gently persuaded him to paint seriously out-of-doors because: "Everything that is painted on the spot has always a strength, a power, a vividness of touch that one doesn't find again in the studio."

The serenity of *Beach at Trouville*, one of Boudin's many beach scenes, gives no hint that it was painted while furor in the art world still raged over the Salon des Refusés, at which Manet, Cézanne, and Whistler had shown their controversial work. Boudin simply noted of this series, "People like my little ladies on the beach very much." He was too modest; Baudelaire had liked them so much on first view in 1859 that he quickly inserted a full page of praise for Boudin's skies into his Salon review.

It was fitting that, although Boudin was of an older generation, he accepted Monet's invitation to join the first Impressionist exhibition of 1874, for they all owed much to his example. He had led the way to painting nature directly and simply in such exquisite small panels as *Beach at Trouville*. Monet acknowledged how much the older painter had taught him about the observation of changing light in 1864, when he and Boudin were together at Honfleur: "We are getting along marvelously . . . in such company there's a lot to be learned and nature begins to grow beautiful."

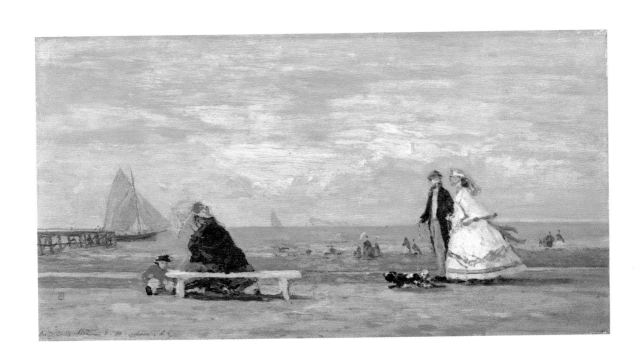

45

CLAUDE MONET

b. Paris, 1840
d. Giverny, 1926

On the Cliffs, Dieppe

1897
Oil on canvas
65.1 x 100 cm. (25⅝ x 39⅜ in.)
Acquired 1959

Already revered as the quintessential Impressionist when he moved to Giverny in 1883, Monet continued to develop different modes of painting even when surrounded by a stifling number of disciples. In the 1890s, he set himself the task of repeating mundane subjects under every conceivable kind of light. He first painted poppy fields, then a row of poplar trees and nondescript haystacks on both bright and dreary days. The series culminated in eighteen cropped, frontal views of Rouen Cathedral, recording the passage of time from dawn until sunset. Shortly after the *Cathedrals* were finished, Monet conceived a plan to summarize his career: he would visit all the sites where he had previously worked, and, in a few canvases from each location, recapitulate his stylistic evolution.

The scheme was never completed, but *On the Cliffs, Dieppe* compresses and epitomizes several of Monet's achievements in a single canvas. In his later years, Monet always limited his means, challenging himself to orchestrate a few notes into a full symphony. Here, he establishes the problem of imbuing a casual, nearly formless composition with a sense of reality through pure painterly artifice, distinguishing the inherent properties of air, earth, water, and vegetation in terms of their absorption and reflection of ambient light.

Monet was reluctant to discuss theory, but his fellow Impressionist Alfred Sisley (page 49) wrote of the evocative potential in keeping the surface "at times raised to the highest pitch of liveliness [so it would] transmit to the beholder the sensation which possessed the artist"; Monet has used this device in *On the Cliffs, Dieppe* masterfully. The sky, smoothly painted in subtle gradations from blue to pink, absorbs light from above and reflections of the sea into an amorphous blue; the sea, painted in shorter strokes of fragmented hues, breaks up color the way water breaks up light; the vegetation seems to absorb the glare and reveals itself in dark blues and greens; the rough painting of the cliff face emulates the texture of rock, flecked with blue echoes of the sea. Later, Monet added a stippled impasto of white pigment as a tangible reminder of thorny brush growing along the ridge.

Working from a nebulous composition without drawing, Monet activated the surface of the canvas to evoke palpable memories of reality. As Sisley suggested, this is particularly important "when it is a question of rendering light-effects. Because when the sun lets certain parts of a landscape appear soft, it lifts others into sharp relief. These effects of light, which have an almost material expression in nature, must be rendered in material fashion on the canvas."

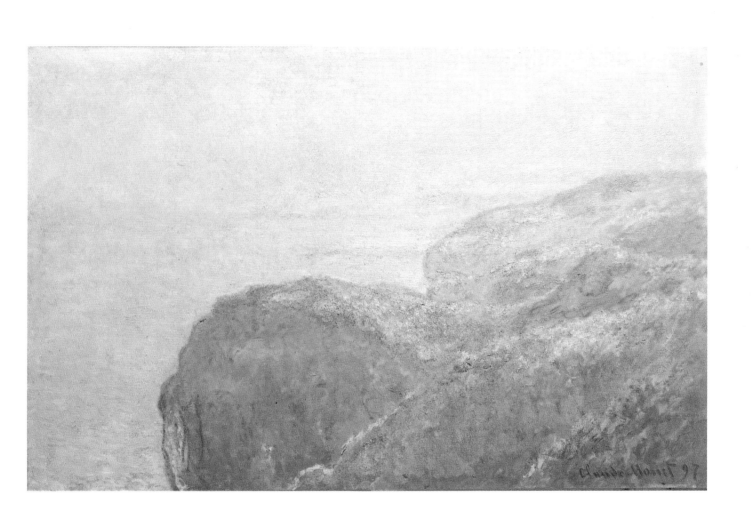

ALFRED SISLEY

b. Paris, 1839
d. Moret-sur-Loing, 1899

Snow at Louveciennes

1874
Oil on canvas
55.9 x 45.7 cm. (22 x 18 in.)
Acquired 1923

The orderly geometry underlying Alfred Sisley's close-valued color in *Snow at Louveciennes* is the exception to the Impressionist rule that compositions should appear to be casual and unplanned. Sisley has carefully framed his view of the village lane so that the fence on the left and stone wall on the right lead the eye straight to the single figure and cool green umbrella against a brick-red wall. The eye moves left to the green gate, upward to the darker green window and related tones in the trees at a reassuringly measured pace that is reminiscent of the altered sense of time and space one may experience when walking in new-fallen snow.

French-born of English parents, Sisley first seriously looked at painting in London, where he carefully studied the work of Constable (page 39) when he was eighteen years old. It would appear that the impact of Constable's highly intelligent compositions was never supplanted. Although, while painting with Monet (page 47) and Renoir (page 53), Sisley enthusiastically embraced the techniques of Impressionism developed during the 1860s, he retained a certain reserve and an insistence on rational, formal composition. Once satisfied with the structure, Sisley adjusted his view from sharp to soft focus in several similar canvases. *Snow at Louveciennes,* which may have been in the first Impressionist exhibition in the spring of 1874, is bolder in both design and execution than the same scene in another canvas, painted more meticulously in the crisp light of fall, while a third version of the work is even more loosely painted.

Sisley insisted that "the manner of painting must be capable of expressing the emotions of the artist" and later confessed to incessantly humming a "gay, singing phrase" from a Beethoven septet while he worked—which may explain the "finesse and tranquillity" a contemporary critic observed in his paintings.

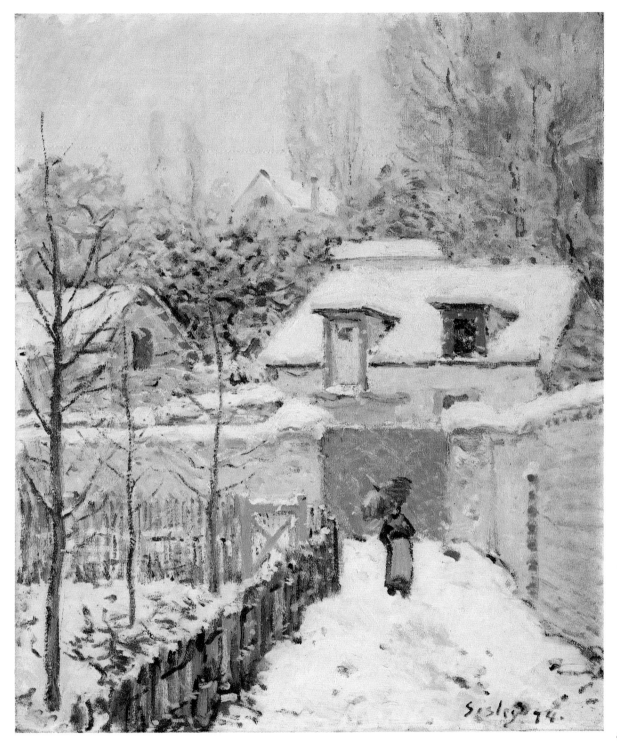

49

BERTHE MORISOT

b. Bourges, France, 1841
d. Paris, 1895

Two Girls

Undated
66 x 54.6 cm. (26 x 21$^1/_2$ in.)
Acquired 1925

Attributing his words to a hypothetical academic painter, a critic wrote in *Charivari* of Berthe Morisot's work in the first Impressionist exhibition, "That young lady is not interested in reproducing trifling details. When she has a hand to paint, she makes exactly as many brushstrokes lengthwise as there are fingers, and the business is done."

Although, like so many pungently insightful remarks on modern painting, the intent was derisive, the critic was perceptive to note Morisot's ability to indicate form with a few deft manipulations of her brush. Her broad strokes and fluid line set her apart stylistically from Monet, whose figures the same critic described as "innumerable black tongue lickings," just as her treatment of light as a descriptive element rather than as the subject itself gave her paintings more solidity than those of Sisley.

Morisot's attitude toward light was undoubtedly derived from her study with Corot during his most mellow years, and her bravura brushwork may have owed a debt to Manet, with whom she frequently painted. But a more basic difference in outlook underlies her technique: Morisot was not content with reproducing only external appearances. Her lyric and poetic sensibility always guided her fluid line to express an inner state of grace. Morisot, herself an activist who loyally boycotted the Salons in favor of showing with the Impressionists, revealed her inward vision toward the end of her life: "life is a dream and the dream is more true than reality—there one is oneself, really oneself. If one does have a soul, that is where it is to be found."

50

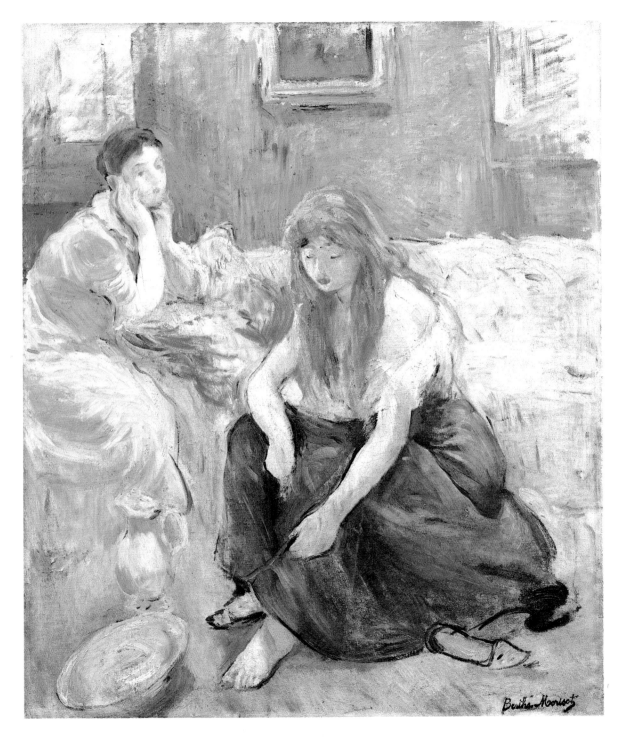

51

PIERRE AUGUSTE RENOIR

b. Limoges, 1841
d. Cagnes, 1919

The Luncheon of the Boating Party

1881
Oil on canvas
129.5 x 172.7 cm. (51 x 68 in.)
Acquired 1923

One of the great paintings of the world and certainly one of the most beloved, *The Luncheon of the Boating Party* engages the apathetic with its charm, and disarms the cynical with its pictorial brilliance.

Auguste Renoir's invitation to the viewer to imbibe vicariously the ebullient spirits of his friends gathered on the terrace of the Cafe Fournaise is irresistible. The scene is readily understood: appetites grown healthy from rowing on the Seine have been sated; flirtatious glances, emboldened by wine, connect this group of artists and models together; we suspend our disbelief in the perfection of such a moment, and bask in the spring sun of Paris and in the languorous camaraderie of friends.

Like all deceptively easy sybaritic entertainments, Renoir's *Luncheon* required careful planning. He turned for precedent to Veronese's great banqueting scene, *The Marriage at Cana,* which he had been studying in the Louvre since adolescence. Never ceasing to be astonished by Veronese's tour de force, which depicts the miracle of water turned into wine, Renoir called it a "marvel . . . prodigious . . . all is in contradiction with the admissible rules, the composition, the perspective, and even the verisimilitude. And despite everything it appears correct and true." In his modern version of a luxurious carousal, Renoir adopted Veronese's inverse perspective and the composition of the lower left segment of the great canvas. In further deference to the sixteenth-century Venetians, he emulated the glowing palette of Titian, as well as his incomparable technique for describing flesh blushing with evanescent youth. Intentionally or coincidentally, a dog, the Venetian symbol of lust and fidelity, is posed nuzzling Renoir's fiancée, Aline Charigot. All these Renaissance elements are transformed, with a genius that Renoir was never again able to summon fully, into this single, epic masterpiece of Impressionism.

Earlier in the spring of 1881, Renoir had written of "struggling with trees in bloom." His exertions brought forth in this painting a poetic image of the time when "The flowers appear on the earth; the time of the singing of birds is come, and the voice of the turtle is heard in our land." (Song of Solomon 2:12.)

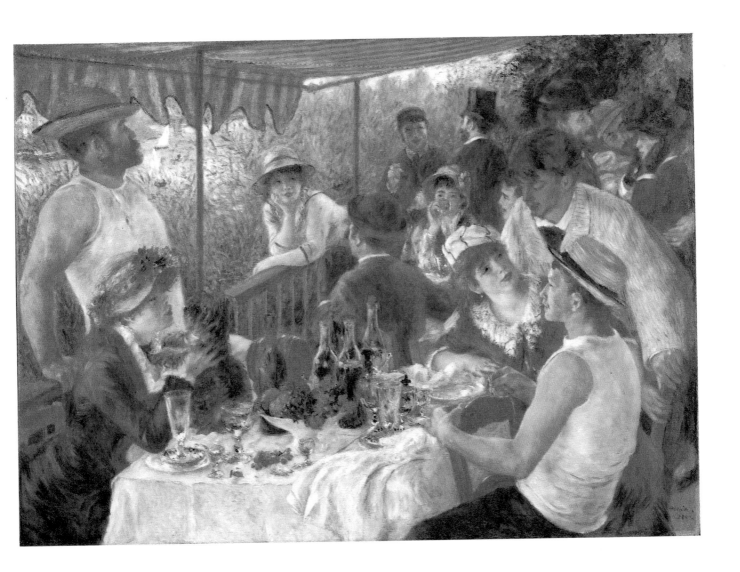

53

EDGAR DEGAS

b. Paris, 1834
d. Paris, 1917

Dancers at the Bar

Ca. 1884–88
Oil on canvas
129.7 x 97.8 cm. (51^1/$_8$ x 38^1/$_2$ in.)
Acquired 1944

As Edgar Degas grew more acerbic and reclusive during the 1890s, his paintings became more radiant and expansive. During the more than twenty years after he first began visiting the ballet rehearsal halls of the Opera, he had grown impatient with drawing anatomically correct figures in contorted positions and resentful of the sociological interpretations attributed to his sympathetic renderings of exploited young girls training for careers of dubious distinction. He said with disdain, "People call me the painter of dancing girls. It has never occurred to them that my chief interest in dancers lies in rendering movement and painting pretty clothes."

Both his ultimate interest in art for art's sake and his working method are evidenced in *Dancers at the Bar* and preliminary sketches made for The Phillips Collection painting. A pastel version of the picture in the National Gallery of Canada shows Degas's record from memory of the musculature of two very corporeal students strained in a limbering exercise. Degas had always believed that by drawing an image repeatedly he could discard nonessential elements and fuse unrelated visual stimuli into a cohesive pictorial whole. Here, in the final oil version of the painting, he has reduced his original impression of movement and fabric to shimmering color fields of tangerine and turquoise, overlaid with a few strokes of witty line denoting skirts and limbs. The dancers' bodies are subsumed in a haze of color, with their legs and arms distended into expansive arcs that trace the sweep of Degas's arm moving in classical dance rhythms.

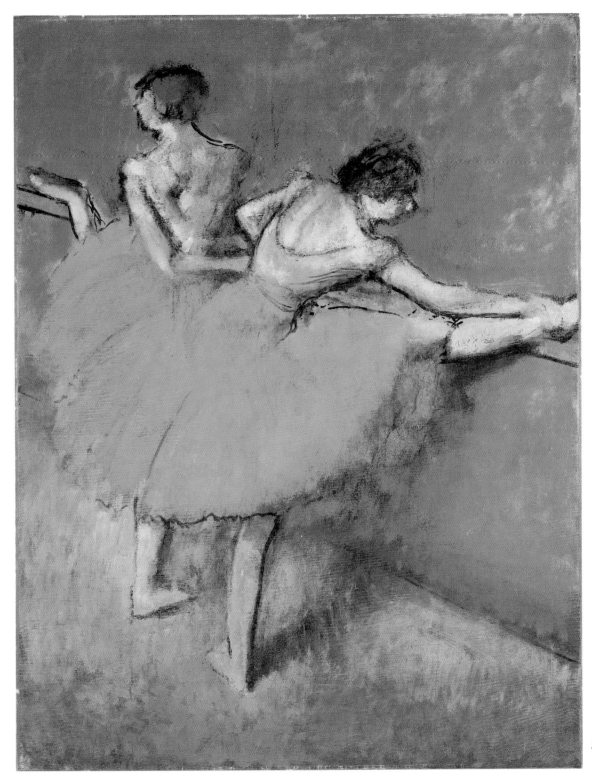

EDGAR DEGAS

b. Paris, 1834
d. Paris, 1917

After the Bath

Ca. 1895
Pastel on paper
76.2 x 82.5 cm. (30 x 32^1/$_2$ in.)
Acquired 1949

Like Monet, Renoir, Pissarro, and the other artists who, in 1874, participated in the first Impressionist exhibition, Degas believed that painting in the grand manner was anachronistic and that a direct confrontation with reality promised to revitalize French art. Degas, however, more than his Impressionist colleagues, cleaved to a more classic approach with regard to the conception and manufacture of a work of art.

Degas decried Monet's painting in the open air and insisted that a directly observed scene be only a point of departure. A true work of art was, ultimately, an autonomous image, which revealed the pictorial essence of the scene that had originally inspired it. In Degas's words, "It's all very well to copy what you see, but it's much better to draw what you see only in your mind. During such transformation the imagination collaborates with the memory. You produce only what strikes you, which is what is necessary."

In order to liberate art from stale, academic, compositional formulas, Degas sought striking images that would yield new pictorial structures. Degas would pose and re-pose his model and, prompted by the Japanese prints then current in Paris, study her from oblique, abstracting angles.

The subject of *After the Bath* is broadly suggested. Only the most salient features of the scene to which it presumably corresponded in reality are preserved. The emphatic volumes embodied in the form of the nude project against a broad, flat plane. These volumes are also set off by the rapidly moving, taut arabesque that articulates the profile of the bather's body. The furniture and the attendant in the background are subordinate, almost purely pictorial elements, which bolster and frame the central image.

The tendency to read *After the Bath* as an abstract pattern stems as much from an assertive liveliness of color as it does from Degas's daring exploitation of the compositional possibilities inherent in the abruptly cropped, close-up view. The broad, variegated areas of color vibrate, suggesting objects rather than describing them. In imitation of the technique of glazing employed by the Old Masters, Degas applied color in successive layers, endeavoring to approach the magnificent color of sixteenth-century Venetian painting. Ironically, Degas's emulation of the great masters resulted in a simplification of form and freedom of color that anticipated the abstract art of the twentieth century.

R.C.C.

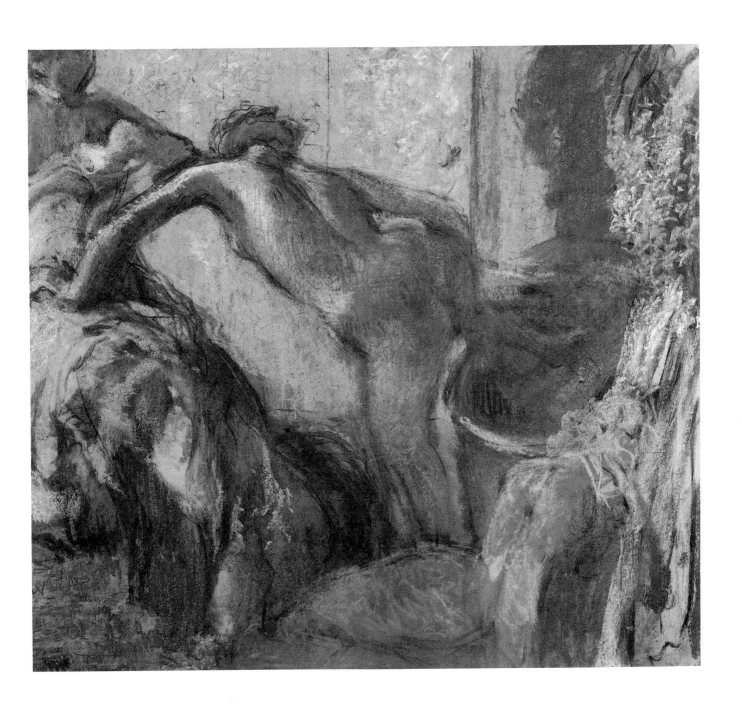

57

PAUL GAUGUIN

b. Paris, 1848
d. Tahiti, 1903

Still Life with Ham

1889
Oil on canvas
50.2 x 57.8 cm. (19¾ x 22¾ in.)
Acquired 1951

"I hope that this winter I shall be able to show you an almost entirely new Gauguin; I say 'almost' because everything is linked togeth-gether and I don't claim to have invented something new. What I wish is to explore an as yet unknown part of myself." Gauguin may have had *Still Life with Ham* in mind when he wrote to his fellow painter Emile Bernard in 1889 of an "almost new Gauguin." The painting unquestionably is a departure from earlier work and, in its color scheme, a link to the future.

In 1889, saddened by the disastrous culmination of his visit to Van Gogh and depressed by public laughter and neglect of his painting, Gauguin nevertheless painted several still lifes that belied his state of mind and manifested his belief that, "The Japanese are masters of us all." Although in the Phillips's painting Gauguin orientalizes less blatantly than in his *Still Life with Japanese Print*, the influence of woodcuts is evident in the flat background and decorative patterning. The scumbled, scraped hot pinks and yellows, on the other hand, anticipate the riotous colors that dominate his late Tahitian paintings.

Five years later, Gauguin embarked on his final unsuccessful search for nirvana in the South Seas. When the dealer Ambroise Vollard heard that Gauguin was ill and suicidal he bought several of his paintings for two hundred francs each, in order to provide the artist a small regular allowance. Other canvases from this purchase were disposed of through his gallery; Vollard kept *Still Life with Ham* in his private collection.

The painting marks a calm, reflective moment in Gauguin's turbulent life. It seems to have been painted in one of those moods he described to Van Gogh, in which he "found everything poetic," even a slice of meat, a handful of onions, a glass, and a tray.

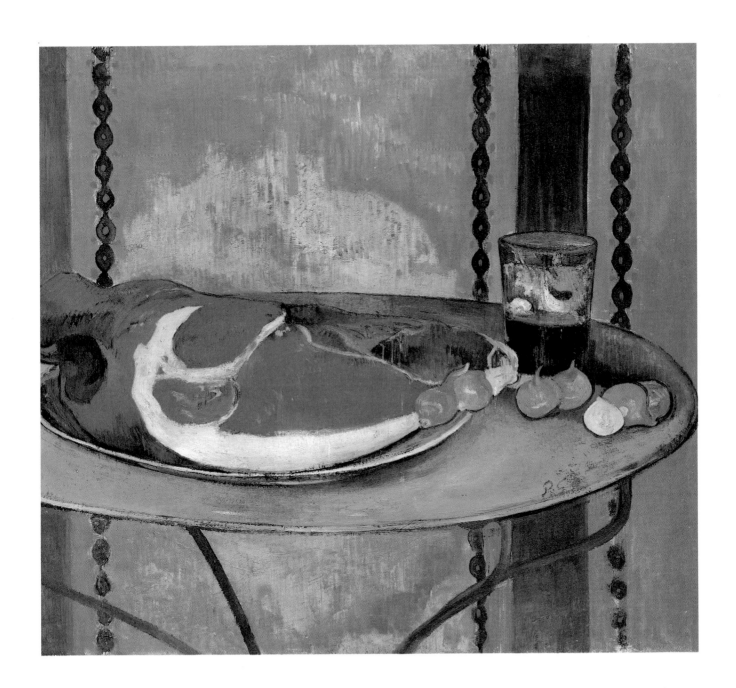

VINCENT VAN GOGH

b. Zundert, Holland, 1853
d. Auvers-sur-Oise, France, 1890

Entrance to the Public Gardens in Arles

1888
Oil on canvas
72.5 x 91 cm. (28½ x 35¾ in.)
Acquired 1930

Fueled and driven by creative energy, Van Gogh was "like a steam engine at painting" as he prepared for Gauguin's October visit to Arles in 1888.

At night he painted interiors and street scenes by the light of candles burning in his hat; seven o'clock in the morning might find him at his easel again at work outside his house. *Entrance to the Public Gardens* is one of the series of garden landscapes worked during that prolific September. As he said in a letter to his brother, Theo, "I wrote you already, early this morning, then I went away to go on with a picture of a garden in the sunshine. Then I brought it back and went out again with a blank canvas, and that is also finished. . . . The last picture, done with the last tubes of paint on the last canvas, of a garden, green of course, is painted without pure green, nothing but Prussian blue and chrome yellow."

As Gauguin later recalled of his stay with Van Gogh, they were "in continuous war for beautiful colors." Gauguin sought "the perfect vermilion," while Van Gogh again and again mixed a multitude of yellows from his few messy, uncapped tubes. As he explained in another letter, "To get at the real character of things here, you must look at them and paint them for a long time."

Impressionism and the
Modern Vision

Master Paintings from The Phillips Collection

California Palace of the Legion of Honor
Lincoln Park. San Francisco
July 4 through November 1, 1981

61

VINCENT VAN GOGH

The Road Menders

1889
Oil on canvas
73.6 x 92.6 cm. (29 x 36½ in.)
Acquired 1949

Early in 1889, while living at the asylum in St.-Rémy, Van Gogh directed much of his energy toward copying the compositions of Delacroix, Rembrandt, Daumier, and Millet from prints and reproductions. He especially responded to the vigor and looming presence of Millet's peasants, as if they held the key to his own future development. The study of prints, both western and Japanese, also may have led him to a change of technique late in the year. Of the group of paintings, which includes *The Road Menders*, done in the autumn of 1889, he wrote in a letter to his brother, Theo, "There are no more impastos. I prepare the thing with a sort of wash essence, and then proceed with strokes or hatching in color with spaces between them. That gives atmosphere and you use less paint."

On one of his excursions into town he came across a street under construction where there were "heaps of sand, stones and the gigantic trunks—the leaves yellowing and here and there . . . a glimpse of a house in front and small figures." He painted the venerable plane trees as monumental symbols of force, endurance, and power, using the "large and knotty line" he admired in Millet. The road pulls the eye diagonally across the canvas and deep into the picture space until it is suddenly stopped by the ominous blue-violet tree at the far right; it comes forward at the lower center of the canvas, almost automatically finding the same color on the shawled woman at left. The workers themselves at first appear incidental. They would hardly be noticed if the red hat did not echo two other areas of the same color seen to the right in half-obscured faces and in the sun reflected on windowpanes. As it is, they anchor an otherwise floating triangle defined by the three points of identical hue. This is only the most salient of several triads, which keep the eye playing hide and seek in and out of the tree, down the long road, and back to the foreground. Van Gogh expertly employs all these optical reflexes to create activity and a balanced tension, which, combined with vigorous brushstrokes, reinforce the physicality of the painting.

Historians have debated whether this painting or a near replica in the Cleveland Museum of Art is a second "more finished" version Van Gogh mentioned to his brother. Visual comparison leads to the conclusion that this is the more precisely conceived of the two. Slight adjustments and simplifications have been made from the presumed model. Crucial drawing outlining the trees has been emphasized and enlivened, while busy linear effects seen in the background of the Cleveland painting are omitted to "give atmosphere and use less paint," and the foreground carries the hatching Van Gogh described. Above all, there is a rightness of balance in this highly complex composition that more than justifies his statement, "I very much like *The Road Menders*."

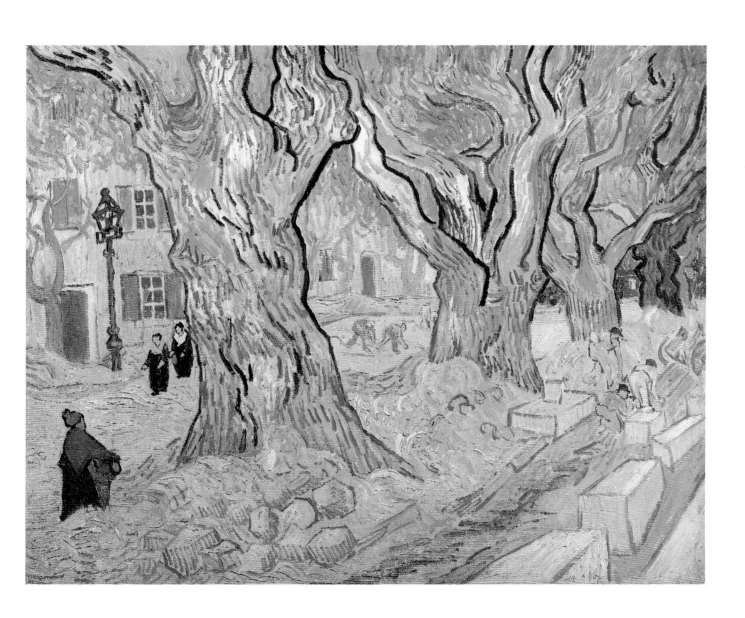

ODILON REDON

b. Bordeaux, 1840
d. Paris, 1916

Mystery

Undated
Oil on canvas
73 x 54 cm. (28³/₄ x 21¹/₄ in.)
Acquired 1925

Odilon Redon initially wrote of primeval flowers as "perhaps a first vision attempted . . . when life was awakening." This was a caption for a series of lithographs depicting grotesque monsters; later, for his written accompaniment to the 1885 *Homage to Goya* album, he explained his demonic figures: "In my dream, I saw in the sky a face of mystery, the marsh flower, a human and sad head . . . on waking, I saw the goddess of the unintelligible."

But, while Redon never ceased to draw images from dreams, his vision became less pessimistic as *fin de siècle* decadence gave way to new-century dynamism. Exuberant color entered his work for the first time and in *Mystery* his "goddess of the unintelligible" appears as a benign apparition hypnotized by the beauty of her disembodied garden. The jubilant reds and greens bursting into a spontaneous bouquet bear no resemblance to the putrified *fleurs du mal* of Baudelaire; rather, they have been cultivated in the bright domain of Matisse and the Fauves, where Redon rediscovered flowers as "fragile scented beings, admirable prodigies of light."

Redon was the only member of the Symbolist movement who successfully bridged the sharp gap between nineteenth- and twentieth-century aesthetics by moving from bleak, weird, literary illustration to painting in which formal expression stands alone without support from verbal explanation.

Mystery undoubtedly alludes to some supernatural phenomenon, but the enigma of subject is subordinate to the lucidity of style.

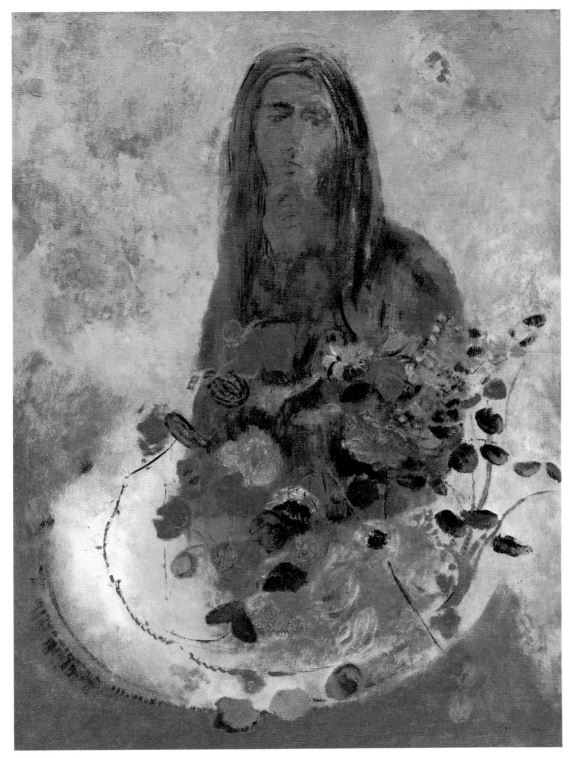

65

PABLO PICASSO

b. Malaga, 1881
d. Mougins, 1973

The Jester

1905
Bronze
41 cm. high (16⅛ in.)
Acquired 1938

In the two years after *The Blue Room* was painted, Picasso's so-called Blue Period came to fruition and was abruptly abandoned in the summer of 1904, when harlequin figures began to appear in his paintings. Pinks and rose tones dominated his palette while he painted these elongated tragicomic figures repeatedly during the next year. A 1905 exhibition of the harlequin-theme paintings closed the series for Picasso. He summed up the style in a group of fourteen drypoints and etchings, then switched to sculpture as a different means of expression.

Picasso frequently turned to sculpture when he lost interest in a particular mode of painting and was hunting for a new direction. *The Jester* is just such a punctuation point between the emotionally charged *Saltimbanques* that preceded it and the detached calm of the portraits that followed.

The Blue Room

1901
Oil on canvas
50.6 x 61.6 cm. (19⅞ x 24¼ in.)
Acquired 1927

Voracious looting from all periods of art was a point of pride to Picasso, who frequently said he felt that previous masters were looking over his shoulder and guiding him, when he was working in the studio.

The influences and borrowings from other artists assimilated in *The Blue Room* are too numerous to list for, as usual, Picasso had been looking at virtually everything from El Greco and Velázquez in Madrid to Cézanne and Bonnard at the Paris Exposition. This scene of a model in his Boulevard de Clichy studio—where he is known to have hung the Lautrec poster of May Milton in the background—was painted in the fall of 1901. Picasso had sold fifteen paintings from his first show at Vollard's gallery the previous summer, and was moving hastily ahead with what the contemporary critic Felicien Fagus called his "youthful impetuous spontaneity" toward the style that would come to be known as his Blue Period.

Just as *The Blue Room* represents an amalgamation of artistic styles and elements, the mood of the painting fuses Picasso's ambivalent reactions to the gaiety and tragedy of his turn-of-the-century Bohemian world. It was shortly after this time that he began to bring harlequins and circus performers into his art. Meanwhile, in this work, Picasso's own presence is felt as a voyeur surreptitiously observing his model—a relationship first implied by Degas in such paintings as *After the Bath* (page 57), and a theme that Picasso returned to time and again throughout his life. The genesis of ideas leading him to Cubism can also be detected in the acutely tilted planes and compressed space, but it was to be several years before he would elaborate fully on the formal potentials implicit in *The Blue Room*.

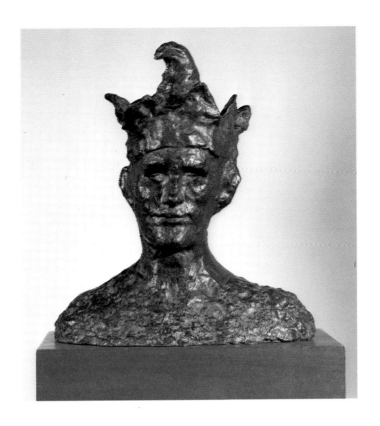

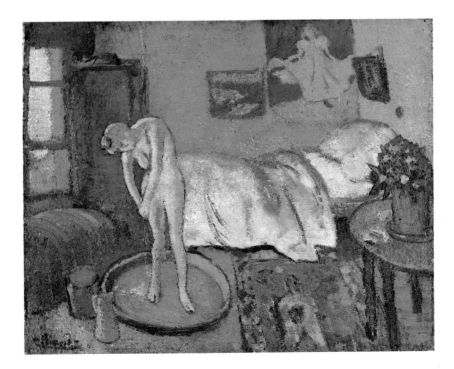

67

EDOUARD VUILLARD

b. Cuisseaux, France, 1868
d. La Baule, France, 1940

Woman Sweeping

Ca. 1892
Oil on cardboard
45.7 x 48.3 cm. (18 x 19 in.)
Acquired 1939

"In Vuillard's company, life smiled and took on its most peaceful aspect. Nothing could have been more harmonious. . . ." Rarely is an artist's personality reflected so clearly in his work as in this intimate view of Vuillard's mother sweeping her cozy room. The artist has reconciled discordant patterns into an overall harmonious play of textures; there is the gentle humor for which he was famous—a kindly spoof on French bourgeois decor and accoutrements—tempered by the dignity with which his mother goes about her chores.

Woman Sweeping typifies the early, small canvases of the always self-effacing Vuillard. Unpretentious and engaging, it is the style that gave rise to the critical term "Intimist" to describe both Vuillard and his lifelong friend Pierre Bonnard (pages 71, 73). Recalling the fifteen years he had shared a studio with Vuillard, Bonnard, and Maurice Denis, Lugné-Poe likened the four of them to the Musketeers, "a band of brothers" working together "with a nobility of ambition." Although Bonnard was more outgoing and a greater source of "energy and excitement" than Vuillard, they shared a fascination for nuances of color and light that overrides the discrepancies between low-key and high-key palette or large and small scale. The two painters have always inevitably been discussed together from the time of an early joint exhibition, when it was noted that "they can manipulate every possible complication of line—symmetrical, asymmetrical, knotted and unknotted—in a delightfully convoluted and decorative way."

Vuillard was also able to sustain the intricacy of his small works in large-scale set designs, of which he created a number. Unfortunately, these scenery flats were painted over for each new production and only the sketchiest accounts exist of their actual appearance. The interesting suggestion has been made, however, that Vuillard's association with theater affected all his vision—that he framed his subjects as if he were seeing them through a proscenium arch.

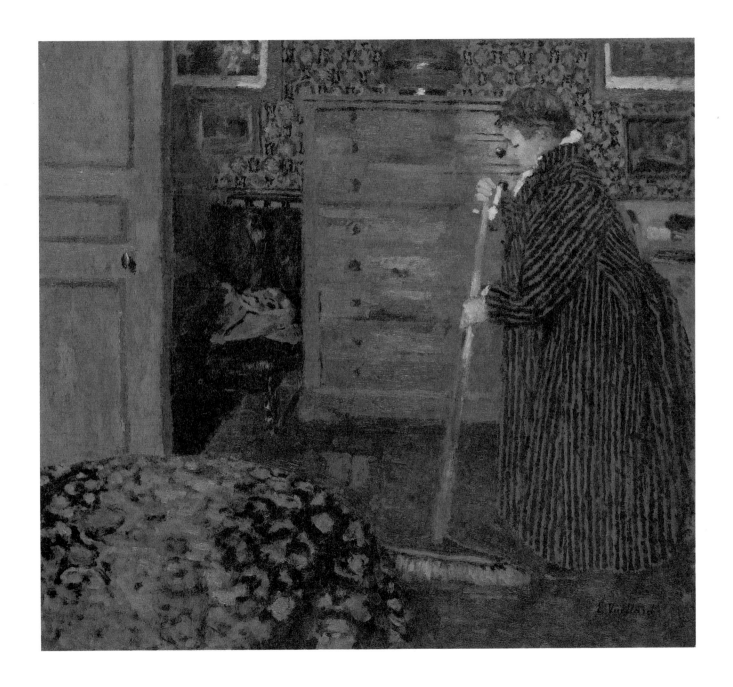

PIERRE BONNARD

b. Fontenay-aux-Roses, 1867
d. Le Cannet, 1947

The Open Window

1921
Oil on canvas
118 x 96 cm. (46½ x 37¾ in.)
Acquired 1930

Bonnard and his close friend Edouard Vuillard are frequently referred to as "intimist" painters because they embraced the commonplace in bourgeois life. Although both artists admired Gauguin's exoticism and listened endlessly to Paul Serusier's discussions of Nabis painting theory in their favorite bistro, their own instincts led them to diverse, individualistic styles.

Bonnard has been seen both as a latter-day Impressionist and as a harbinger of mid-twentieth-century color painting. Actually he was neither; he had a strong attachment to drawing and form and feared, with some reason, that his natural predilection for expressive color would obscure the structure of his painting. As a preventive discipline, he had taken drawing lessons throughout World War I. In *The Open Window*, as in many other canvases, Bonnard risked diffusion of the design by leaving empty space in the center and relegating figurative elements to the edge of the canvas and beyond. And in the end, for all his compositional planning, the painting is held together by the overall mist of oranges and violets.

Unlike the Matisse window with its explosive palm tree blocking the space behind the Egyptian curtain, Bonnard's opens on an enticing garden where breezes stir the dense atmosphere of a languorous Midi summer afternoon.

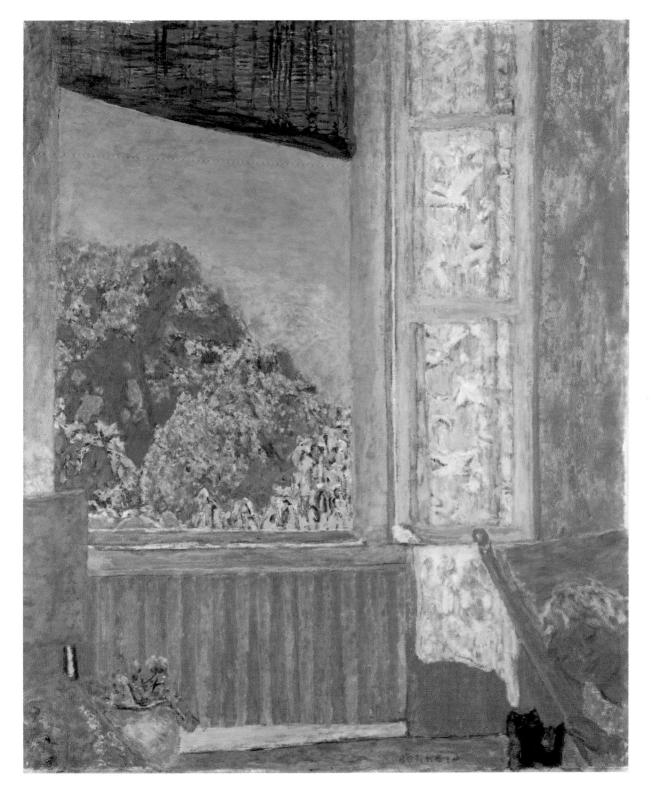

71

PIERRE BONNARD

The Palm

1926
Oil on canvas
114.3 x 147 cm. (45 x 57⅞ in.)
Acquired 1928

No one could have divined from the Impressionists' experiments the limits to which color would be pushed in the early twentieth century by Matisse and Bonnard. Both built with color and exalted in its sheer magic; in totally different idioms, both expanded our ways of experiencing the world through color.

The Palm stands out as a summation of the unique qualities of the artist's long career. Its seeming informality belies a carefully considered underpinning of arcs, horizontals, and verticals. Sun and shadow play off against each other as foils for warm and cool. The abruptly cropped foreground figure establishes a focus of scale and mood as she holds a fruit uplifted in a ritual gesture of celebration. The shadow in which she stands is alive with dappled light. Paint, lovingly applied in sensuous contrasts of thin washes and impasto, defines the light on the palm fronds above her. The blues and greens, the violets and oranges, are woven into a skein of rich pattern. The network of color, laid upon a firm scaffolding of underdrawing, suffuses Bonnard's intimate and private world with a sense of opulent grandeur.

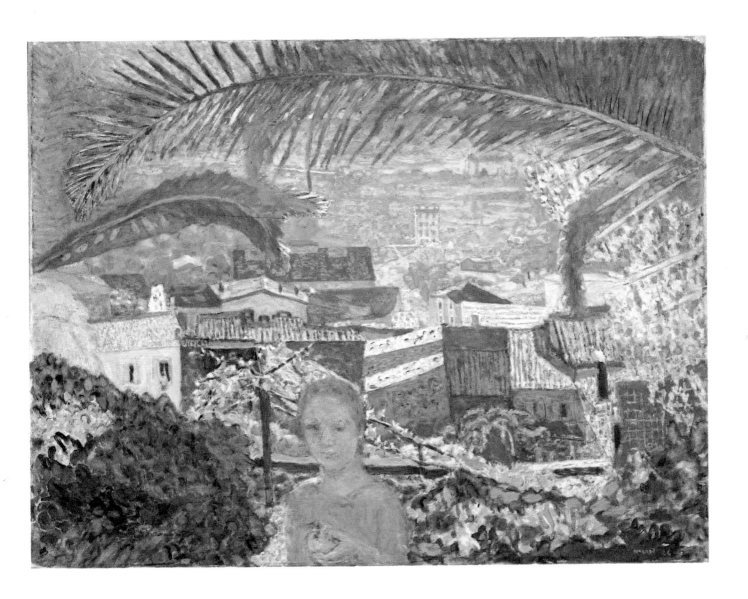

73

PAUL CEZANNE

b. Aix-en-Provence, 1839
d. Aix-en-Provence, 1906

Self-Portrait

1878–80
Oil on canvas
60.6 x 47.3 cm. (23⅞ x 18⅝ in.)
Acquired 1928

Nowhere else is Cézanne's ability to resolve the dualism between optical impressions and subjective thought more effectively demonstrated than in this *Self-Portrait*. He considered maintenance of a balance between them critical to his development, "in the eye by looking at nature, in the mind by the logic of organized sensations." Here Cézanne confronted the special problem of presenting an objective view of his physiognomy and a subjective view of his ego. Although he treats the curvature of his forehead as dispassionately as if it were an apple or an orange, his stare fixes an unforgettable image of the artist himself in the viewer's mind. Cézanne compels attention by virtue of a number of ambiguities in both the imagery and the structure of the painting. The look of the eyes can be interpreted as expressing anger, determination, or secret amusement; the set of his mouth, which would give a further clue to his feelings, he keeps hidden under his beard.

The construction of the painting itself is as fascinating to analyze as the imagery. The artist laid on thin washes over the ground, in warm colors on one side and cool on the other. A fury of loose drawing ensued, which can still be seen in the turn of his coat sleeve and the contours of his head. Then, much more slowly, the flesh tones were built up, in small, meticulous impasto strokes, to highlights that describe the convexity of his skull. Finally, to give further prominence to the structure of the head, the ground was broadly brushed with subtly modulated blues and greens which open up what Leonardo called "atmospheric perspective" behind the figure.

The presence of the artist in the painting is commanding and direct, yet Cézanne remains aloof from his audience. He has observed himself from a detached point of view and is neither disappointed nor overly vain in what he has seen.

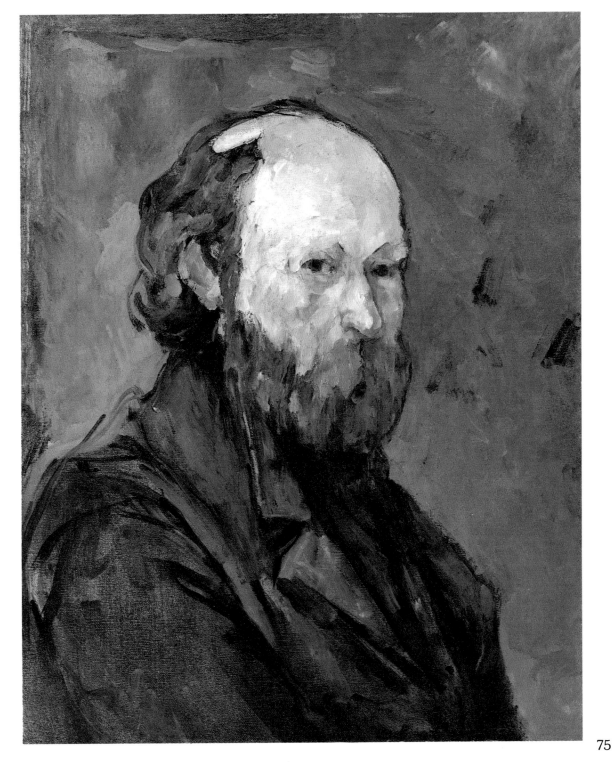

PAUL CEZANNE

Mont Ste.-Victoire

1886–87
Oil on canvas
59.7 x 72.4 cm. (23$^1/_2$ x 28$^1/_2$ in.)
Acquired 1925

"Cézanne was the father of us all." Many years and millions of words later, no one has better expressed Matisse's appraisal of his mentor.

Cézanne's influence on the course of twentieth-century art can never be fully assessed. It is impossible to do more than hint at the number of new directions touched off by the memorial exhibitions of his work in 1907 alone. The hanging of seventy-nine watercolors at the Bernheim-Jeune Gallery and the forty-nine paintings in the Salon d'Automne precipitated changes of style for Matisse, Dufy, and their fellow Fauves; they led Braque on the path to Cubism; Prendergast, breathless with excitement over paintings that "left everything to the imagination," returned to America sure of his own bent toward abstraction; Kandinsky, Marc, and the other German Expressionists interpreted strong color and simplicity of form as a basis for an ideal pure art free of representation; Mondrian's paintings of the next few years suggest that he had been studying the compositional structure of landscapes in the exhibition. The list of references to Cézanne appearing in artists' letters from the "banquet years" is endless.

Mont Ste.-Victoire, in southern France, famous only as seen through Cézanne's eyes in innumerable paintings, is the earliest of his canvases held in The Phillips Collection. Here his art is seen at its full maturity, having discarded all the inherited baggage of nineteenth-century landscape painting. Cézanne has, so to speak, peeled off the accumulated layer of varnish that clouded post-Renaissance painting to reveal fresh, clear imagery.

With a striking economy of means (which he reduced even further in later years) he leads the eye down from the hillside grove, across the sparsely settled valley, along the Roman aqueduct and up the foothills to the granite mountain. With a limited palette predominated by green and yellow, he simulates the ambience of Provence's dry, herb-scented air, yet the associative pleasures of the locale are secondary. The compelling subject of the painting, especially as seen by other artists, is painting itself: the exquisitely subtle relationship between skyline and echoing tree branch, the calculated rhythms of dark forms against light ground, the modelling of the mountain from light to shadow—all are improvisations necessitated by the artist's urge to bring a more beautiful world into being.

It is a favorite pastime of art historians to visit the environs of Mont Ste.-Victoire, camera in hand, seeking the exact sites of Cézanne's viewpoints. They return with slides of an only moderately attractive landscape; unfortunately, nature is simply unable to imitate art.

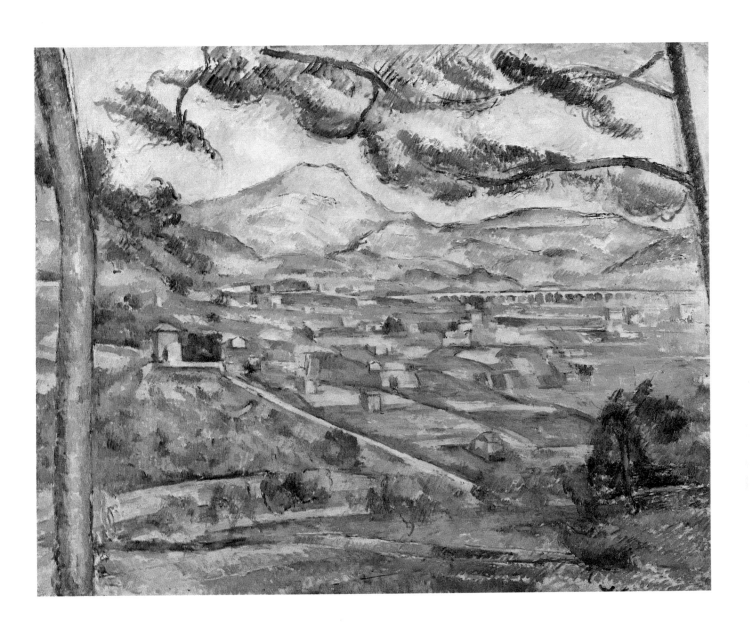

PAUL CEZANNE

Still Life with Pomegranate and Pears

Ca. 1895–1900
Oil on canvas
47 x 55.3 cm. (18½ x 21¾ in.)
Acquired 1939, Gift of Gifford
Phillips

Each artist saw something in Cézanne's painting comparable to his own aspirations. Renoir marvelled, as did Picasso, that Cézanne "could not put two touches of color on a canvas without its already being very good." Braque, on the other hand, with a better understanding of Cézanne's own concerns, said, "Cézanne is as great for his clumsiness as for his genius."

The term clumsiness applies most accurately to the early work; by the 1890s, Cézanne seems to have been almost intimidated by his own proficiency, his inability to lay down an ugly or unnecessary brushstroke. He continually averred that he was not "making pictures"—that is to say, objects for pure visual delectation—but was working toward creating a new language. His language comprised an invented vocabulary of colors and strokes arranged in a syntax of formal relationships which could describe objects in space without resorting to the dictates of linear perspective.

One of his primary axioms was that "bodies seen in space are all convex." So, in paintings like *Still Life with Pomegranate and Pears*, there are simply no flat planes. The modulations of color in the fruit and the ginger pot all emphasize the same roundness sought by Chardin; each stroke builds the form logically back into space from the point closest to the eye. Even the surfaces known from empirical experience to be more or less flat—boards of a table, the wall behind the curtain, book covers—lose their immutable geometry by the juxtaposition of warm and cool strokes within the same area.

This *Still Life* has been redated several times by ranking Cézanne experts and the date of execution remains open to speculation. The familiar drapery, the kitchen table, the ginger pot, and the plate were favorite props for canvases painted both in Paris and Aix over a long period of years; and it is a risky business to chart stylistic changes in a mature artist who would put canvases aside and pick them up again much later. There is no way of being sure whether or not the painting might have been in Cézanne's first one-man show at Vollard's gallery in 1895. According to Pissarro, there were paintings in that exhibition which, shockingly, let areas of bare canvas to function as part of the total composition, just as Cézanne has allowed the thin washes describing the white cloth to run out to nothingness at the left and bottom of this *Still Life*. Pissarro innocently described these paintings that exhibited areas of unpainted canvas as "beautiful, yet left unfinished." It is unfortunate that he had no inkling of the vexing semantic arguments that would ensue as the phrase took on unwanted meaning in translation and was ultimately claimed as evidence that Cézanne's late paintings were not satisfactory in the artist's own eye.

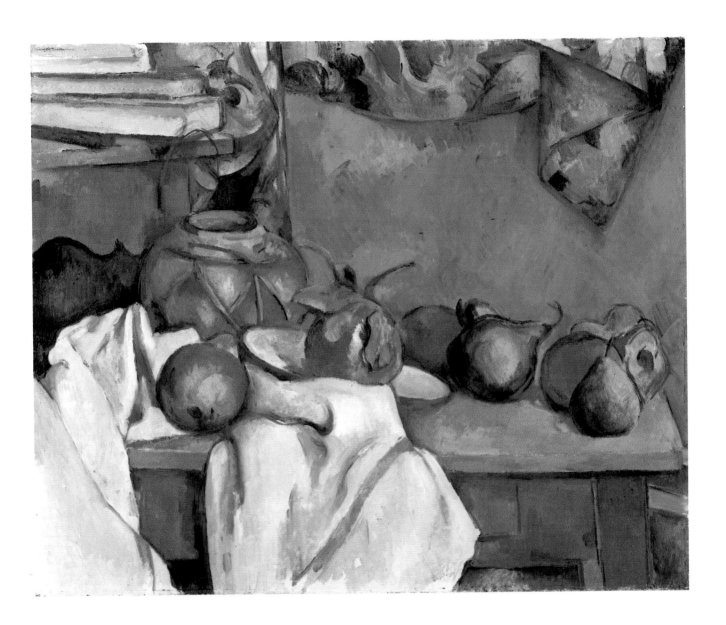

PAUL CEZANNE

Jardin des Lauves

1906
Oil on canvas
65.4 x 81.3 cm. (25³/₄ x 32 in.)
Acquired 1955

In his sixties, Cézanne, a consummate master at mediating between the irreconcilable demands of emulating nature and synthetically restructuring optic sensations, was blessed with well-earned liberation from all the constraints of his youth. He expressed his joy simply in a letter to his son, saying that he had finally got "rid of the devil who . . . used to stand behind me and force me to imitate."

As if to justify his new economy of means in paintings like *Jardin des Lauves*, Cézanne explained, "The sensations of color, which give light, are the reason for the abstractions which prevent me from either covering my canvas or continuing the delimitation of the objects when their points of contact are fine and delicate; from which it results that my image or picture is incomplete." In spite of this explicit rationalization for putting down only as many beautiful strokes as his color sense required, and in spite of his admonition that any painting which did not live up to the artist's conception should be thrown in the fire, the late paintings with areas of bare canvas are still treated apologetically as "incomplete."

The question would be academic except that it has given rise to slanderous discussion and sometimes abusive physical treatment of *Jardin des Lauves*. The painting was probably one of many purchased by Ambroise Vollard and "hauled away in a hand cart" shortly after Cézanne's death. Because the "unfinished" paintings were in little demand, it was seldom, if ever, exhibited for the next two or three decades; it was then given a "unifying" yellowish coat of varnish, photographed, and published in the 1936 catalogue raisonné under the title *Paysage* (Landscape). After Vollard's death in 1938 (and probably even later, after World War II) the painting came to America where, presumably to give it legitimacy as being true to nature, the purple area was interpreted as the garden wall outside Cézanne's studio and the new title, *Jardin des Lauves*, was affixed to it. Finally, to conform to the taste of an audience still unaccustomed to swirling, airy compositions, at some time between 1951 and 1955, when it came to Washington, a trick frame was constructed to conceal two inches of mostly bare canvas on the left side and the bottom, in order to make the color patches appear rigidly anchored to the edges. The painting has been reproduced several times in its cropped state and described accordingly. Very recently the canvas was taken out of its frame and shown to Marjorie Phillips, whose artist's eye was delighted at "seeing the painting as Cézanne intended." The yellowish varnish has been removed; the full canvas is shown here in color for the first time.

After the better part of a century, and countless revolutionary artistic dicta, we have come full cycle to understand that "the sensations of color, which give light" are reason enough for any degree of abstraction.

80

HENRI MATISSE

b. Le Cateau-Cambrésis, 1869
d. Nice, 1954

Studio, Quai St. Michel

1916
Oil on canvas
148 x 116.8 cm. (58¼ x 46 in.)
Acquired 1940

In spite of feeling "irrelevant" compared to his friends in the trenches, Matisse painted some of his finest canvases during the battle of Verdun. *Studio, Quai St. Michel* and two companion interiors (now in the Detroit Institute of Arts and the Musée National d'Art Moderne, Paris) can deservedly be counted among them.

Matisse derived the painting's radically simplified composition from the strong vertical and horizontal architectural elements seen in the corners of the rooms he had occupied since 1913. His favorite model of the time, Lorette, reclines on a couch, and the spires of the Palais de Justice and Ste. Chapelle can be seen beyond a balcony.

Oddly enough, the sharp angularity and reduction of spatial description to a few planes can be traced to his youthful copy of Jan de Heem's *Dessert*, made in the Louvre years before. Matisse had been flirting with Cubism, and may have been temporarily influenced by Juan Gris when, on his return to the Quai St. Michel after a summer in Issy, he came upon his copy of the seventeenth-century Dutch still life. Ignoring the tight drawing and high finish of the original, he restructured a second copy on a large scale that led him away from the intricate conventions of Cubism toward the abstract simplicity of such paintings as *Studio*.

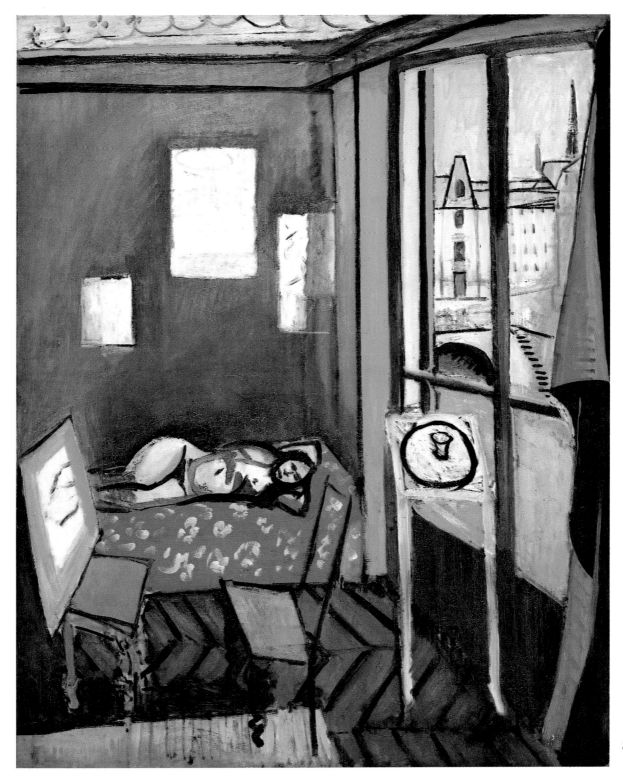

HENRI MATISSE

Interior with Egyptian Curtain

1948
Oil on canvas
116.2 x 89.2 cm. (45³/₄ x 35¹/₈ in.)
Acquired 1950

Thirty-two years after painting the interior of his studio at Quai St. Michel (see page 83), the artist was still occasionally preoccupied with the pictorial possibilities of windows as framing elements. *Interior with Egyptian Curtain* is the last of seven magnificent interiors completed at Vence before Matisse put aside easel painting to design the Chapel of the Rosary of the Dominican nuns of Vence. Although some of the philodendron-leaf forms in the garish curtain at the right appear in the Vence project, *Egyptian Curtain* appears more as the culmination of a series of color-charged secular celebrations than as preparation for a chapel commission. Painted as Matisse neared eighty, it summons all the artistic powers developed over his long career to synthesize its strident individual elements. As Alfred Barr wrote of the painting: "Instead of following the obvious and comparatively easy formula of leaving his bright window rectangle as part of his background . . . he has hung a curtain right up against the front plane. . . . And what a curtain! A barbaric modern Egyptian cotton with the most aggressive and indigestible pattern. And, one might also exclaim, what a window! . . . with an explosive palm tree with its branches whizzing like rockets. . . . Clearly Matisse is not concerned here with serenity. . . . Instead he challenges the sensibility of the beholder by balancing dissonances, tension against tension." (Alfred Barr, *Matisse: His Art and His Public*, New York, Museum of Modern Art, 1951, p. 238.)

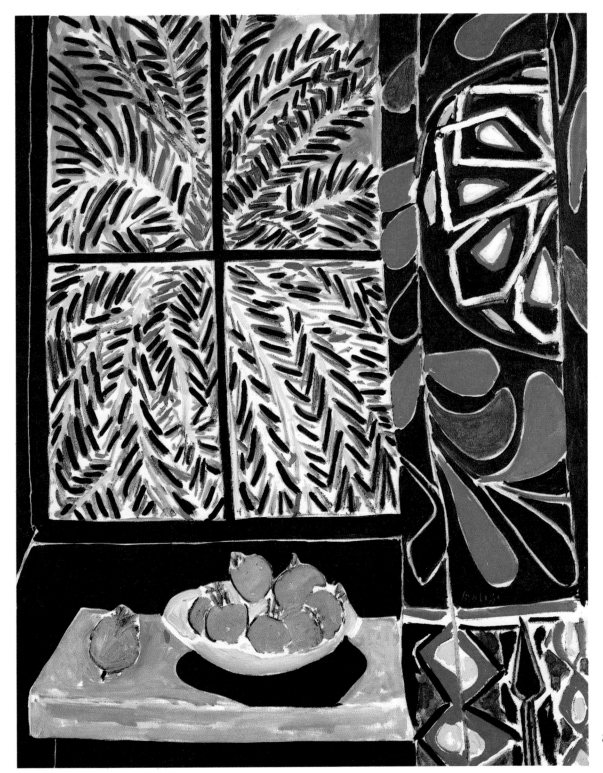

GEORGES ROUAULT

b. Paris, 1871
d. Paris, 1958

Circus Trio (Dancers and Punch)

1924
Oil on paper mounted on canvas
75 x 105.4 cm. (29¹/₂ x 41¹/₂ in.)
Acquired 1933

Georges Rouault saw circus troupes as performers of latter-day morality plays, acting out mankind's temptations and torments. In the *Circus Trio,* the limp, drained central figure of Punch, supported by two disproportionately small women, recalls a variety of paintings depicting the *Deposition from the Cross* with the two Marys in attendance. Similar compositions and the distortion of figures according to their hieratical importance occur in Rouault's more overtly religious paintings, which contain more specific symbols of their subjects' roles in biblical narrative; here he has borrowed from and generalized the history of Christian art to evoke man's despair at his own inadequacy.

Although Rouault was accorded an *Hommage* exhibition by the Catholic Center of French Intellectuals toward the end of his life, he always saw himself as an artisan—an anonymous laborer making devotional images in the tradition of Byzantine mosaicists, Romanesque stone carvers, and Gothic stained-glass craftsmen. Much has been made of his early apprenticeship as a stained-glass painter as the source of Rouault's glowing color and heavy black line, but he does not use outline as a supportive leading; it instead reinforces the brilliancy of color and expressive gesture in the manner of mosaics or medieval miniatures. In other words, Rouault drew freely from many sources in order to give conventional overtones to his modern statement of human dilemma. His preoccupation over the years with the plight of prostitutes, tragicomic clowns, and biblical martyrs, who, as outcasts from society, suffer the burden of insoluble ethical demands, reflects the Existential dread and despair he, as an artist, suffered himself.

Circus Trio is one of the few paintings executed during a period in which Rouault's energies were primarily directed toward printmaking. The *Miserere* series of etchings from the fifty-first psalm, which begins "Have mercy upon me, O God ... blot out my transgressions," shares with the *Circus Trio* many depictions of hapless penitential figures, but the bleakness of the black and white etchings is relieved in the oil by singing color, as if the battered Punch were intoning the eighth verse, "Make me to hear joy and gladness; that the bones which thou hast broken may rejoice."

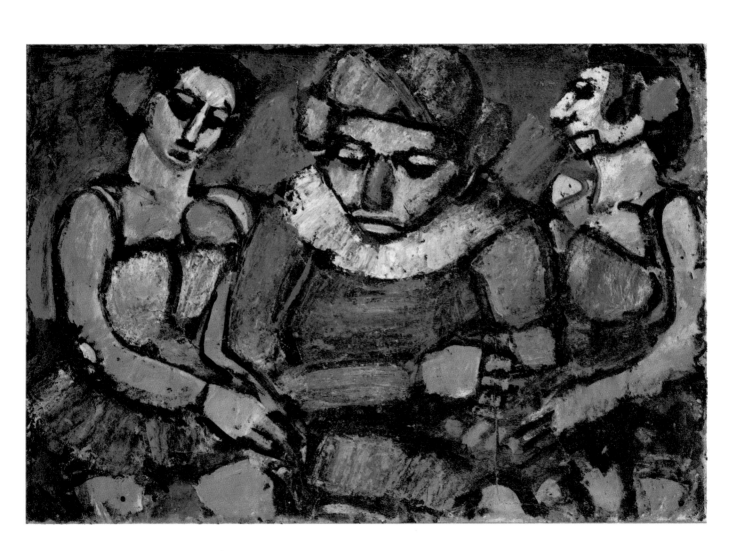

RAOUL DUFY

b. Le Havre, 1877
d. Forcalquier, 1953

L'Opéra, Paris

Ca. 1924
Watercolor and gouache on paper
54.6 x 69.2 cm. (21½ x 27¼ in.)
Acquired 1939

Raoul Dufy describes the festive splendor of *L'Opéra* with darting calligraphy injected into brilliant fields of color. The verve of his line and the sumptuousness of his color lend Dufy's paintings an elegance appropriate to the spectacles he celebrates, be they horse races, regattas, or a gala evening at the theater. In his world there is no awkwardness or ugliness; just as in the perfectly sung aria all evidence of tedious rehearsal is subverted in the joyous, deceptively spontaneous performance.

Dufy's paintings of this period beguile the eye into believing they are effortless products of a virtuoso. This mature facility hides nearly thirty years of persistent work and study, beginning even before Dufy had left Le Havre at the age of nineteen. In Paris he had studied drawing at the conservative Ecole des Beaux-Arts, as well as the Impressionist canvases on display in dealers' windows. By 1905 he was showing his work with Matisse and the other "Wild Beasts" of the short-lived Fauve movement. Braque introduced him to Cubism in 1908 (Dufy found the discipline alien to his nature), and a thorough understanding of German Expressionist principles appears in paintings dating from his 1909 Munich trip. After World War I, the *haut monde* designer Paul Poiret persuaded Dufy to design fabrics for his couture business; it was there, caught up in the world of fashion and accommodating to the stylized patterns requisite to the textile industry, that Dufy learned to eliminate all nonessential description from his art. Unfortunately, this phase of his career also brought him to the attention of commercial illustrators, who saw him as a source they could readily vulgarize. Versions of Dufy's style could often be found in posters and advertisements.

L'Opéra reflects Dufy's dexterity and ebullient spirit at a high point. The opera house itself stars in the painting: its vast space gleams red and gold with a rich density of hue seldom obtained in a watercolor, and its opulent ornamentation vibrates with Dufy's insistent calligraphy. The orchestra and audience are little more than "extras," serving to reflect light from crystal chandeliers—a light about to dim as the curtain rises and the house fills with music.

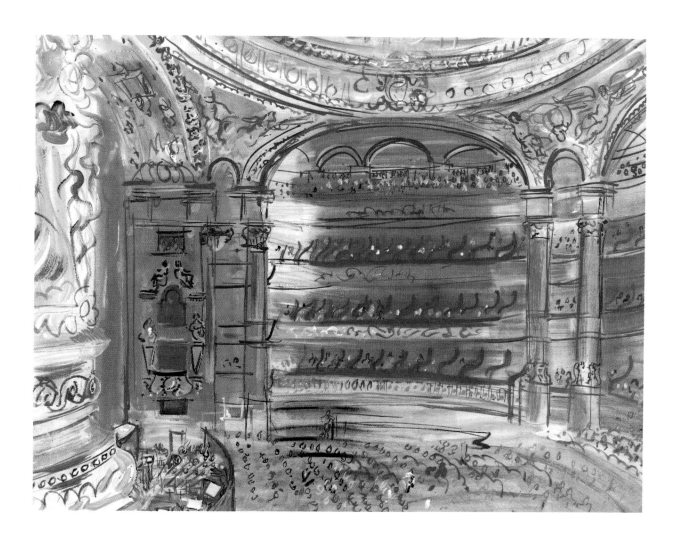

ROGER DE LA FRESNAYE

b. Le Mans, 1885
d. Grasse, 1925

Emblems ("La Mappemonde")

Ca. 1913
Oil on canvas
88.9 x 200 cm. (35 x 78¾ in.)
Acquired 1939

In 1912, André Mare, a painter and designer, gathered a group of artists to create and present an entire house at the Salon d'Automne. Raymond Duchamp-Villon designed the facade and persuaded his brother, Marcel Duchamp, to contribute a painting. Gleizes, Léger, and Metzinger, among others, also participated. Roger de la Fresnaye worked throughout the summer on the project, decorating the drawing room with paintings, and actually carving flower motifs in the boiseries. Crowds came to jeer at the *Maison Cubiste*, but Paul Poiret, the couturier, bought La Fresnaye's paintings and carvings from the exhibition.

The following year, a similar project was planned. *La Mappemonde* and its companion piece, *L'Arrosoir (The Watering Can)*, now in the collection of Mr. and Mrs. Paul Mellon, were shown at the Salon, ornamenting the *trumeaux* for a boudoir designed by André Mare. The delicate colors blended with the rose-damask covering of the walls and the subject matter of the two panels was selected to symbolize, respectively, the active and the contemplative life. *La Mappemonde*, named for the globe of the world resting on the tilted tabletop, pays homage to the Cubist movement in its shallow space and semi-abstract forms, yet retains the recognizable objects of an attribute portrait. Books, the globe, a violin, papers, a sphere, all suggest the intellectual pursuits of the room's imaginary occupant. La Fresnaye, himself of ancient Norman lineage, symbolized the halcyon life of classical order he might have lived had it not been for World War I.

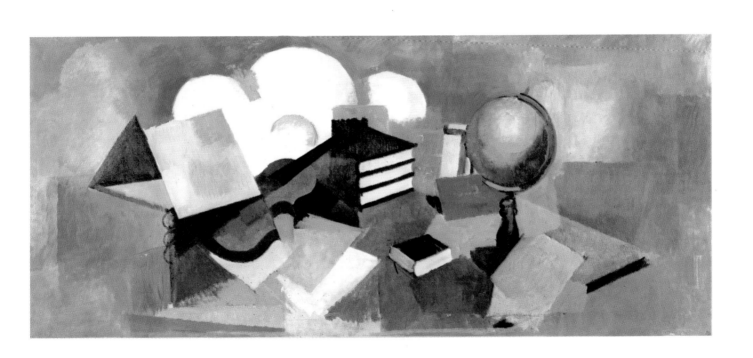

JUAN GRIS

b. Madrid, 1887
d. Boulogne-sur-Seine, France, 1927

Still Life with Newspaper

1916
Oil on canvas
73.6 x 60.3 cm. (29 x 23¾ in.)
Acquired 1950

Juan Gris did not evolve into a Cubist—he made his debut as a fully developed painter in the style invented by Braque and Picasso. Gris had grown up and gone to engineering school in Madrid, where he was known for doodling caricatures of his professors and fellow students. When he moved to Paris at the age of nineteen he considered himself strictly a graphic artist, an illustrator who contributed drawings to various periodicals. Nevertheless, perhaps to be in contact with his countryman Picasso, he took rooms at the Bateau Lavoir tenement—a gathering place of many young Cubists—and soon met Braque, Apollinaire, and Max Jacob. For the next six years, Gris was an observer rather than a participant in the upheavals that permanently changed the course of western art.

Gris began painting watercolors in 1910; the following year he allowed his friends to see his first authoritative oils. As Gertrude Stein wrote, "As a Spaniard he knew Cubism and had stepped through into it."

From 1912, when Gris first showed his work, he was an accepted member of the Cubist group and kept pace with the evolution of the style, from Analytic Cubism, through collage, to Synthetic Cubism. *Still Life with Newspaper* falls in the category of Gris paintings called "architectural" by his dealer, Daniel Henry Kahnweiler. The term is apt for a work which is actually a trompe l'oeil painting imitating a collage, or assemblage, of found objects. Even though Gris abandoned the career for which he was trained, his paintings always seem to be logically structured out of interlocking forms and according to precise engineering principles.

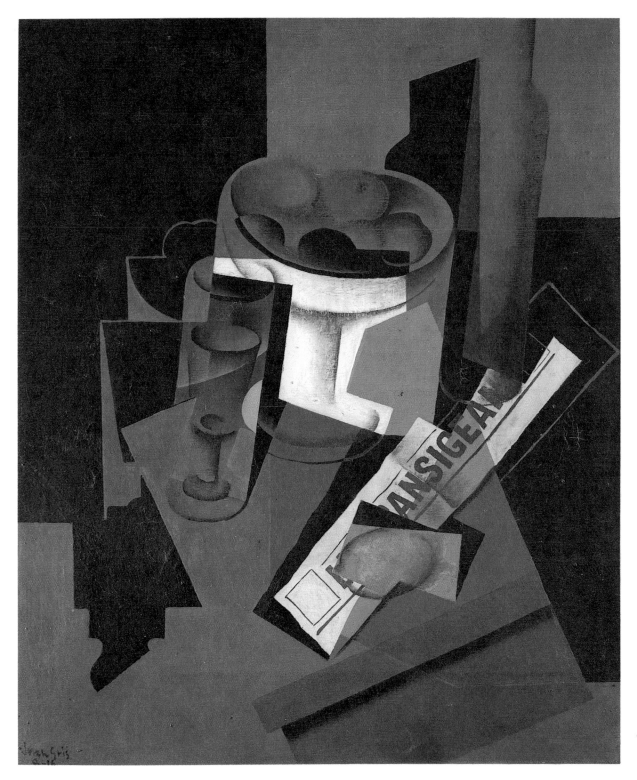

93

GEORGES BRAQUE

b. Argenteuil, 1882
d. Paris, 1963

Still Life with Grapes and Clarinet

1927
Oil on canvas
54 x 73 cm. (21$\frac{1}{4}$ x 28$\frac{3}{4}$ in.)
Acquired 1930

During the decade following his World War I military service, Georges Braque continued to approach painting according to pre-war Cubist theory. For Braque, still-life painting was essentially a dispassionate, cerebral enterprise; never impetuous, he used the still life as a vehicle for the formal resolution of his conceptualized vision. Braque considered the rendering of an object in one- or two-point perspective false, because the method only took into account a single aspect, rather than the full experience apprehended from multiple viewpoints.

In *Still Life with Grapes and Clarinet,* an assemblage of quasi-naturalistic, upright forms is balanced against angular horizontal fragments. The radiating horizontals harmonize several simultaneous viewpoints, such as the severely foreshortened rendering of wineglass, clarinet, and bowl of grapes, with the view from below of the wainscotting as a backdrop.

Although *Still Life with Grapes and Clarinet* builds on the artist's continuing exploration of structural methods, it exhibits the increased sensuousness characteristic of Braque's work of the 1920s. In addition to a more resonant and diverse palette, there is an added emphasis on tactility. Like other monumental still lifes from the 1920s, such as *The Round Table* (page 97), *Still Life with Grapes and Clarinet* appeals to the sense of touch far more than any painting Braque had produced before the war. The artist drew on his boyhood apprenticeship under his father, a master house painter, to inject passages of *faux-marbre*, wood-graining, and stucco in precise verisimilitude.

The eye is fooled by the palpable surfaces into believing they must be elements of a literal rendition of reality, while the brain comprehends the forms as synthetic inventions. As the perceptions of familiar surfaces with unfamiliar forms alternate, a dialogue, or, more accurately, a dialectic, is established between the two. Paralleling this dialectic between trompe l'oeil surfaces and purely abstract elements is the play between the latter and the more naturalistic still-life forms. Comprehension of Braque's painting proceeds step by step through thesis, antithesis, and synthesis as the abstract and the literal are reconciled.

R.C.C.

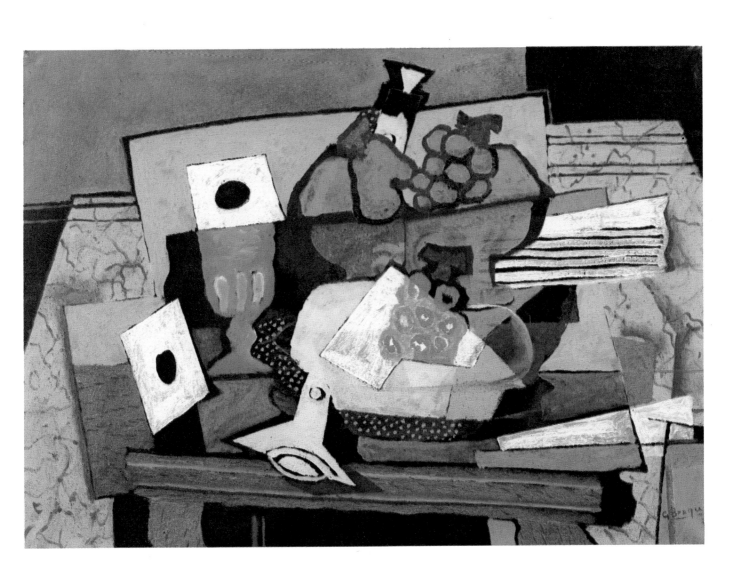

95

GEORGES BRAQUE

The Round Table (Le Grand Guéridon)

1929
Oil on canvas
147.3 x 114.3 cm. (58 x 45 in.)
Acquired 1949

Distinguished by the fact that the object-laden table is set in the ample space provided by the corner of the room, *The Round Table* is the most majestic of several variations on this theme executed by Braque in the 1920s. Braque has exploited the unusual proportions of the large, nearly square canvas, through the use of a classical formal device: a false perspective created by the passages of brown wainscoting, which simultaneously affords a suggestion and denial of illusionistic space. On the one hand, the areas of wainscoting appear to recede, emphasizing the volume and mass of the base of the table. On the other hand, they also establish themselves on a continuous plane behind the table. This spatial device presses the table forward, projecting the image boldly, in the manner of an icon.

Indeed, an overall breadth of form, a fresco-like surface, and a centralized, symmetrical composition invest this work with a lucidity and a heraldic, monumental formality, reminiscent of High Renaissance art. The venerability of past artistic traditions is also evoked in the chevron-patterned floor, the Doric-style columnar base of the table, and in the dado—replete with scrolled border and inset panels in the classical style.

In *The Round Table*, Braque couples architectural scale with a formal and decorative evocation of the heroic tradition in Western art. The painting exudes an undeniable eloquence and aplomb, in spite of Braque's later disavowal of what he was to term the *"esprit théâtral"* of classic art.

R.C.C.

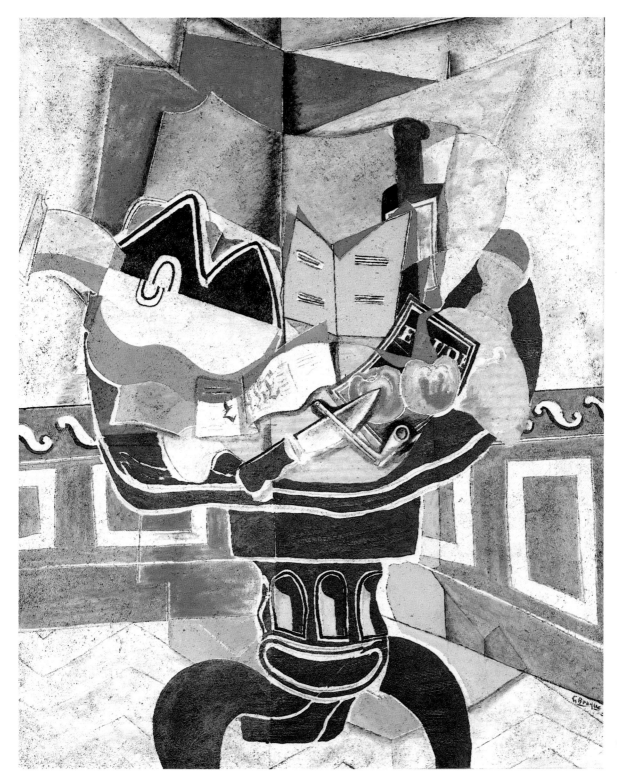

97

GEORGES BRAQUE

The Philodendron

1952
Oil on canvas
130 x 74 cm. (51^3/$_{16}$ x 29^1/$_8$ in.)
Acquired 1953

Beginning in the 1920s, Braque's work became increasingly diverse in style and subject matter. As if in counterpoint to such elaborate, highly finished works as *The Round Table* (page 97), Braque also produced many still-life paintings, consistently modest in scale and intimate in tone, treated in an improvised, naturalistic style.

He continued to explore increasingly esoteric and complex ways of seeing, but after World War II the more spontaneous, direct, and painterly tendencies blossomed forth. A group of startlingly simplified, nostalgic landscapes and terrace scenes, such as *The Philodendron*, testify to the liberation of a heretofore carefully contained lyricism.

The foreground of *The Philodendron* is occupied by a garden chair and a metal table, on which stand a carafe and large apple. These objects are rendered in a "cutout" style; areas of bare canvas stand for light. (The flat forms, together with the abstract rendering of light, probably derive from the pictorial conventions of color lithography, a medium that Braque mastered in the 1950s.) The white areas in the foreground are echoed by the shimmering white and silver highlights, brushed in a kind of broadened Impressionism, that enliven the seemingly near-transparent background plane of foliage and curtains.

Braque has invented a drastically simplified, accelerated atmospheric perspective to evoke a visually convincing, but totally idiosyncratic space, in which the eye feels the flat forms in the foreground as having volume. The play of an arbitrary, harsh light interrupts the otherwise strange crepuscular dimness of this space. The hallucinatory style of *The Philodendron* conveys the fugitive, evanescent qualities of a memory or a dream.

R.C.C.

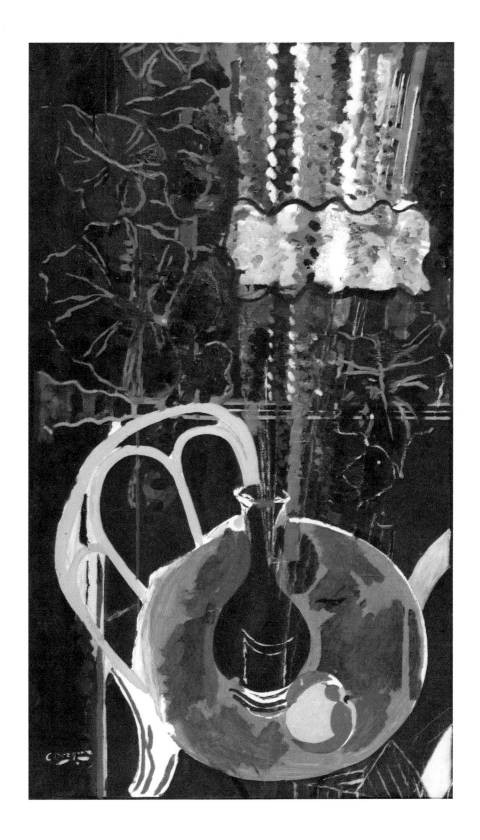

HENRI ROUSSEAU

b. Laval, France, 1844
d. Paris, 1910

The Pink Candle

1905–08
Oil on canvas
16.2 x 22.2 cm. (6³/₈ x 8³/₄ in.)
Acquired 1930

Notre Dame

1909
Oil on canvas
33 x 40.6 cm. (13 x 16 in.)
Acquired 1930

The legend of Henri Rousseau as a gifted simpleton is largely Apollinaire's contribution to the apotheosis of untutored "original genius" so esteemed by nineteenth-century sophisticates in search of innocence.

Rousseau (called the Douanier because one biographical fiction had him serving as a customs agent) aspired to official acclaim in the Salons where he first exhibited in 1885; instead, he became the mascot of the unruly bohemian crowd centered around the Bateau Lavoir apartments of Picasso and Apollinaire at the turn of the century. He was the butt of cruel practical jokes such as a false invitation from the President of the Republic, and on the other hand was the honored guest at the 1908 *Banquet Rousseau,* which celebrated the artistic revolutions of the decade. Most important, though he was twice in his life tried and convicted for petty embezzlement, his artistic integrity was never questioned. Picasso, who made a profession of "embezzling" from other artists, found nothing he could take from Rousseau's formal style; nevertheless, he paid the Douanier the high compliment of taking him seriously: "Rousseau is not an accident. He represents a certain order of thought."

Rousseau's method of ordering observed nature frequently began with a naturalistic oil sketch, in which both linear and atmospheric perspective are noted in an Impressionist manner. Later (sometimes decades later), in his studio, he would clarify the air and carefully delineate each component as he assembled the parts of the painting into a serene composition. His resolution of the age-old conflict between copying nature and making an original painting was so simple that it presented an hypnotic enigma. The resulting works caused an early critic to muse on their "dangerous fascination" and another writer to invent the phrase *cage aux fauves* to describe the room in the 1905 Salon d'Automne where Rousseau showed his painting *The Hungry Lion* along with brilliant canvases by others of the "wild beasts."

Picasso organized the famous *Banquet Rousseau* because he was so delighted with his purchase of a Rousseau canvas. In one of several accounts of the evening, Gertrude Stein describes the party as another joke in which Rousseau played the buffoon; other artists disagreed. Picasso said, "The first of the Douanier's works that I had the opportunity of acquiring took hold of me with the force of obsession." Subsequent generations have remained obsessed with the paradoxes of Rousseau's life and art. His statements remain oracular and his unique presentations of simplified form and extravagant color in academic technique fascinate because of their inherent formal contradictions.

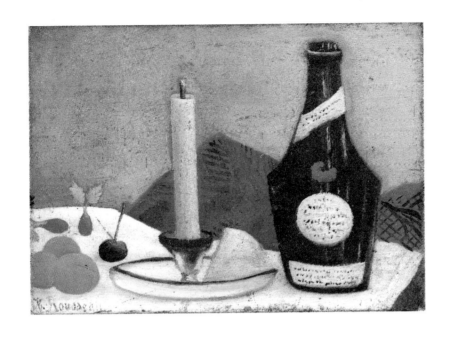

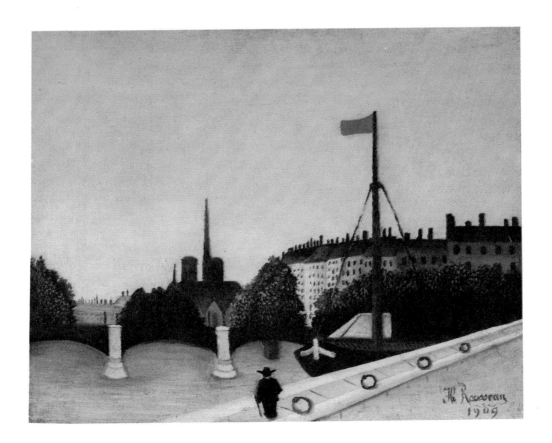

OSKAR KOKOSCHKA

b. Pöchlarn, Austria, 1886
d. Montreux, Switzerland, 1980

Lyon

1927
Oil on canvas
97.1 x 130.2 cm. (38^1/$_4$ x 51^1/$_4$ in.)
Acquired 1949

For Oskar Kokoschka, the *Painted World* series of cityscapes represented a conservative modification of the highly expressive style for which he had become famous. As a rebellious writer, artist, and political activist, Kokoschka gained a wide reputation before World War I by offending the staid moral and aesthetic sensibilities of his Viennese audience. By 1910 he had become a leader of the Expressionist painters in Berlin, where his emotionally charged portraits were sympathetically received. It was only after the war, when, as a professor at the Dresden Academy, he came under the influence of Dutch painting and Japanese prints, that his line became more calm and his viewpoint more objective.

He resigned his teaching post in 1924 to begin a seven-year odyssey, painting European cities as he travelled. In Lyon, as was his custom, he found the highest vantage point available, in order to gain a panoramic view, or, as Kokoschka would more likely have called it, a "cosmic view." His ambition went far beyond the accurate recording of topography: he was not painting cityscapes; he was, as ever, the portrait artist seeking out the elements of physiognomy that reveal character. None of the *Painted World* series is accurate according to maps nor necessarily identifiable by any inclusion of well-known monuments. Although in *Lyon,* Notre-Dame Fourvière can be seen rising from a hill above the Saône River, its prominence and exact location reflect the artist's feelings about the personality, the psychology, of the whole city.

While *Lyon* represents a relatively serene period in Kokoschka's long, tumultuous life, he could never be dispassionate about his subject matter. The birds circling against the dramatically illuminated sky seem to presage a revelation; a battalion of spikey chimney pots in the foreground presses against the riverbank; a jumble of irrational structures rises heavenward. Even in 1927, the visionary Kokoschka foresaw omens of turbulence in the air; within the next decade he was on the Nazis' list of most-hated, "decadent" artists.

103

FRANZ MARC

b. Munich, 1880
d. Verdun, 1916

Deer in the Forest I

1913
Oil on canvas
101 x 104.8 cm. (39¾ x 41¼ in.)
Acquired 1953, Katherine S. Dreier
 Bequest

Franz Marc wrote in a 1912 essay for *Der Blaue Reiter*, the almanac of the German avant garde: "In this time of the great struggle for a new art we fight like disorganized 'savages' against an old, established power. The battle seems to be unequal, but spiritual matters are never decided by number, only by the power of ideas." For Marc, as for his friend and mentor, Wassily Kandinsky, implementation of new art forms was indeed a religious crusade. He saw pure abstract art as truth and worked toward it with the same fervor he had once directed toward the study of theology.

Although Marc was rapidly moving toward abstraction at the time *Deer in the Forest I* was painted, his iconography remained precise. Horses, and later deer and birds, personified the spiritual for Marc. He wrote: "Animals with their virginal sense of life awakened all that is good in me." The innocent Deer are compositionally blended in with their environment and, according to Marc's symbolism, at one with the forces of God and nature. The bird can be seen either as a representation of hope or as a predator.

Marc's career ended abruptly with his conscription in 1914. Many years after his death in the battle of Verdun, Paul Klee and Lothar Schreyer agreed, "Cruel that Franz Marc was taken away from us so soon. If I'm not mistaken, he could see farther than all the rest of us—as far as the reflections of the world."

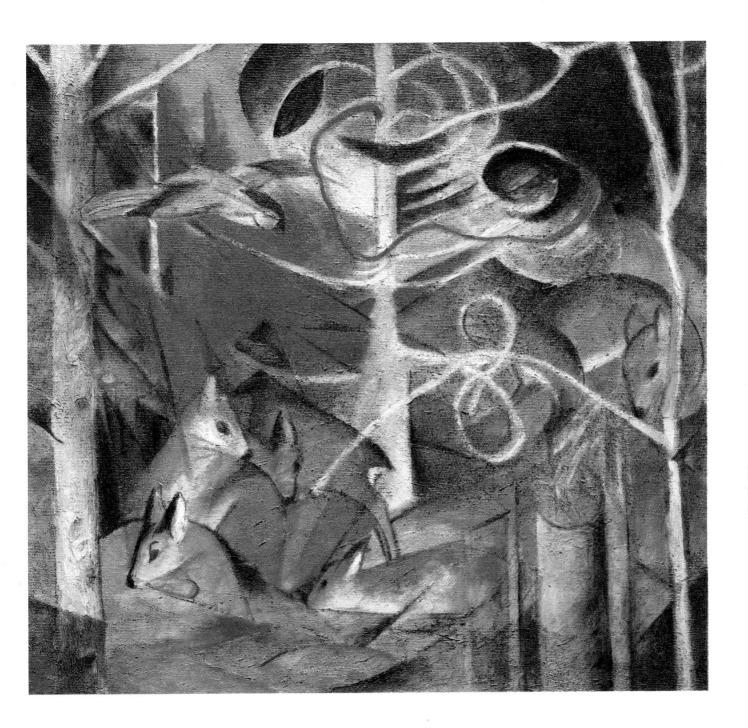

105

WASSILY KANDINSKY

b. Moscow, 1866
d. Neuilly, 1944

Composition–Storm

(Original title: *Study for "Painting with White Border"*; later title: *The Coming Storm*)

1913
Oil on canvas
100 x 78.8 cm. (39³/₈ x 31 in.)
Acquired 1953, Katherine S. Dreier
 Bequest

The objective title *Study for "Painting with White Border"* and the more evocative *The Coming Storm,* both of which have identified this painting, represent the two horns of Wassily Kandinsky's dilemma: the search for a pure abstract art on the one hand, and the desire to retain associative emotional content on the other.

Kandinsky, initially trained for the legal profession in Czarist Russia, had his belief in a comprehensible, stable reality shaken by the writings of Einstein and Max Planck on relativity and flux. Their radical theories of physics created an intellectual atmosphere receptive to the equally extreme revisions of aesthetics that Kandinsky in turn published in 1912. Kandinsky's book *Concerning the Spiritual in Art* attempted to reconcile nonreferential (or "nonobjective," as it came to be called) painting with theological and metaphysical interpretations of color and geometry.

In a series of paintings of 1913, titled only with reference to their inclusion of white shapes, Kandinsky struggled to eliminate from his work forms which could be read as ciphers for natural phenomena. While his biomorphic drawing still invited landscape interpretations, the artist's nonreferential intention may clearly be understood from the original title, *Study for "Painting with White Border."* This work, which does not show the white border, is a study for the left-hand portion of a painting which is now in the Solomon R. Guggenheim Museum, New York.

Kandinsky had optimistically written of the color white that it is a symbol "of a world . . . too far above us for its harmony to touch our souls . . . a silence like an impenetrable wall . . . but one pregnant with possibilities." The possibilities envisioned by Kandinsky, Marc (page 105), and Klee (pages 109, 111) for communal development of a new art were soon destroyed by World War I. Marc and Klee were conscripted, and Kandinsky returned to Russia shortly after the outbreak of the war.

It was not until 1930 that this painting was shown under the title *The Coming Storm.* At that time, it may have been construed as a prescient political vision, rather than as a prophecy of harmony and birth.

106

PAUL KLEE

b. Münchenbuchsee, near Bern, 1879
d. Muralto-Locarno, Switzerland, 1940

Arab Song

1932
Gouache on unprimed burlap
91.1 x 64.8 cm. (35⅞ x 25½ in.)
Acquired 1941

"The most melancholy melodies!" Klee noted in his diary after he first heard an Arab concert in Tunis. He was overwhelmed by the moon, the colors of the bazaar, the texture of the sand—images he said would "last a lifetime. . . . The essence of *A Thousand and One Nights.*" Over the years his affinity for Muhammadan culture proved as strong an influence as his love of music and poetry. This is especially evident in his vocabulary of glyphs, which often resemble decorative kufic writing, or patterns from mosque walls and floor mosaics. *Arab Song* most overtly alludes to the eternal rhythms of Tunisia, the texture of desert sands, the mystery of women tightly bundled in the obscuring robes of the chador.

From his earliest years, Klee had employed the masked face as an allegory for the essential duality of character. In 1932, as he became increasingly disquieted by German politics, he painted two figures concealed down to the knees by a huge *Mask of Fear.* Here, in *Arab Song,* the concealing mask hides all but a pair of sad and frightened eyes. However, Klee's art is never totally pessimistic. The red leaf on the vertically rising stem symbolizes hope, energy, and equilibrium; the leaf—perhaps a heart—at the end of the gracefully curved downward line resembles his notebook diagrams of lines and circles meeting in "accommodation . . . a figure of struggle or friendship." Klee's own notations for the structure and rhythm of the song are spelled out in the cryptic notations of linear hatching leading to the edge of the burlap ground.

In *Arab Song,* as in all Klee's painting, contradictions abound. Beyond the immediate charm of Klee's deliberately childlike drawing is an underlying balance of symbolic elements thought out according to his basic belief that a concept cannot exist without its opposite: no cosmos without chaos, no good without bad.

109

PAUL KLEE

Young Moe

1938
Oil on newspaper mounted on burlap
53.3 x 70.2 cm. (21 x 27⁵/₈ in.)
Acquired 1948

Klee's titles always hold some key to the source or content of his paintings, if his puns and playful obfuscations can be deciphered. Who or what, then, is *Young Moe*? The stick figure at the left and the symbolic marks across the canvas have been open to numerous interpretations until recently, when Klee's friend from the last Bern years (1934–40), Alfred Moeschinger, was located. Moeschinger recalled that while he was professor of music theory at the Conservatory of Bern he came to know Klee well enough to be called by the abbreviated name Moe. Klee was a gifted amateur violinist, and Moeschinger dedicated three humoresque compositions for violin and piano to Klee. In return, the artist gave him two paintings and immortalized him here, conducting what is probably a Moeschinger composition.

According to Klee's personal notational system, partially explicated in his notebooks, each calligraphic figure carries indications of tempo and rhythm when applied to music, as well as other meanings in different contexts. The not-quite-closed triangle, for example, is a line "speeding" to get from one point to another. The converging and crossing lines could symbolize a restful, leisurely pace; in this case, they probably refer to the folk melodies Moeschinger incorporated into his music; in another painting they could refer to the parting and uniting of friends.

Klee once lamented after the performance of a play, "If only we had a score, as at the opera; but the way it is, we are at the mercy of the director's and the actor's arbitrariness." Klee himself was, in a wry way, as arbitrary as any director and as coy about letting anyone see the full score he orchestrated, but, given the clues of Moe's identity and occupation, it is possible to take a fleeting glimpse of Klee's source and process of transformation.

KURT SCHWITTERS

b. Hanover, Germany, 1887
d. Ambleside, England, 1948

Radiating World

1920
Oil and paper collage on
 composition board
95.2 x 67.9 cm. (37½ x 26¾ in.)
Acquired 1953, Katherine S. Dreier
 Bequest

With a minimalist language of tilted, superimposed rectangles, taut, radiating diagonals, and a few pure ovoid forms, Schwitters elegantly composed a self-sufficient, austere, yet lively cosmos, *Radiating World*.

The play of painted shapes against unpainted engenders a sense of space. The center of the picture appears to deflect penetration by the points of the interlocking spearhead forms that radiate tangentially around it. As a consequence, the center of *Radiating World* becomes a vortex—a mysterious void, occupied by an unseen force.

The smooth, volumetric oval in the upper right partakes of the sense of dynamic radial movement, which stems from the calculated interplay of void with harsh, angular forms. The appearance of a similar but flat oval in the lower left gives the impression that this image is meant, like a diagram, to explain and record the trajectory of the ovoid.

Yet in contrast to Gabo's (page 117) world of pure geometry, Schwitters's cosmos is actually composed of material retrieved from the wastebasket, and, in spite of the artist's assertion that "what the material signified before its use in the work of art is a matter of indifference," the scraps of newspaper, envelopes, and the like invest *Radiating World* with a resonant, associative power.

Of particular interest is the reference, in the upper right, below the ovoid, to the Dada movement—MOUVEMENT DADA—because, although he was one of its most famous propagandists, Schwitters's relationship to Dada was actually quite ambivalent.

Probably the single most important contribution of the Dadaists was their popularization of the theory and practice of automatism. Automatism liberated artistic expression from the formal and conceptual patterns that had traditionally shaped it. It generated structures and imagery that defied conventional categories, yet were nonetheless meaningful. The artistic potential of automatism would later be exploited by the Surrealists, and above all, by American Abstract Expressionists such as Motherwell (page 195) and Pollock (page 179).

Schwitters, who had received the usual art school training, always emphasized the aesthetic impulse brought into play in making his abstract collages, for which he invented the nonsense term "Merz": "I adjusted the elements of the picture to one another, just as I had done at the academy. . . . The work of art comes into being through artistic evaluation of its elements. I know only my medium, of which I partake, to what end I know not." Thus, while Schwitters adhered to the Dadaists' anti-idealistic conception of the work of art, adopting the automatist approach, he did not embrace their nihilistic anti-aestheticism.

R.C.C.

ALEXANDER ARCHIPENKO

b. Kiev, 1887
d. New York, 1964

Standing Woman

1920
Polychromed plaster on wood panel
46.7 x 29.2 cm. (18⅜ x 11½ in.,
 frame opening)
Acquired 1953, Katherine S. Dreier
 Bequest

In February 1921, when *Standing Woman* was shown in New York by the then recently formed Société Anonyme, the Dada-oriented organization placed an advertisement in *The Arts*, calling attention to the "Archie Pen Co." Among the virtues listed for the products created by the company, the ad touted them as being "without equal" for "artistic design, quality and value." Illustrated by a streamlined version of *Standing Woman*, the text and design were undoubtedly the brainchildren of Marcel Duchamp and/or Man Ray, his cohort in many mischievous art-world pranks. Here the pun on the artist's name also serves as a double entendre by likening his Cubist aesthetic to futuristic machine-age industrial design. With a wry look back at the "Pen Co.," Archipenko named his own 1924 invention of a machine for showing paintings in motion the "Archipentura."

Archipenko first exhibited with Duchamp and his brothers, Jacques Villon and Raymond Duchamp-Villon, along with other Cubists, at the 1910 Salon des Artistes Indépendants, and was well known in Europe before his inclusion in the 1913 New York Armory Show. The 1921 Société Anonyme exhibition was, however, his first American one-man show. Accompanied by lectures, symposia, and a Man Ray postcard of *Standing Woman*, the show introduced him to American audiences and may have influenced his decision to immigrate in 1923.

Standing Woman, one of a group of works Archipenko called "sculptopeinture" because some of the forms which appear to be in relief are actually painted flat on the wood support, while others are built up from carved plaster, demonstrates the artist's ability to manipulate void as form. All too frequently, Cubist sculptures fail to conform visually to the theories behind them; they merely demonstrate in a literal manner planes set at angles in a shallow space. Archipenko invented his own vocabulary of illusionistic solids and voids, of mixed media and contradictory, polychrome shapes, in the true spirit of Cubism and its theories.

115

NAUM GABO

b. Briansk, Russia, 1890
d. Waterbury, Connecticut, 1977

Linear Construction, Variation

1942–43
Lucite with nylon string
61.3 x 61.3 x 25 cm. (24$\frac{1}{8}$ x 24$\frac{1}{8}$
 9$\frac{7}{8}$ in.)
Acquired 1948

Naum Gabo, who had studied medicine, natural science, and engineering at Munich, retained a messianic belief in time-space theory and the principles of physics as the proper guides to twentieth-century art. As he wrote in the 1920 *Realistic Manifesto*, "No new artistic system will withstand the pressure of a growing new culture until the very foundation of Art will be erected on the real laws of Life."

Although the early cardboard heads constructed by Gabo and his brother, Antoine Pevsner, owe a strong debt to the Cubist breaking up of form into planes, in the *Manifesto* Gabo accused the Cubists of failing to touch the foundations of art. The Futurists were similarly dismissed as "very ordinary chatterer[s]." After renouncing color as superficial, descriptive line as accidental, volume as a mere means of measuring space, mass as a sculptural element, and "the thousand-year-old delusion in art that held the static rhythms as the only elements of the plastic and pictorial arts," Gabo affirmed "kinetic rhythms as the basic forms of our perception in real time."

In all of Gabo's mature sculpture "kinetic rhythms" are translated into ambiguous lines and shadows emanating from transparent materials. The Phillips's *Construction*, one of a series dating from Gabo's wartime stay in London, emulates a model of a topological equation. He took great trouble, however, to explain that shapes, which mean nothing to a scientist except as units of measurement, can be appropriated by the artist as a remarkably precise vocabulary for communicating nonscientific ideas. In this ethereal, light-reflecting *Construction*, Gabo has redefined space as the essence of sculpture by truly dispensing with mass.

117

AMEDEO MODIGLIANI

b. Leghorn, Italy, 1884
d. Paris, 1920

Elena Pavlowski (Hélène Povolotzka)

1917
Oil on canvas
64.8 x 48.9 cm. (25^1/$_2$ x 19^1/$_4$ in.)
Acquired 1949

When Amedeo Modigliani jettisoned his bourgeois Italian heritage and rejected Renaissance painting tradition, he took on the mores of flagrant Parisian Bohemianism and adopted the forms of primitive art. Like Picasso, whom he sometimes emulated, and Brancusi, with whom he studied, Modigliani found a source for simplified, expressionistic representation of the human figure in African sculpture. Whether the influence came to him directly, or through the earlier work of Picasso and Brancusi, his trademark conventions of elongated neck, exaggeratedly oval eyes, and flat, scooped nose all ultimately derive from ritual tribal sculpture.

Elena, more than most of his female portraits, is individualized by the intensity of her stare and the broad proportions of her face. One of his many anonymous models, who had undoubtedly been translated into the Modigliani stereotype of feminine elegance, said that he saw "only the beautiful and the pure." But his portraits of Picasso, Chaim Soutine, Jean Cocteau, and other colleagues are incisive, for all their refined simplification. Elena Pavlowski (also referred to as Mme Hélène Povolotzka) was one of the few women accorded the same close scrutiny. Little is known about her except that she is said to have been a member of the "Montparnasse intelligentsia." She was probably one of the circle of Polish emigrés formed by Modigliani's devoted dealer, Leopold Zborowski—a group that did all it could to sustain Modigliani in spite of his self-destructive impulses. Whoever Elena may have been, the sense of a forceful presence in her portrait insistently demands comparison with Picasso's powerful 1906 rendering of Gertrude Stein, in the Metropolitan Museum in New York. The two paintings are very similar in the drawing of the almond eyes overhung with wide, evenly curved brows; both noses are abnormally prominent; both ears protrude; in both cases, the only white in an otherwise brown-toned painting defines the base of the neck; and even a curved sofa back with vaguely flowered upholstery appears to the right of the figure in both paintings. Modigliani departs from the prototype only in flattening his figure and in giving Elena the cupid's-bow mouth that was his signature.

Modigliani greatly admired Picasso; if Elena were someone he credited with the influence of a Gertrude Stein, was it not logical to pay homage to both his friend and his hero in a single picture?

119

CHAIM SOUTINE

b. Smilovitchi, Lithuania, 1893
d. Paris, 1943

The Pheasant

1926–27
Oil on canvas
31.1 x 75.6 cm. (12¼ x 29¾ in.)
Acquired 1951

Chaim Soutine's passionately expressive manipulation of paint was an outrage to Parisian critics, who saw it as debauching "the slender, graceful, precise French style." His personal posture as a loutish anti-intellectual and his destructive carousing with Amedeo Modigliani (page 119) only corroborated the fear that the civilization which had produced Voltaire and Watteau was crumbling under the assault of Soutine's "feverish, disconcerting, hyperbolic art . . . a kind of Jewish mysticism through appallingly violent detonations of color."

Soutine, born a Russian peasant, gravitated toward the more robust (but equally French) traditions of painting exemplified by Courbet (page 35) and the late still lifes of Monticelli (page 37). On the other hand, he confounded his colleagues by proclaiming the delicately drawn, perfectly finished fifteenth-century portrait of Charles VII by Jean Fouquet "the finest painting in the Louvre," and many of his compositions appear to be variations on carefully studied Chardin paintings. A comparison to Chardin's still lifes has repeatedly been made, to Soutine's detriment, on the basis that the latter's birds are "too dead" and lack "appetizing plumpness." Perhaps more to the point, Chardin's technique stemmed from the necessity to fool the eye with a smooth surface that depicted rich texture; in Soutine's time it was permissible actually to texture the paint on the canvas.

As for Soutine's perplexing admiration of Fouquet, a close look at the delicate strokes of a sable brush delineating the claws of *The Pheasant* reveals his often suppressed capacity for elegance and refinement.

GIORGIO MORANDI

b. Bologna, 1890
d. Bologna, 1964

Still Life

1953
Oil on canvas
20.3 x 39.7 cm. (8 x 15⁵/₈ in.)
Acquired 1954

Giorgio Morandi spent the better part of his life seeking equivalences between reality and illusion. Although early in his career he had contributed paintings that demonstrate purely formal interests to the 1914 Futurist exhibition, he soon realized that his true métier was philosophy. A few years later, in the early 1920s, he was briefly allied with de Chirico as a "metaphysical painter" of strange objects in false perspective. Then, as his aesthetic concerns narrowed to the primary, ontological question of the essence of reality, he sequestered himself in his small, orderly Bologna studio to create works that defy categorization.

Contrary to the unwieldy, often pompous, metaphysical theories underlying his art, Morandi's paintings have a direct, unpretentious clarity that gently entices the viewer to contemplation and meditation on the true nature of things. The close-valued, carefully crafted structures he erects nevertheless emanate a pre-Classic solemnity that transcends their decorative function.

Morandi began his process of creation by collecting empty bottles and other containers. There is undoubtedly significance to be found in his choice of objects originally designed to enclose or support other things. Geometric configurations of pale paint, applied to the surfaces of his found objects, often contradict the physical stereometric forms and remove the vessels, as subject matter, one more step from their original utilitarian reality. Ultimately, these once-humble objects, twice transformed, determine their own atmosphereless, but solid, indisputable world. The resulting microcosm beguiles, not only in the subtlety of color and suavity of paint, but by the suggestion that more harmonious worlds do, in fact, exist.

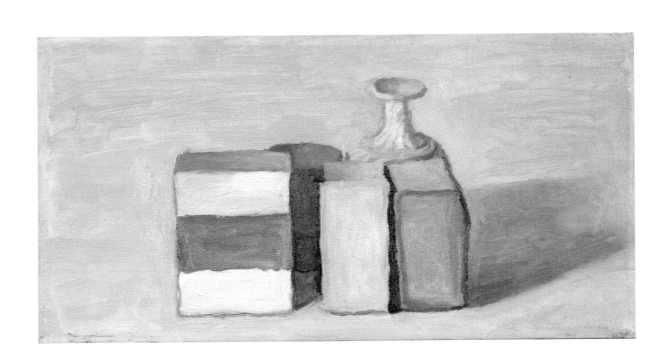

JACQUES VILLON

b. Damville, 1875
d. Puteaux, 1963

The Little Machine Shop

1946
Oil on canvas
81.2 x 116.2 cm. (32 x 45³/₄ in.)
Acquired 1951

In 1911, at his house in the Parisian suburb of Puteaux, Jacques Villon, along with his brothers, Marcel Duchamp and Raymond Duchamp-Villon, hosted a series of discussions about modern art that resulted in one of the first important redefinitions of both the style and substance of Cubism as it had been practised by its inventors, Braque and Picasso. The so-called Puteaux group, whose works were brought together in a 1912 Paris exhibition, *La Section d'Or,* judged strict Cubism as too exclusively pictorial in aim—too arbitrary and subjective with regard to form and too restricted with regard to subject matter. For them, Braque's and Picasso's concerted rejection of both the formal structures and the humanistic concerns of traditional painting was excessive, yielding an inaccessible kind of art, devoid of significance in the eyes of society.

For Villon, who alone of the original group remained throughout his career devoted to the goals formulated at Puteaux, the history of art, modern science, and contemporary experience were all to play a role in the integration of modern art with modern society. The fragmented Cubist language was to be disciplined by the tried and true pictorial solutions of Renaissance art. From modern theories of color were deduced color harmonies with objectively verifiable appeal. Finally, the expressive range of Cubism was broadened to encompass significant aspects of modern life, such as the special awareness of the impersonal physical forces immanent in the universe, especially as experienced through the machine.

The formal unity of a picture like *The Little Machine Shop* of 1946 stems from Villon's use of a grid constructed according to the Golden Section, a classical formula sometimes used by Renaissance artists to establish the perfect proportional relationship of part to whole. Projected through this grid are several contiguous visual pyramids, used to synthesize the surface dimensions of the picture with the space depicted therein. Villon has introduced into this perfectly integrated concatenation of triangulated planes a carefully adjusted harmony of glowing greens and blues, which, in a manner reminiscent of the theoretical color charts from which the scheme derives, radiate from a central area of blacks, greys, and whites. The repetition of accented diagonals, left to right, induces a rhythmic movement across the picture plane. This movement is taken up in the large white spiral on the right, whose apparent rotation begins the circuit all over again.

Closer examination reveals the unexpected presence in this shallow, crystalline structure of suggestive fragmentary forms. They are evidence of the scene from life which was Villon's point of departure. The theme of this picture is not, however, the machine shop itself, but the forces it brings into play.

124

R.C.C.

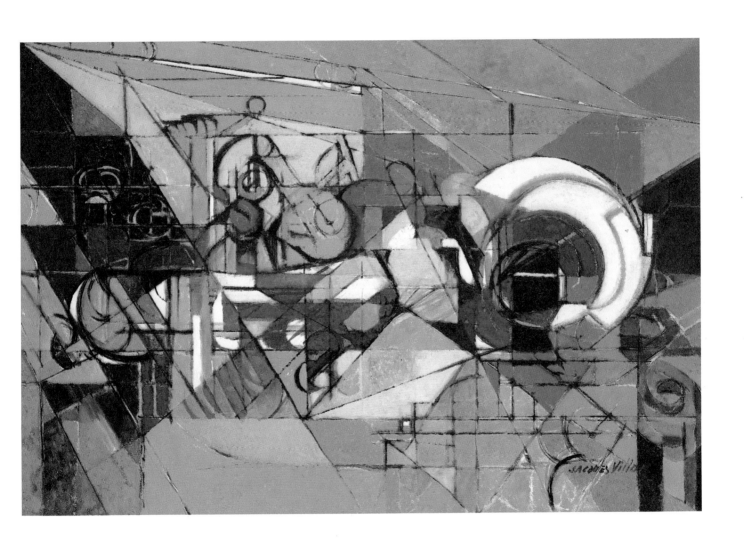

EDWARD HICKS

b. Attleborough, Pennsylvania,
 1780
d. Newtown, Pennsylvania, 1849

A Peaceable Kingdom

1846
Oil on canvas
61.3 x 81.6 cm. (24^1/$_8$ x 32^1/$_8$ in.)
Acquired 1939

The wolf also shall dwell with the lamb, and the leopard shall lie down with the kid; and the calf and the young lion and the fatling together; and a little child shall lead them. And the cow and the bear shall feed; their young ones shall lie down together; and the lion shall eat straw like the ox. And the sucking child shall play on the hole of the asp, and the weaned child shall put his hand on the cockatrice' den. They shall not hurt nor destroy in all my holy mountain. . . . (Isaiah 11:6–9).

Trained as a carriage maker and sign painter before he became an itinerant preacher, Edward Hicks freely employed the conventions of commercial decoration to illustrate Isaiah's prophecy that heaven on earth could be achieved, if man would yield up such bestial instincts as pride, anger, and jealousy. Each of the more than one hundred *Peaceable Kingdoms* he left with friends can be read like one of his sermons, telling of his particular feelings and concerns of the moment. The canvas in The Phillips Collection, inscribed on the back as "Painted by Edward Hicks in the sixty-sixth year of his age," presents a panoply of animals coexisting in the foreground, while William Penn negotiates the treaty with the Delaware Indians in the distance. Hicks, grieving over the recent death of his granddaughter, may have identified himself with the hoary-maned, sad-eyed lion who has renounced his pride and accommodated himself to a diet of straw.

Unlike most pietistic art of the nineteenth century, Hicks's *Peaceable Kingdom* carries the same degree of conviction as a medieval manuscript illustration or an African ceremonial mask, and hence holds the same degree of interest to twentieth-century artists weary of pseudo-naturalistic academic art.

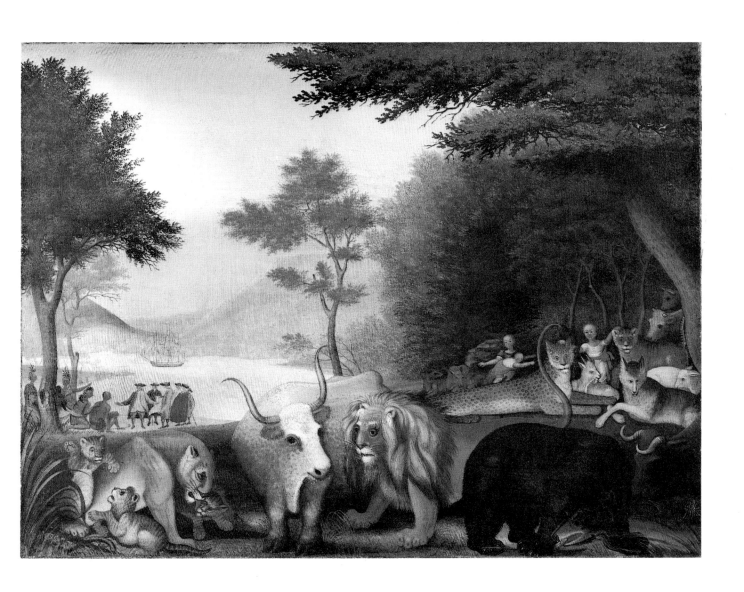

GEORGE INNESS

b. Newburgh, New York, 1825
d. Bridge-of-Allan, Scotland, 1894

Lake Albano

1869
Oil on canvas
77.1 x 115.2 cm. (30⅜ x 45⅜ in.)
Acquired 1920

Although during his lifetime he was considered to be the greatest of American landscape painters, George Inness was largely neglected during the first half of the twentieth century nearly everywhere except at The Phillips Collection. Now, partly because of revived appreciation of nineteenth-century American art, his paintings are once again displayed proudly in many museums.

Early in Inness's career he assimilated the broad, suggestive style of the French Barbizon painters into an art more descriptive of mood than of nature. As he said before he ever heard of a movement called Impressionism, his aim was to "reproduce in other minds the impression which a scene has made." And, as if to deliberately shock his countrymen who firmly believed that the purpose of art was to be uplifting, he added, "A work of art does not appeal to the intellect . . . to the moral sense. Its aim is not to instruct, not to edify, but to awaken an emotion."

Inness's romantic, mystic instincts, reinforced by his conversion to Swedenborgianism in 1865, repeatedly drew him to the Arcadian landscapes of Italy where Lake Albano was a favorite subject. The Phillips's *Lake Albano* is an interpretation of the site that might be more accurately described as an allegory than as a landscape, for it was conceived in the studio as personifying his accumulated sensations of Italy. Inness more than recreated a single impression; he intensified and compressed myriad feelings and experiences. To do so, he had to orchestrate his composition as if preparing an opera production, assigning clearly defined symbolic roles to each segment. Different associative emotions are triggered by Roman ruins, cypress trees, contemporary tile-roofed villas, the unfathomable lake, and a carefully deployed cast of characters acting out the many pleasurable activities of a bucolic Sunday afternoon.

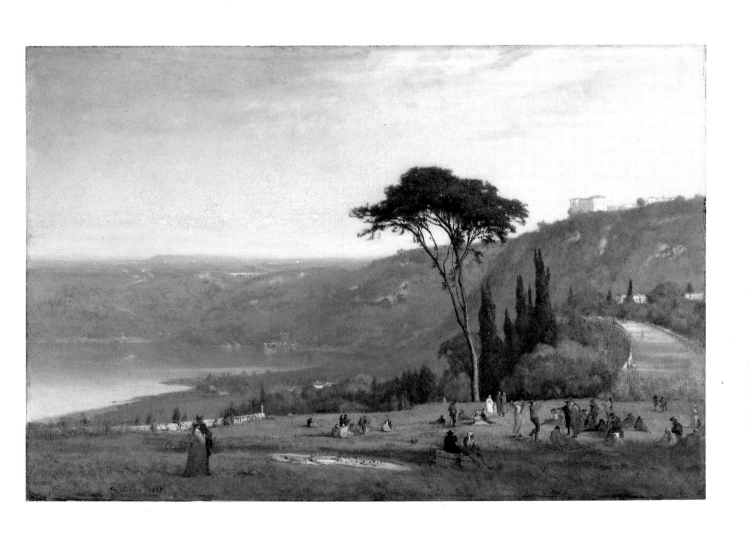

THOMAS EAKINS

b. Philadelphia, 1844
d. Philadelphia, 1916

Miss Van Buren

Ca. 1886–90
Oil on canvas
113.1 x 81.3 cm. (44¹/₂ x 32 in.)
Acquired 1927

After being relieved of his teaching duties at the Pennsylvania Academy of the Fine Arts in 1886 (because of his insistence on drawing from nude models), Eakins executed some of his greatest portraits, based on multiple photographic studies and close daily observation. Among his most sympathetic sitters was Amelia van Buren. She had briefly been his pupil at the Academy from 1884 to 1885, and she fully respected the artist's aesthetic, suppressing her vanity and submitting to Eakins's penetrating eye.

In many cases, Eakins made photographic studies of posture and muscle structure, which he incorporated into subsequent portraits; a number of prints identifiable as Miss Van Buren exist. It is curious in her case, however, that the photographs, in many different moods and poses, reveal a full-faced blonde, who appears almost adolescently youthful, while the portrait presents a fine-boned woman of *un certain age*. This discrepancy may be accounted for by an understanding of Eakins's so-called Realist aesthetic; he did not equate realism with literalism and, when not pressured by sitters for a flattering likeness, interpreted what he saw to be the essence of character and personality. In the portrait of Miss Van Buren, he has pared away extraneous flesh and painted her as the graceful, composed woman people who knew her much later in life remember.

JAMES ABBOTT McNEILL WHISTLER

b. Lowell, Massachusetts, 1834
d. London, 1903

Miss Lillian Woakes

1890–91
Oil on canvas
53.3 x 35.6 cm. (21 x 14 in.)
Acquired 1920

Miss Lillian Woakes typifies the sensitive portraits of young women Whistler painted in the late 1880s and 1890s. Twelve years had passed since the artist had sued John Ruskin for libelously accusing him of "flinging a pot of paint in the public's face." Whistler had married, published *The Gentle Art of Making Enemies*, and attracted official patronage. Success mellowed his personality and refined his style.

Whistler, who had once bragged of finishing a *Nocturne* painting "in a couple of days," assured Miss Woakes when the portrait was commissioned that he could accomplish it in three sittings. Once at work, he elected to build the painting meticulously, in a series of thin washes from monochromatic underpainting to the full color values. While he kept the luminous greys and blush pinks in exquisite balance at each stage of the painting, the process required twenty-five sittings over a period of six months.

Finally satisfied, Whistler signed his butterfly logo into the bow of the blouse and, at the sitter's insistence, once again over her right shoulder. He insisted no varnish be applied to dull his subtle colors and proclaimed, "Now! Miss Woakes will live forever."

ALBERT PINKHAM RYDER

b. New Bedford, Massachusetts, 1847
d. Elmhurst, New York, 1917

Moonlit Cove

1880–90
Oil on canvas
35.9 x 43.5 cm. (14$^1/_8$ x 17$^1/_8$ in.)
Acquired 1924

The elusive forms of *Moonlit Cove* can easily be read as a biomorphic abstraction akin to Arthur Dove's *Cows in Pasture* (page 164), but it is the darkened canvas that makes the boat seem to merge with its shadow and the cliffs. Dove worked methodically through a series of studies, simplifying and extracting what he saw as the essential forms; Ryder believed that "It is the first vision that counts."

One of the most poetic, romantic, and elusive of American artists, Albert Pinkham Ryder was self-taught except for a brief stint at the National Academy, cut short by his impatience at drawing from plaster casts. Impatience, in fact, was a determining trait in Ryder's life and art. He travelled to England and Europe twice, and both times hurried home before completing the planned tour; he joined rebellious artists' groups, then quickly lost interest in wrangling and details; he did not suffer fools even momentarily and became renowned for avoiding society. The same impatience, coupled with an obsessive reluctance to stop reworking his canvases, caused the ruination of many of his paintings over the years. Being self-taught did not, in Ryder's case, imply naive vision; it did, however, result in disregard for the craft of oil painting.

When Ryder said, "Art is long. The artist must buckle himself with infinite patience," he was talking about ways of seeing the world and public recognition. He himself was erratic in his methods, sometimes working very rapidly, at other times continuing to rework a painting for many years. He would stack up multiple layers of "big chunks of pure, moist color," and freely add asphaltum (also known as bitumen), in spite of admonitions in artists' handbooks against such practices. The result is that the paint on many of his canvases has become brittle and deeply cracked.

Moonlit Cove has fared better than many Ryder paintings (although a conservator called the normally simple process of removing the canvas from the stretcher a "nightmare") since the time when it was exhibited at the 1913 Armory Show, where Ryder was first established as a forerunner of modernist painting. Often, the aura of mystery exuded by Ryder's work and admired by later painters results from the deterioration caused by his negligence. Here, it is still possible to see nature as he discovered it in a moment of revelation, "bathed in an atmosphere of golden luminosity."

JOHN HENRY TWACHTMAN

b. Cincinnati, 1853
d. Gloucester, 1902

Emerald Pool

(Yellowstone National Park,
 Wyoming)

Ca. 1895
Oil on canvas
63.5 x 63.5 cm. (25 x 25 in.)
Acquired 1921

In 1894, when John Henry Twachtman was commissioned to paint views of Yellowstone National Park, one might have expected him to return with panoramic landscapes meticulously depicting scenic grandeur. Instead, Twachtman's painterly sensibility led him to focus on details, and by cropping, magnifying, and arbitrarily adjusting scale he suggested an infinity of space on small canvases. In comparison with many belabored landscape paintings of the nineteenth century, drenched in the dark glazes that came to be known as "brown sauce," the *alla prima* technique and high-key palette of *Emerald Pool* strike the senses directly, as vibrant metaphors rather than pallid description. It is as if Twachtman, in the twenty years after his studies at the Royal Academy in Munich, had made the difficult artistic journey Clyfford Still (page 187) much later described, across "the dark and wasted valley . . . into clear air . . . on a high and limitless plain."

Twachtman's blond palette and professional association with artists who had made the pilgrimage to Monet's home at Giverny have caused him to be called, somewhat misleadingly, an American Impressionist. In *Emerald Pool,* painted at about the time when Monet (page 47) was finishing the last of his studies of light reflected off the facade of Rouen Cathedral, there is no indication of time of day other than overall brightness, nor is there any concern for light and shadow. While Monet's way of seeing only reflections exaggerates the porousness of surfaces, Twachtman paints every element in his landscape—water, valley floor, bluffs, and trees—as being of equally impenetrable density. His dry-brush technique, which seems to compress the pigment into the canvas, further contributes to the sense of abstract independent solidity that anticipates the assertive audacity of Still's much later canvases.

On the other hand, a kinship to elegant French painting exists in Twachtman's sensitivity to subtly graded color relationships—a sensitivity so keen that Pierre Bonnard, on his single trip to The Phillips Collection in 1926, immediately pronounced *Emerald Pool* to be his favorite American painting.

ERNEST LAWSON

b. Halifax, Nova Scotia, 1873
d. Coral Gables, Florida, 1939

May in the Mountains

1919
Oil on canvas mounted on panel
63.5 x 76.2 cm. (25 x 30 in.)
Acquired 1922

Ernest Lawson, who appears in the Somerset Maugham novel *Of Human Bondage* as the artist Frederick Lawson, began his career with knowledge that it had taken John Twachtman twenty years to acquire. As a young student of Twachtman's in 1892, Lawson immediately had the benefit of what he succinctly described as his mentor's "dramatic transformation from . . . the bituminous impasto of the Munich style . . . through [the] period where he eliminated the heavy impasto and cleaned up his color . . . to his impressionist manner."

The fortuitous timing of Lawson's introduction to painting afforded him an early and easy command of the language of Impressionism just at the time when it was most fully articulated. Lawson himself told a story of accosting Alfred Sisley (page 49) on his first trip to France in 1893 and brashly asking for a critique from one of the original Impressionists. Since Sisley was not known as a sarcastic man, his reply, "Put more paint on your canvas and less on yourself," may be interpreted as a way of saying that there were no obvious, inept faults to be corrected.

But the same chance of birth date that gave him the opportunity to learn a fully formed tradition at the beginning of his career worked to his disadvantage during later years. On his return to America, his style was still too advanced for wide public acceptance; later, when he joined Prendergast (page 153) and Sloan (page 145) in the 1908 exhibition of "The Eight," he was out of step with the others. Nor did he fit in with such pioneering abstractionists as Arthur Dove (pages 163, 164) shown by Alfred Stieglitz and, although he did participate in the Armory Show of 1913, his work was overshadowed by the shock value of modern European paintings.

It was left to collectors like Duncan Phillips and Albert Barnes, who had no patience with the proposition that artistic progress was a linear "inexorable march toward modernism," to acquire the most beautiful Lawson paintings during the artist's lifetime. Although Lawson won his share of prizes in conservative American exhibitions, and historical interest in his work has greatly revived recently, his accomplishment is still best seen in the context of certain other painters, like Bonnard (pages 71, 73), who defied categorization by following their own innate predilections.

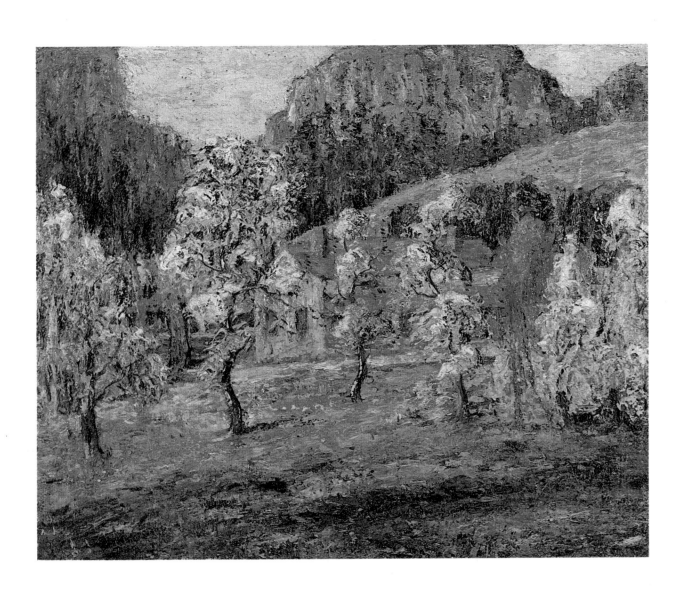

LOUIS EILSHEMIUS

b. Near Newark, New Jersey, 1864
d. New York, 1941

Approaching Storm

1890
Oil on panel
57.3 x 68 cm. (22⁹/₁₆ x 26³/₄ in.)
Acquired 1937

Louis Eilshemius, who often spelled his name "Elshemus," was at his best a painter of lyrical and luminous landscapes reminiscent of Corot, epitomizing the idiosyncratic nineteenth-century artist. Although his career began auspiciously enough with his parents' blessing and financial support for study and travel, he never encountered teachers or patrons capable of nurturing his considerable talent to mature fruition. Eilshemius suffered the tragedy of being essentially a Romantic artist who made his entrance as the drama of that movement reached its denouement, and before the same impulses had been reenunciated as twentieth-century Expressionism.

Approaching Storm allegorically presages the turbulence of Eilshemius's life in its contrasts of light and dark, as clouds move to obscure the sunny landscape, and winds threaten to prematurely denude its growth. Although Eilshemius received scattered approbation from influential critics, and sold more paintings than many of his fellow artists, fear of failure and rejection progressively clouded his mind and turned his hand toward morose outpourings until, in 1921, he abandoned painting altogether.

One of eighteen paintings by Eilshemius in The Phillips Collection, *Approaching Storm* is painted with a charming, awkward directness appropriate to his nostalgia for uncomplicated rural life. The narrative is spun in a deliberately naive style evocative of eighteenth-century America, the tales of Washington Irving, and unblemished fields. Although Eilshemius had thorough academic training and used advanced color theories to portray light falling on a field, he always seemed to belong to a more gentle era.

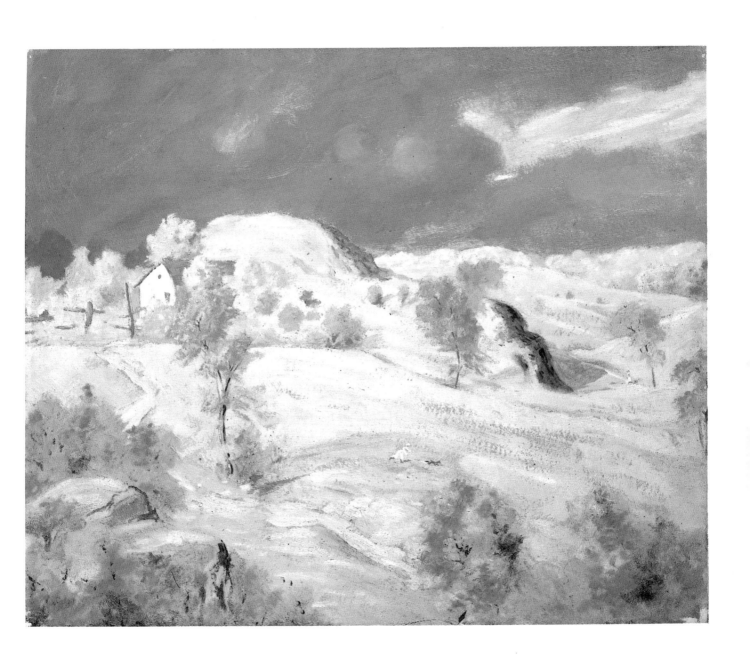

WINSLOW HOMER

b. Boston, 1836
d. Prout's Neck, Maine, 1910

Rowing Home

1890
Watercolor on paper
34.3 x 49.5 cm. (13½ x 19½ in.)
Acquired 1920

In spite of Winslow Homer's professed fondness for the hardships of winter life on the Maine coast, he would often escape to more benign climates when the cold became intolerable.

These three fishermen, rowing home with their catch in the warm glow of the setting sun, were observed on the St. John's River near Enterprise, Florida, during Homer's February 1890 vacation there. Like so many other artists fascinated with the recently invented portable Kodak camera (sold with the slogan "You Push The Button, We Do The Rest"), Homer photographed the activities on the river and used the prints as references for paintings. Some seven watercolors have been identified as related to photographs taken on this trip. Although many of these watercolors are composites or rearrangements of separate elements from the photographs, the Phillips watercolor and a nearly identical one in the Colby College Art Museum in Waterville, Maine, appear to be direct recordings.

Rowing Home, a tour de force of purist watercolor technique, shows no preliminary drawing. Homer deftly laid down two perfectly controlled washes and, with a few flecks of the brush, drew in the details. Due to the nature of the watercolor medium he must have finished the painting in no more than ten to fifteen minutes with, as Whistler once said, "the knowledge gained through a lifetime."

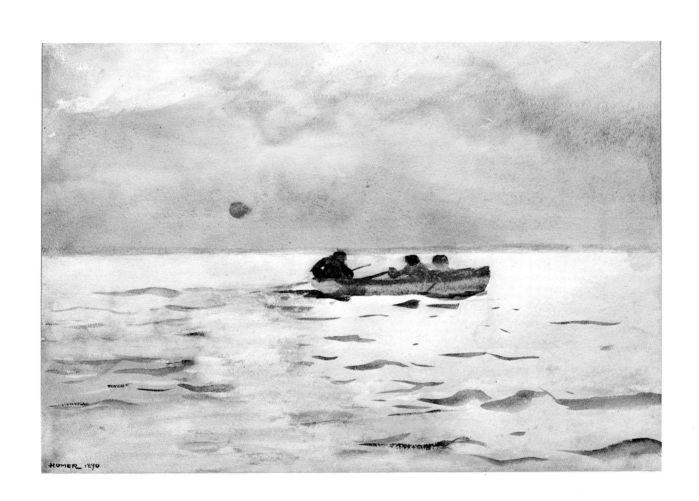

JOHN SLOAN

b. Lock Haven, Pennsylvania, 1871
d. Hanover, New Hampshire, 1951

The Wake of the Ferry II

1907
Oil on canvas
66 x 81.3 cm. (26 x 32 in.)
Acquired 1922

John Sloan, newspaper staff artist, pioneer developer of the Poster Style, organizer of exhibitions for dissident artists and American Indian crafts, contributor to Socialist publications, and—most important—a gifted painter and draftsman, was a major force in American culture for fifty years. Sloan shared with Edward Hopper (page 147) a determination to define "racial and territorial characteristics"; this impelled them to saturate themselves "in the spirit of our land until it oozes from our pens and pencils. . . ."

Sloan was one of the few painters who resisted the lure of the banquet years in Paris. While his colleague Maurice Prendergast exclaimed over the 1907 Cézanne retrospective, that he "gets the most wonderful color, a dusky kind of grey," Sloan stayed in New York, working on paintings for the forthcoming exhibition of "The Eight" at the Macbeth Gallery. The prospect of exhibiting without the intervention of a jury gave Sloan abundant energy and the sense of freedom necessary for him to complete some nineteen of his finest paintings during the months preceding the February 1908 opening. In *The Wake of the Ferry,* Sloan found in a bleak day his own excuse for wonderful greys of a more robust nature than the evanescent tones of Whistler (see page 133) or the subtle modulations of Cézanne. Here, as a masterly range of cool tones is set off against the rich plum skirt of the single figure, he builds a solid, architectonic structure of blacks, which gives the painting solidity.

In the final selection for the exhibition of "The Eight," *The Wake of the Ferry* was not included, and Sloan's more anecdotal paintings of street scenes, such as *Hairdresser's Window* and *Sixth Avenue and Thirtieth Street,* were chosen because an emphasis was placed on city scenes. However, in retrospect, *The Wake of the Ferry,* more than any genre painting, seems to embody the stern solidity of early twentieth-century Americanness.

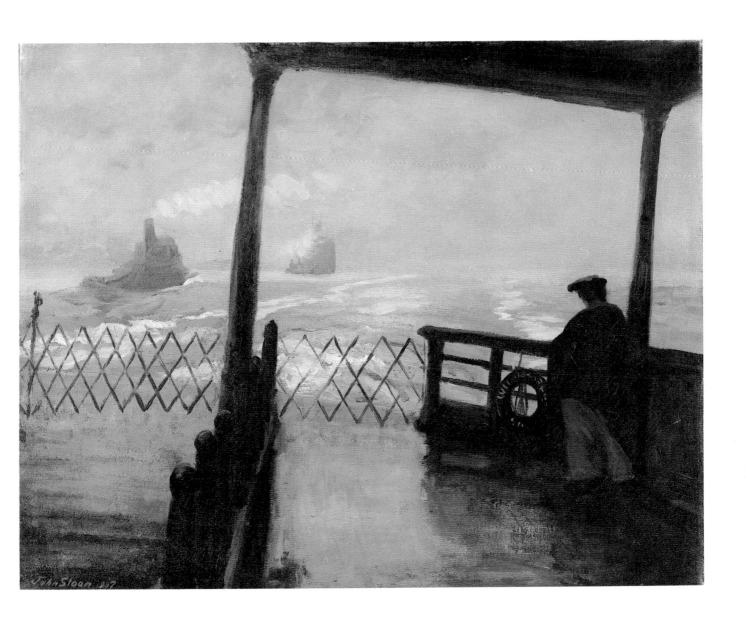

145

EDWARD HOPPER

b. Nyack, New York, 1882
d. New York, 1967

Approaching a City

1946
Oil on canvas
69 x 91.5 cm. (27⅛ x 36 in.)
Acquired 1947

Edward Hopper is the only artist among the so-called American Scene painters of the 1920s and 1930s whose work does not look somewhat quaint and provincial today. Hopper retains his appeal because he evokes rather than describes. In contrast to artistically loquacious painters who related minute details to particularize a regional landscape, Hopper was laconic.

Taciturn of speech as well as sparing of form, he was a man who seldom explicated his painting. He did, however, say of *Approaching a City* that he wanted to capture the fleeting sensation of "interest, curiosity, fear" one feels coming into a strange metropolis by train. "You realize the quality of a place most fully on coming to it or leaving it," he said. In the Phillips painting, Hopper summarizes all the conflicting emotions of apprehension and anticipation in a nearly abstract, broadly painted composition. His symbols—the darkness of a tunnel, anonymous windows without visible human occupation, and railroad tracks receding in exaggerated perspective—are universal metaphors for insecurity, alienation, and transience, and no hint is given of the identity of the city. Yet Hopper passionately believed great American art could only derive from uniquely American subject matter. He succeeds in making his city "feel" American by infusing it with sharp light, which articulates the simple planes of buildings and engineering projects. Hopper's city, vast, new, mass-produced, requires no "made in America" label.

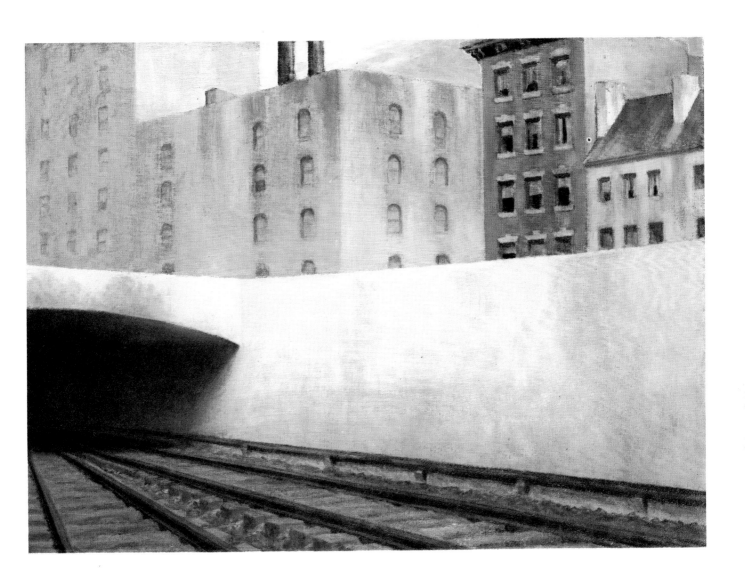

MARJORIE PHILLIPS

b. Bourbon, Indiana, 1894

Night Baseball

1951
Oil on canvas
61.3 x 91.8 cm. (24⅛ x 36⅛ in.)
Acquired 1952

In choosing *Night Baseball* as a subject, Marjorie Phillips seized the opportunity to capture in a single painting one of those moments she prizes in life and art—a moment that combines surprise with calm. Only the pitcher is in motion; Joe DiMaggio, at bat against the Washington Senators in Griffith Stadium during his last season with the fearsome Yankees, stands vibrantly poised for the throw. There seems to be a still over the crowd in the bleachers, and the ominous sky harbors a storm. The painting is alive with latent energy, yet classically static in balance. The overall cool palette and crisp drawing lend an objectivity to the recording of an instant that precedes frenzied activity and an emotional outburst. (One would not guess from this canvas that the artist, a passionate Senators fan, felt strongly about the outcome of the game.)

She has always eschewed self-expression in favor of recording the tempos and moods of life. Most frequently her lyric still-life, figure, and landscape paintings, which have been compared with the works of Berthe Morisot in line and with Bonnard in color, follow the Intimist tradition. *Night Baseball* marks a rare digression to impending drama on a large scale.

Peculiarly enough, few other American artists have dared to attempt to put the essence of our ubiquitous pastime on canvas. (Although the National Collection of Fine Arts owns a 1934 *Baseball at Night* by Morris Kantor, it has seldom been publicly displayed.) Marjorie Phillips has remarked on the phenomenon of "how few American artists have painted our national sport, when you think of Spanish artists' absorption with bull fighting, Degas's great horse-racing canvases . . . or equestrian subjects by the British." (*Christian Science Monitor*, October 9, 1971.)

At one time the Baseball Hall of Fame attempted to acquire *Night Baseball*. But, unlike the lamented Senators it depicts, the painting remains in Washington. Here, in a museum context, it is one of the most popular works in the Collection, sought out for both its documentary and aesthetic appeal.

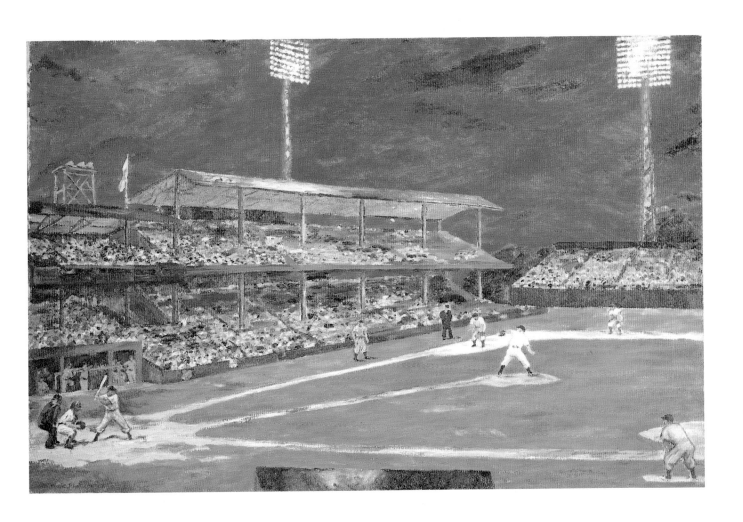

HORACE PIPPIN

b. West Chester, Pennsylvania, 1888
d. West Chester, 1946

Domino Players

1943
Oil on composition board
32.4 x 55.9 cm. (12¾ x 22 in.)
Acquired 1943

Duncan Phillips wrote to Horace Pippin's dealer in 1946: "Pippin, as you will agree, has two manners, one the decorative work of other primitives the world over, and the other the very intimate expression of Negro thought and imagination. . . . I prefer this second manner into which I feel he pours his greatest emotion and has more unique vision."

"Primitive" needs modification. Pippin's primitivism, like the Douanier Rousseau's, is a miraculously childlike vision sustained and disciplined without being dulled by a long professional career as a painter. It is the paradoxically sophisticated primitivism of an artist who retains his way of looking at the world out of conviction, rather than out of ignorance of mainstream conventions. Pippin's vision—his dream, as he called it—so overrode any concern for formal pictorial niceties that he was undaunted by loss of technical control when a sniper's bullet paralyzed his right arm during World War I. He returned to painting by simply placing the brush between his right fingers and pushing his arm around the canvas with his left hand.

Despite the somewhat awkward drawing and application of paint, pictures like the *Domino Players* stand with the best of American genre painting. Like the nineteenth-century painter William Sidney Mount, Pippin goes beyond the anecdotal recording of a homey pastime to elusively convey the mood, the thoughts, and even the cultural background of his subjects. He explained his process: "Pictures just come to my mind, I then tell my heart to go ahead."

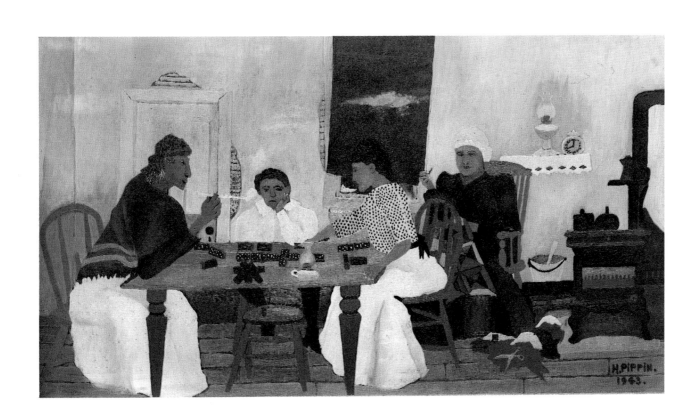

MAURICE PRENDERGAST

b. St. John's, Newfoundland, 1859
d. New York, 1924

Ponte della Paglia, Venice

1898–99 and 1922
Oil on canvas
71.1 x 58.4 cm. (28 x 23 in.)
Acquired 1922

Ponte della Paglia spans nearly the entire career of an American modernist painter who has always been outside the realm of easy categorization. Prendergast laid in the framework of this painting in monochromatic sepia tones during an 1898–99 trip to Venice. The view, looking left down the Grand Canal from a balcony of the Doges' Palace, corresponds exactly to one of the watercolors from the same date, and is his only known painting executed identically in the two mediums. He was infamous, however, for keeping canvases in his studio and reworking them from time to time over a period of years. Although the watercolor version was immediately exhibited along with other virtuoso depictions of *fin de siècle* Venice, the oil was not seen publicly until 1920, after Prendergast had become famous for frontal, tapestry-like overall compositions. In the intervening years, the painter had been influenced by the 1907 Cézanne retrospective and the Fauve exhibitions in Paris; in America he had shown with the group known as The Eight. He had also served on the committee of the landmark Armory Show, and had gained considerable success with the few early collectors of contemporary American art for creating a fantasy land where, as a critic remarked in 1908, "the sun shines in a curious manner, where color is wonderfully made manifest, where the people are careless about their drawing . . . and where everything is a jumble of riotous pigment."

It is not surprising, then, that a painter who had been accused of creating canvases which "look for all the world like an explosion in a color factory," would want to add brilliant accents to *Ponte della Paglia* before it entered The Phillips Collection in 1922. Prendergast wrote his dealer, John Kraushaar, asking to have the painting brought to the studio before it was sent to Washington explaining that he must "be thoroughly satisfied with it before I let it go." Recent inspection under ultraviolet light confirms the surmise that the areas of bright pigment which lead the eye from the fashionable procession over the bridge and back through the composition were added at the time of sale. The hiatus between beginning and completion explains the provocative juxtaposition of almost academic composition and masterfully carefree overpainting.

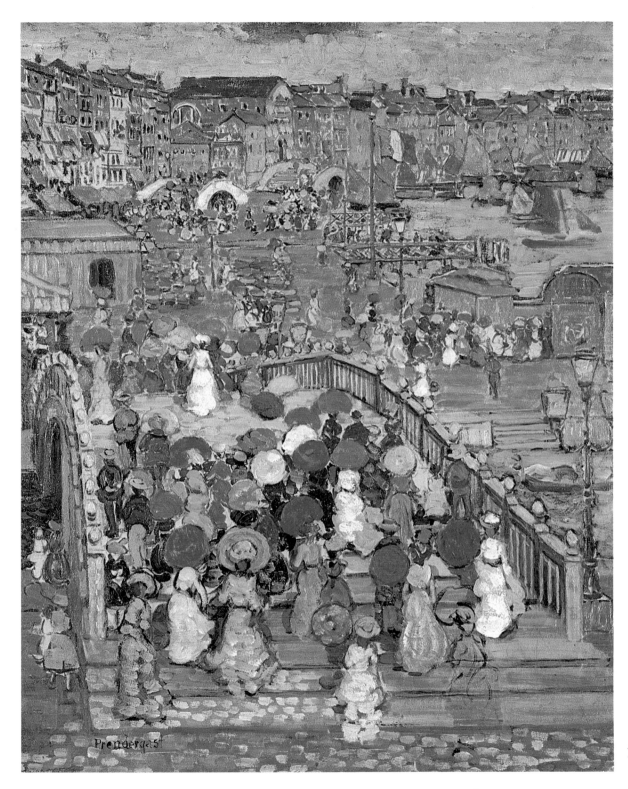

153

STUART DAVIS

b. Philadelphia, 1894
d. New York, 1964

Eggbeater No. 1

1927
Oil on canvas
68.6 x 97.2 cm. (27 x 38¼ in.)
Acquired 1939

Eggbeater No. 1 originated as part of a series of four compositions reworked in drawing, tempera, and oil, in which Stuart Davis meticulously worked out the premises of his modernist style. Seen in retrospect, Davis's evolution seems almost as inevitable and theoretical as Mondrian's development from landscape to abstraction. Like many other American artists, his earliest firsthand exposure to Post-Impressionism occurred at the 1913 Armory Show, where he admired the nonimitative use of color in canvases by Gauguin, Van Gogh, and Matisse. Davis slowly began his own experiments, methodically working his way through Synthetic Cubism, the contemporary aesthetics of Clive Bell, and modern color theory, before he felt himself to be abreast of the European avant garde.

In 1927, Davis nailed an eggbeater, a rubber glove, and an electric fan to a table in his studio. Chosen for their "non-arty" properties, they remained there as points of departure for more than a year while Davis painstakingly achieved three critical goals of modernism. First, he gained absolute control over subject matter by self-consciously introducing into each rendition of a subject some recollection of having seen it at other times from other angles. Second, he deliberately disregarded the local, observed color of the objects and imposed a color scheme determined by scientific systems. Finally, he "mentally simplified the objects and the space perspective into arbitrary geometric shapes and moved them around." (John Lane, *Stuart Davis: Art and Art Theory*, New York, The Brooklyn Museum, 1978, p. 17.)

In *Eggbeater No. 1*, very similar in composition to the paintings in the *Eggbeater No. 3* group, the forms of kitchen implements are totally abstracted and so monumentalized in a shadowbox-like space as to appear architectonic. Davis himself apparently thought of the paintings as interiors or street scenes, rather than as still lifes. *Eggbeater No. 1* is a night view, as the dark ground indicates, and may have been one of the two paintings Davis took with him to Paris in 1929 as a basis for his series of French street scenes.

155

GASTON LACHAISE

b. Paris, 1886
d. New York, 1935

Head of John Marin

1928
Bronze
36.8 cm. high (14½ in.), including
 marble base
Acquired 1930

Unless he particularly admired the sitter, Gaston Lachaise much preferred modelling the sweeping monumental forms of voluptuous, idealized women to taking likenesses. His great respect for John Marin manifests itself here in the most expressionist and immediate of all Lachaise's portraits. The artist thought of it as "the face of a man who had suffered, sacrificed and triumphed without vanity."

The second of fifteen casts (ten others are also in museums), this sculpture seems especially at home in The Phillips Collection, where Marin visited frequently and where twenty-six of his own works are housed (see, for example, pages 158–59). Aside from the sitter's personal contact with the museum, the sculpture, with its painterly surface, relates aesthetically—sometimes unexpectedly—to much of the collection. *John Marin* is frequently displayed brooding in a gallery dominated by Rouault's tragic *Circus Trio* (page 87), and the two works seem to share the doubts and laments so characteristic of early twentieth-century artists on both sides of the Atlantic.

Coincidentally, the French-born Lachaise's earliest memories were of the same circuses Rouault frequented. At five years of age he had been attracted not to the clowns but to the bareback rider—a "beautiful roun-bossomed and roun-heaped lady tossing herself gently up and down on a beautiful decorated horse galloping gently in circles." He never forgot the experience; aggrandized women became his most frequent and characteristic subjects. They were so prevalent in his work that when he showed portraits at Stieglitz's Intimate Gallery in 1927, a pleased and surprised public applauded the departure from the grand Venuses.

Nevertheless, most of the portraits from 1927–28 were as idealized and smooth-surfaced as the full figure sculptures. The cool, haughty head of Georgia O'Keeffe and other busts of acquaintances maintain the psychological distance of public monuments. In the head of Marin alone, Lachaise reveals his full expressive power in roughly modelled, craggy forms reminiscent of Rodin. The *Marin*, with its painterly surface, does not conform to the style or subject matter usually associated with Lachaise, but, as the poet E.E. Cummings wrote, "the artist creates . . . let criticism do its stumbling worst. In the case of Lachaise, before one has spoken one has been already ashamed."

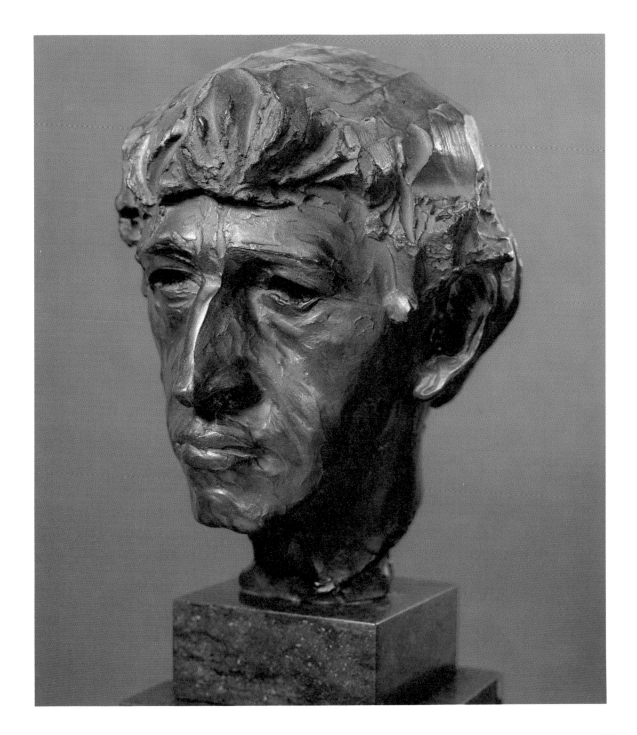

JOHN MARIN

b. Rutherford, New Jersey, 1870
d. Cape Split, Maine, 1953

Maine Islands

1922
Watercolor on paper
42.5 x 50.8 cm. (16¾ x 20 in.)
Acquired 1926

By 1922, Marin had received considerable critical acclaim and public acceptance. After an enormously successful January 1922 exhibition in New York, he planned a summer of boating and painting in Maine. However, he arrived to find his boat not working and his own abilities impaired by an attack of arthritis. As he wrote to Stieglitz, all the frustrations had given him a "don't give a dam feeling about most everything." But he added, "Maybe now I'll get a few things done. . . . The islands look more beautiful than ever."

This view of Maine islands, as if seen through a windowpane, mirrors both the beauty of the seascape and the Cubist and Futurist paintings Marin had studied in New York and Europe. He effectively made use of the device of a "frame within a frame" to create ambiguous space—the same trick of perception played on the eyes by the unique Maine light and atmosphere.

JOHN MARIN

Fifth Avenue and Forty-Second Street

1933
Oil on canvas
71.1 x 92 cm. (28 x 36¼ in.)
Acquired 1937

In 1931, Marin shocked many of his admirers with an exhibition of oils which hardly anyone found as beautiful as his vibrant watercolors. Nevertheless, he continued to experiment with oils, freely incorporating disparate techniques that a more traditionally grounded painter would have feared to attempt. It is a tribute to his infallible sense of design that *Fifth Avenue* holds together as a composition when the surface reads like a sampler for methods of paint application. Marin first drew in either ink or a very thin oil, and worked the middle section of the painting in washes, using patches of bare canvas to indicate white, as in a watercolor. Then, he painted the background with a variety of brushstrokes and used a palette knife for highlights in the sky.

159

KARL KNATHS

b. Eau Claire, Wisconsin, 1891
d. Hyannis, Massachusetts, 1971

Harvest

Ca. 1932–33
Oil on canvas
101.6 x 121.9 cm. (40 x 48 in.)
Acquired 1935

The art of Karl Knaths is exciting and satisfying. It celebrates the qualities and moods of nature, particularly the sea-washed clarity of light on Cape Cod, where he settled in 1919 and lived the year round until his death in 1971. In some ways Knaths was like Thoreau, whom he admired, with the sea his Walden Pond. His painting is semi-abstract, but its source in nature is always decipherable. His style certainly derives from Cubism, which he absorbed from his sister-in-law, who had studied with Albert Gleizes in Paris, but the nature-poet in Knaths finds expression in freer and more open rhythms.

Knaths grew up in Portage, Wisconsin. His desire to be a painter came from his father's reminiscences of the great paintings he had seen in the museums of Dresden and Munich before his emigration from Leipzig to America. After high school it happened that the Pulitzer Prize-winning novelist and playwright Zona Gale, who lived and worked in Portage, introduced him to the director of the Milwaukee Art Institute, who advised Knaths to study at the Art Institute of Chicago. In 1912, Knaths entered the Institute, where he studied for the next five years. When the famous Armory Show of 1913 came to the Art Institute, the excited but baffled student seized upon Cézanne as the most "profound" of the artists he saw there.

At the end of his study, Knaths moved to New York, and, later, to a fishing village on Cape Cod. In Provincetown he found his real spiritual home. The time was a Golden Age of the arts in America, and Provincetown was a microcosm of it.

Harvest, an early work, is vigorous and robust in its treatment of the American Thanksgiving theme. There is interplay of the curvilinear with the rectangular, and dramatic but subtle color. The orange pumpkin, red apples, yellow corn, and green bench sing out against the greys. The shapes are simplified and defined by dark calligraphy. The mauve and grey shed interior is broken by a window showing outside light. This rectangle is answered by the crock with its bird decoration and by the whites in the feathered body of the turkey. Broad and exhilarating swinging movements animate the surface and are finally resolved into equilibrium.

There is more than a hint of drama and Expressionist intensity in Knaths's work. But insistence upon order and structure outweighs all other considerations. Knaths often spoke of "measures" related to music and its intervals, and of "tonalities" drawn from the color circle—a large area taken from one segment with a smaller proportion of a dissonant drawn from an opposite segment. As an aid to setting up a particular palette, he used detachable color chips of the Ostwald color system. Recognizing the limitations of theories, however, he went beyond their confines to create a dynamic but always lyrical art celebrating the joy of the senses.

J.G.

161

ARTHUR G. DOVE

b. Canandaigua, New York, 1880
d. Huntington, New York, 1946

Flour Mill Abstraction

1938
Wax emulsion on canvas
66.1 x 40.6 cm. (26 x 16 in.)
Acquired 1938

Arthur Dove's transformation from successful New York magazine illustrator to impoverished farmer and painter of controversial abstractions was triggered by his decision to visit Europe in that vintage year for European art, 1907. In Paris he saw the Cézanne retrospective and Fauve painting at its most dazzling, and, through expatriate American friends, was introduced to Matisse. When he was not looking at exhibitions, Dove worked in the south of France, developing his own style of "simplified" Impressionism.

Nature and the rural landscape were always critical nutrients for Dove's creative growth. When he returned to America in 1909, he began the process of reducing forms found in nature to increasingly broad areas of pure color—a process that soon led him to virtually nonrepresentational painting. In investigations coincidentally parallel to the work of Marc (page 105) and Kandinsky (page 107) in Germany, Dove abstracted from organic forms progressively less recognizable images, until the paintings became "Nature Symbolized."

Dove's *Flour Mill Abstraction,* like *Cows in Pasture* (page 164), evolved from a landscape painting, through several metamorphoses, to become an abstraction. Dove frequently worked his ideas out through a progression of small sketches and, when he was nearly satisfied, would enlarge the composition mechanically by means of a pantograph, or would use a magic lantern to project the image onto the final canvas. Six small abstract paintings from 1910, which were never exhibited during his lifetime, are the first evidence of this conceptual process. In spite of using laborious means, Dove could impart a sense of spontaneity to the final canvas. *Flour Mill* is unusual in having no vestige of horizon line or sense of deep landscape space; the painting looks as if the fresh yellows, blues, greens, and earth colors had been quickly applied in quantities governed only by the shape appropriate to the hue. The seemingly arbitrary geometric forms here tempt historians to laud Dove as a harbinger of Abstract Expressionism and, because the colors float on a neutral ground, as a forerunner of the stain paintings of Morris Louis (page 201) as well.

Yet Dove, even at his most two-dimensional, his most formally abstract, retains an almost mystical tie to nature. His is an art of transformation rather than invention: Dove did not juxtapose yellow with brown simply for the color harmony; he filtered sunshine and earth.

163

ARTHUR G. DOVE

Cows in Pasture

1935
Wax emulsion on canvas
51.1 x 71.6 cm. (20$\frac{1}{8}$ x 28$\frac{3}{16}$ in.)
Acquired 1936

164

Dove wanted to extract and set forth the essence of nature. *Cows in Pasture,* with its interlocking forms, demonstrates his way of seeing animals and landscape interrelated and integrated, as chords in what he called "music of the eye."

Dove's search for essence—for specific equivalents to general, universal rhythms of life and the workings of nature—followed the scientific method of microscopically examining parts in order to understand the whole. Although there is no evidence to indicate that he used photographic techniques in his work, the similarity of *Cows in Pasture* to the close-up photography practiced by Stieglitz suggests a possible collaboration between these two close friends.

GEORGIA O'KEEFFE

b. Sun Prairie, Wisconsin, 1887

Ranchos Church

Ca. 1930
Oil on canvas
60.9 x 91.4 cm. (24 x 36 in.)
Acquired 1930

Arthur Dove's _Nature Symbolized_ pastels in the 1916 Forum Exhibition of Modern American Painters made a vivid impression on Georgia O'Keeffe at a time when, as she said, "I found I could say things with color and shapes that I couldn't say in any other way." O'Keeffe had just strongly protested Stieglitz's unauthorized hanging of her first abstract drawings at his "291" gallery because she regarded them as too personal and tentative. When she saw Dove's pastels—characterized by vaguely biomorphic shapes reminiscent of particles seen through a microscope—O'Keeffe immediately felt an affinity to the older artist's method of deriving autonomous forms from nature.

Ranchos Church, like Dove's _Flour Mill Abstraction_ (page 163), is one of a series extracted from multiple experiences of a single subject. Painted during O'Keeffe's first year in the stark highlands of New Mexico, The Phillips Collection version of the Taos church, blanched in midday light, is reduced to a few architectonic forms. Other paintings in the series enlarge details of the church beyond recognition, further exemplifying the methodology shared by O'Keeffe and Dove. **165**

AUGUSTUS VINCENT TACK

b. Pittsburgh, 1870
d. Deerfield, Massachusetts, 1949

Aspiration

Ca. 1931
Oil on canvas
194.3 x 344.2 cm. (76½ x 135½ in.)
Acquired 1932

At the apex of a successful career as a portraitist and muralist, Augustus Vincent Tack began to experiment with what he called "motion" or "mood" studies. To break the drawing habit of his well-trained hand, he enlarged photographs of the desert until recognizable images disappeared, and selectively traced the outlines onto canvas as a matrix for delicate color relationships. As such titles as *Aspiration* indicate, however, Tack never thought of these canvases as abstract. For him, a Roman Catholic imbued with Symbolist aesthetic, color was a rich language for voicing the mysteries of God, nature, and human emotion.

Initially, Tack had no idea that these private paintings would ever sell or even be seen outside his studio, but he and Duncan Phillips had great respect for one another's judgment. Phillips elected to exhibit some of Tack's figurative religious paintings and reported to him in a letter of 1924, "Your meaning baffles many. . . . It is significant that the [abstractions] are appreciated in the proper way whereas the compositions with figures with their compromise by the representation and abstraction cause dissatisfaction." Phillips's enthusiasm for the abstract works led him to commission an entire group for possible use as architectural decoration of the gallery in the museum where concerts are now held. Although the plans for remodelling the building to house the murals permanently were never carried out, the studies frequently are hung as easel paintings.

After being virtually ignored outside of Washington for many years, Tack's paintings have recently attracted considerable attention, and attempts have been made to link him to the history of American landscape painting. Tack would laugh heartily at the very idea, for although the contours of his forms were initially derived from photographs of nature, he himself was much more preoccupied with the celestial than the mundane.

167

PIET MONDRIAN

b. Amersfoort, Holland, 1872
d. New York, 1944

Painting No. 9 (Composition in Black, White, Yellow, and Red)

1939–42
Oil on canvas
79.4 x 74 cm. (31¼ x 29⅛ in.)
Acquired 1953, Katherine S. Dreier
Bequest

Every Mondrian painting is a link to another. While each single painting was kept in the artist's studio for endless adjustments until the perfect equilibrium between line, color, plane, and interval was found, Mondrian always thought of a finished canvas merely as part of a progression. As his friend and biographer, Michel Seuphor, explained, "He painted only because he believed that painting could be improved; each work had to be an advance over the previous one." (Seuphor, *Piet Mondrian: Life and Work*, New York, Abrams, 1956, p. 198.) Mondrian was quite satisfied to ask of a painting that it represent "even a little step forward." *Composition in Black, White, Yellow, and Red* occasions a great step forward, a step toward the pure-color, jazz-inspired *Boogie Woogie* canvases painted at the very end of his life.

When Mondrian came to New York to escape the German Blitz of London, he managed to have nine or ten unfinished canvases sent after him. Three of these had been started in Paris in 1936 and 1937, and the others in London in 1938 or 1939. One by one, he finished the paintings over the next three years, adding a second date when he was satisfied that some progress had been made.

This work (identifiable by the standard Seuphor numbering system as c.c. 417) is the first in the series incorporating colored lines unbounded by black. The red band crossing over the three black horizontals, the three red connecting bars, and even the lower yellow area, which begins to function more as line than plane, presage the use of color in two important paintings which have come to be known as *Trafalgar Square* and *Place de la Concorde*. In other words, *Painting No. 9*, although it has previously been overlooked in Mondrian literature, is the true primogenitor of the wholly colorful *Broadway Boogie Woogie*.

Katherine Dreier, who had been purchasing Mondrians since a 1926 trip to Paris, bought the canvas at the first and only one-man show ever accorded him during his lifetime, which was held in January–February 1942, at the Valentine Gallery in New York. Mondrian wrote her on February 19, 1942, "I am glad to hear my picture pleases you and would like to come and see it hang." Dreier left the painting to The Phillips Collection as a tribute from one pioneer collector to another.

168

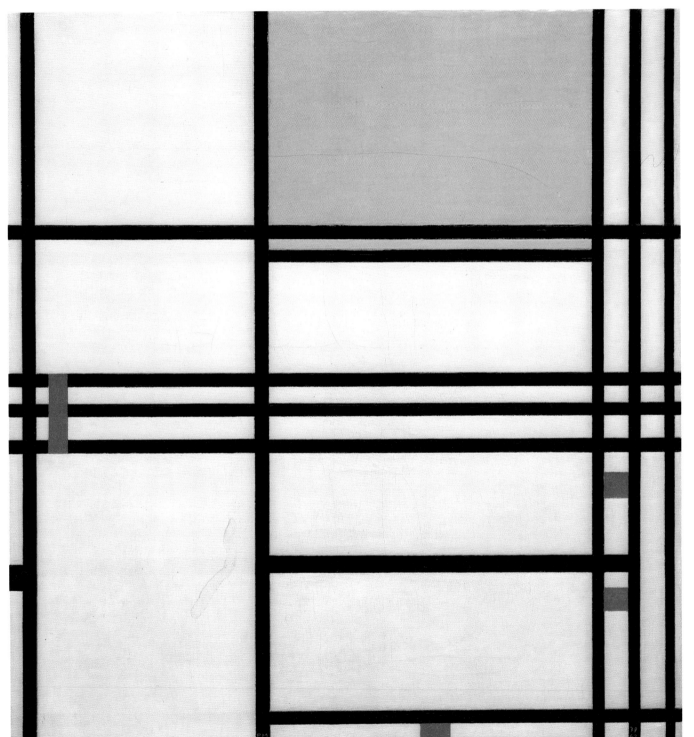

169

ALEXANDER CALDER

b. Philadelphia, 1898
d. New York, 1976

Helicoidal Mobile-Stabile

Ca. 1932
Painted metal and wire
Approximately 65.4 cm. high
 (25³/₄ in.)
Stabile alone, 22.8 cm. high (9 in.)
Acquired 1953, Katherine S. Dreier
 Bequest

After a visit to Piet Mondrian in 1930, Calder put aside his wire caricatures for nonrepresentational sculptures painted in primary colors. The first of these, shown in 1931, were stationary and hence called "stabiles" by Jean Arp, for their semblance of being firmly rooted in place. But Calder could not long resist animating his abstract forms. Just as his famous 1926 circus troupe had performed stunts to delight the Paris art world, contraptions powered either by motor or by hand charmed visitors to his 1932 exhibition at the Galerie Vignon. More like idiosyncratic living organisms than machines, the first movable sculptures prompted Marcel Duchamp to borrow the rarely used term from metaphysics "mobile" to lastingly designate these "bodies in motion or capable of movement." Calder recalled discussing the title with Duchamp: "I asked him . . . what sort of a name I could give these things and he at once produced 'mobile.' In addition to something that moves, in French it also means 'motive.' "

Duchamp may also have had a further role in naming the Phillips mobile *Helicoidal.* One of Calder's earliest experiments in delicately balancing sculptures to move of their own accord on currents of air rather than mechanically, *Helicoidal Mobile-Stabile* originally belonged to Katherine Dreier, founder, with Duchamp, of the avant-garde Société Anonyme, Inc. He had advised her to give the organization a name that she thought meant "Anonymous Society," but which actually translated as "Incorporated, Inc." By the same token, he would have relished "helicoidal," a word so obscure and unwieldy that it sounds invented, but one that actually has very specific meanings in mathematics and zoology. According to the Oxford definitions, the title gives an appropriate dualism to this life-infused little conceit of steel and wire. It can be construed either according to mathematical usage, to describe the helical motion of the sculpture's arms as they dip and turn, or in zoological parlance, to signify that the sculpture is snail-like in its slow pace. Calder, Duchamp, and Arp would all be pleased with the conundrum.

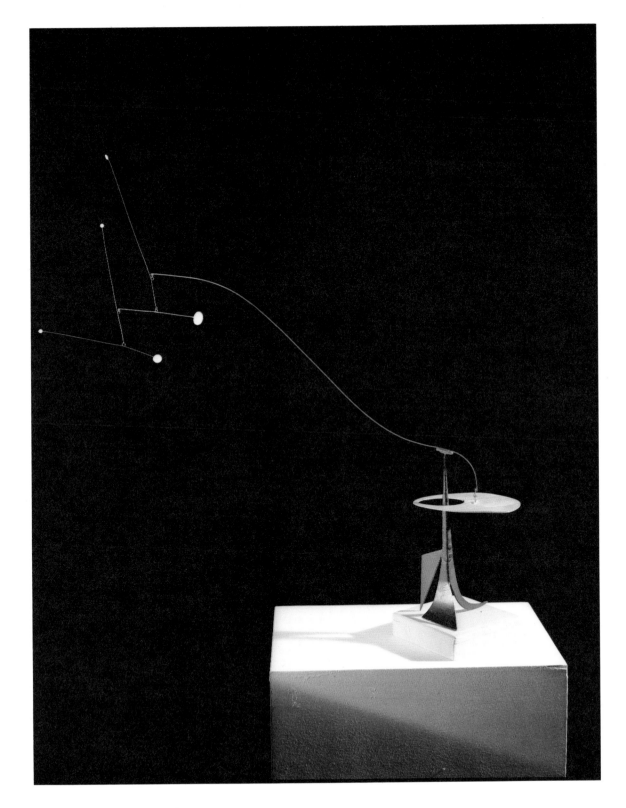

171

JACOB LAWRENCE

b. Atlantic City, New Jersey, 1917

The Migration of the Negro, Panel No. 1

1940
Tempera on masonite panel
30.5 x 45.7 cm. (12 x 18 in.)
Acquired 1942

Like the second-century carvers of Trajan's Column, Jacob Lawrence has chronicled the upheaval of his people, their tragedies and few triumphs during a period of crisis and turmoil.

The title of Panel No. 1, *During the World War There Was a Great Migration North by Southern Negroes*, states the theme for Lawrence's narrative cycle of sixty small tempera paintings. The titles of the other panels continue: "In every town Negroes were leaving by the hundreds The Negroes were given free passage on the railroads The Negro was now going into and living a new life in the urban centers food had doubled in price Due to the South's losing so much of its labor, the crops were left to dry and spoil Another cause was lynching There had always been discrimination And the migration spread.... some communities were left almost bare The labor agent also recruited laborers to break strikes In many cities in the North where Negroes had been overcrowded in their own living quarters they attempted to spread out. This resulted in many of the race riots and the bombing of Negro homes The Negroes who had been North for quite some time met their fellowmen with disgust and aloofness And the migrants kept coming."

Deceptively simple in both verbal and visual presentation, *The Migration of the Negro* came out of Lawrence's serious study of Black history and his artistic training. He has acknowledged influences from such disparate artists as Brueghel, Diego Rivera, Clemente Orozco, and Arthur Dove. William Saroyan was his friend during their years on the WPA. He was a successful magazine illustrator (the *Migration* series was, in fact, published in *Fortune* magazine). But to be the first artist to enunciate Black social and cultural history required the most direct declarative grammar—a kind of visual literacy of which Lawrence was a master.

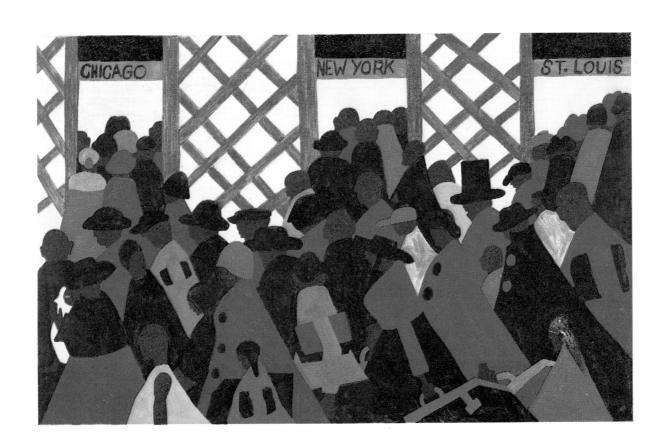

173

HENRY MOORE

b. Castleford, England, 1898

Figures in a Setting

1942
Watercolor, ink, and crayon on paper
36.2 x 51.4 cm. (14¼ x 20¼ in.),
 mat opening
Acquired 1946

While journalists kept track of the Battle of Britain in the skies over London, Henry Moore recorded civilians waiting out the bombings on the platforms of underground stations. As he watched families and friends communally warmed under hastily gathered bedclothes, he saw similarities to his interpretation of human form in his reclining figures. He also saw these frightened groups as both pitiful and heroic.

Too circumspect to violate their privacy, he discreetly observed them, making an occasional notation, and later generalized the nightmare into surreal drawings for his government-commissioned *Shelter Sketchbooks*. The Phillips drawing, a poignant document of the Blitz, exaggerates the scale of the subway station, transforming it into mysterious arches and endless space, classicizing the drapery to make a timeless, universal comment on human helplessness.

Family Group

1946
Bronze
44.4 x 33.7 x 21.9 cm. (17½ x 13¼
 x 8⅝ in.)
Acquired 1947

In 1945, after spending the latter years of the war on his *Shelter Sketchbooks*, Moore returned to sculpture. The *Madonna and Child* project, begun in 1943 for the Church of St. Matthew in Northampton, was finally unveiled and Moore now took the opportunity to expand on the family theme that had begun with this commission, and which he had developed further in the wartime drawings.

The Phillips Collection *Family Group,* with its mother, father, and two children rather than the more usual two figures, is one of the most complex of seventeen versions of this theme. These studies eventually led to an edition of four monumental sculptures now located at the Barclay School, Stevenage, the Tate Gallery, London, the Museum of Modern Art, New York, and the Nelson D. Rockefeller Collection.

Like many artists of his generation, perhaps most notably his colleague Barbara Hepworth, Moore spent his early career discarding Renaissance conventions and seeking new ways to interpret forms from primitive art. He has sought, as he said, "to react to form in life, in the human figure, and in past sculpture." *Family Group* reflects Moore's search at one of its most intense moments. Prior to this, Moore had carved in wood and stone. Bronze, then a relatively new medium to him, offered the possibility to express more fluidly the deeply felt experience of family closeness during the crisis of World War II.

174

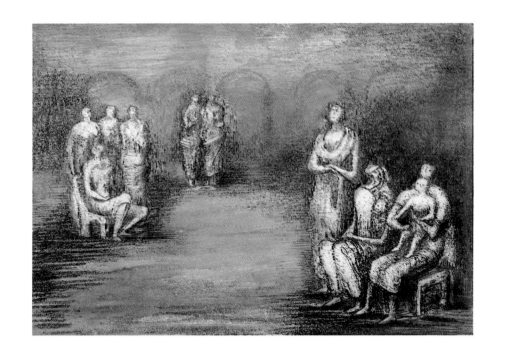

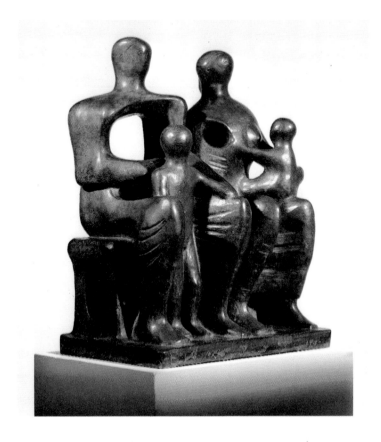

JOAN MIRÓ

b. Barcelona, 1893

The Red Sun

1948
Oil on canvas
91.1 x 71.1 cm. (35⅞ x 28 in.)
Acquired 1951

Joan Miró, the most enduring of the Surrealist artists, first visited the United States in 1947, in order to execute a mural commission in Cincinnati. His reputation had preceded him and he had already had enormous influence on such American artists as Adolph Gottlieb and Mark Rothko, who had adopted Miró's Surrealist automatism and mysterious primitive symbols for their own purposes.

New York exhilarated Miró, especially because he had spent the war years in total seclusion; the size and vitality of the city struck him, as he said, like "a blow to the solar plexus." He spent eight months there working on the Cincinnati mural and also began several relatively large canvases. The Red Sun may well have been conceived while the mural was in progress, for it has a similarly clear organization of relatively few, simple forms and the intense colors he associated with the city.

As if he could not make the black ominous enough by ordinary means, he poured it on the canvas in thick layers, until it was built up like a relief—threatening to the touch as well as to the eye. But Miró always juxtaposes opposites in his work, and the impish face of the rising eminence bodes more humor than harm. The red sun hangs as a powerful symbol, but, like the forms in the lower right, it is a symbol to be interpreted in each viewer's own psyche, for Miró's iconography can not be clearly decoded. We do have a clue, however, to the source of the walking object/person by knowing that, when Miró returned to Europe from America, he carried a collection of windup toys he had purchased from sidewalk vendors.

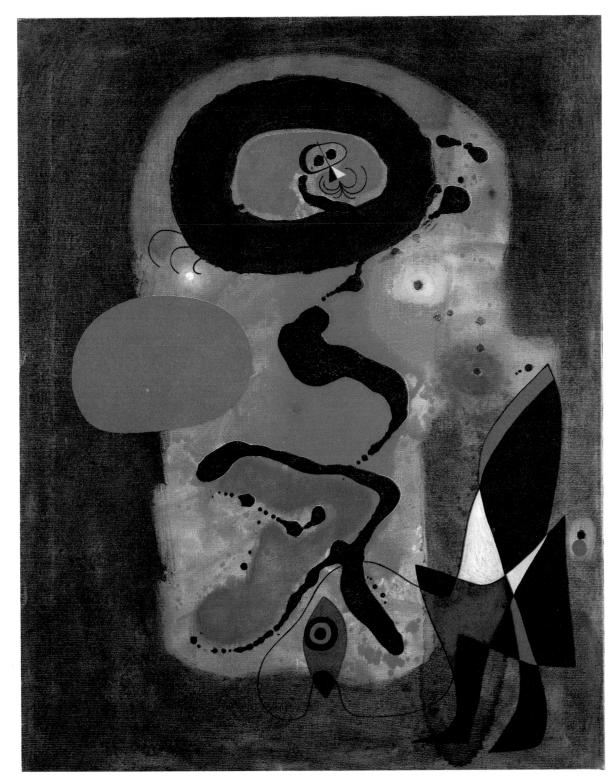

177

JACKSON POLLOCK

b. Cody, Wyoming, 1912
d. East Hampton, New York, 1956

Collage and Oil

1951
Oil and paper collage on canvas
127 x 88.9 cm. (50 x 35 in.)
Acquired 1958

If this elegant collage had been more typical of the style of the artist whom contemporary critics deprecatingly called "Jack the Dripper," and the "killer of easel painting," it would probably never have found its way into The Phillips Collection. Although the comparison has never been made elsewhere, Duncan Phillips, who had passed over the "heroic" Pollock canvases, purchased this collage because he said it reminded him of Vuillard. The almost oriental delicacy of the black drawing on rice paper harmonizes with subtly orchestrated color chords reminiscent of Bonnard and the Intimists. Pollock's use of over-all patterns and strong areas of black, and his concern with texture, have much in common with Vuillard in particular. Oddly enough, if one looks at Pollock's work in the context of Post-Impressionist Intimist painting, one can find a new way of perceiving paintings that were once thought of as an assault on the senses.

Pollock, together with Robert Motherwell, first experimented with tearing and clipping paper in 1943, when Peggy Guggenheim invited them to participate in a collage exhibition at her newly opened "Art of This Century" Gallery. Although the show led to a contract with the gallery and his first one-man exhibition the following November, Pollock only sporadically returned to the medium.

Then, in January 1951, exhausted after a large and successful show, Pollock wrote to a friend, "I have really hit an all time low—with depression and drinking—NYC is brutal. . . . I hope this letter doesn't seem so damned down and out—because I have been making some drawings on rice paper and feel good about them." He incorporated some of the drawings in this collage, gluing them to a ground painted in the single color he was using at the time, and then dripped calligraphic swirls of paint over the surface.

After their 1943 collaboration, Motherwell had remarked on Pollock's intense concentration and his enjoyment in savagely clipping and searing paper as they progressed. Here, in the physical activity of tearing and re-forming, Pollock seems to have found release from his anguish into an almost oriental statement of tranquillity.

178

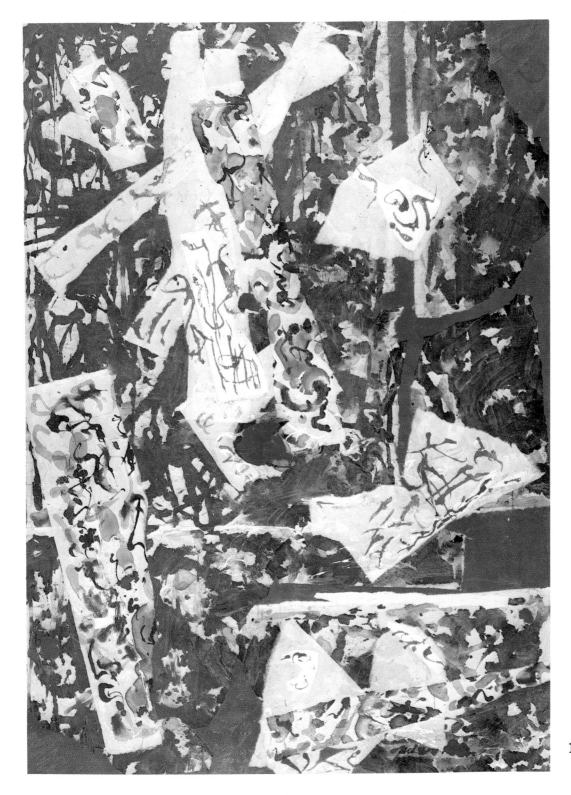

179

MILTON AVERY

b. Altmar, New York, 1893
d. New York, 1965

Girl Writing

1941
Oil on canvas
121.9 x 81.3 cm. (48 x 32 in.)
Acquired 1943

Milton Avery remains something of an anomaly among twentieth-century American artists—an intimist for whom paint was a means of expressing his love of the familiar in a nonspecific vocabulary. He translated his sense of people, places, and the things he knew best into planes of characteristic color and light without the intrusion of distracting detail.

Girl Writing, generalized into large simplified forms and broad color planes, conveys the natural awkwardness of a child laboring over her lessons. Given the ingenuous color and tender treatment of the gawky figure, it comes as no surprise to know that the sitter was Avery's nine-year-old daughter, March, preoccupied with her schoolwork, as seen through the eyes of an affectionate father.

Avery's wife and daughter, his friends, calm seas, still lifes, sea gulls, and other such traditional and homely subjects remained grist for his painting, although he was mentor to some of the painters most determined to aggrandize American avant-garde painting after World War II. Mark Rothko, speaking at Avery's funeral in 1965, called him an "anchor" to younger artists and said: "Avery is first a great poet. His is the poetry of sheer loveliness, of sheer beauty. Thanks to him this kind of poetry has been able to survive in our time. This—alone—took great courage in a generation which felt that it could be heard only through clamor, force, and a show of power. But Avery had that inner power in which gentleness and silence proved more audible and poignant."

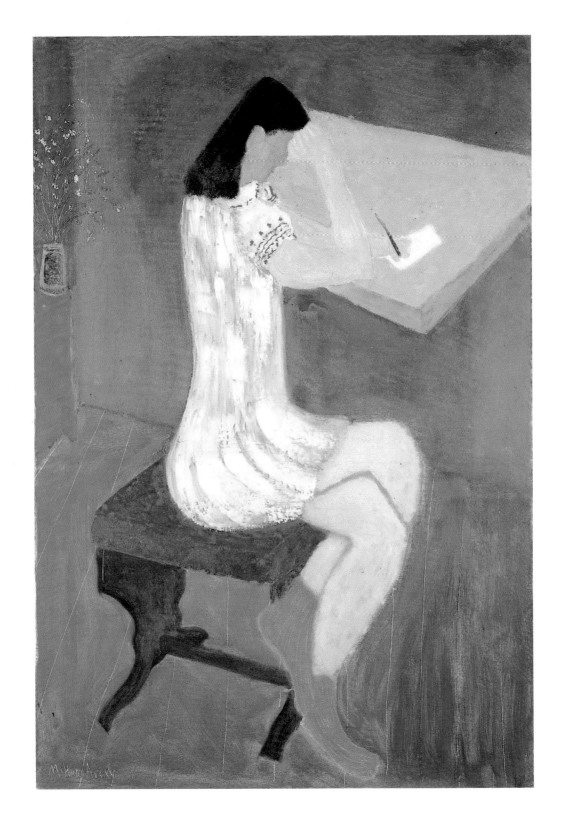

181

MARK ROTHKO

b. Dvinsk, Russia, 1903
d. New York, 1970

Green and Maroon

1953
Oil on canvas
231.8 x 139.1 cm. (91¼ x 54¾ in.)
Acquired 1957

In their famous joint letter to *The New York Times* in 1943, Rothko and Gottlieb averred, "We favor the simple expression of complex thought. We are for the large shape because it has the impact of the unequivocal. We wish to reassert the picture plane. We are for flat forms because they destroy illusion and reveal truth." Ironically, although Rothko formulated his mature style on this premise, the ephemeral colors which hang weightlessly in their own misty atmosphere seem anything but flat. Western painting, by definition, has always been an equivocal art of illusion. Rothko's canvases are no exception in that simple planes of color play tricks on visual perception as they advance and retreat—sometimes billowing out like fog. Nevertheless, by sheer genius and will, he imbues simple fields of hovering color with the "impact of the unequivocal."

The authentic experience of Rothko's art requires direct confrontation. It is best felt (Rothko's works somehow act on all the senses) in the presence of more than one canvas, isolated from other distractions. The artist first saw the potential for heightened sensations emanating from a group installation of paintings in 1960, in a collaborative effort, he, the director, and the assistant director of The Phillips Collection designed for the museum a carefully proportioned, smallish room with dramatic light raking over four canvases. There *Green and Maroon, Ochre and Red on Red, Orange and Red on Red*, and *Green and Tangerine on Red* hang in a sanctified atmosphere that later inspired a commission of Rothko paintings for the Rice University Chapel in Houston. Once having seen his paintings in the Phillips environment, Rothko insisted, whenever he could, that his canvases be similarly presented in a manner that would enhance their mystical and metaphysical essence.

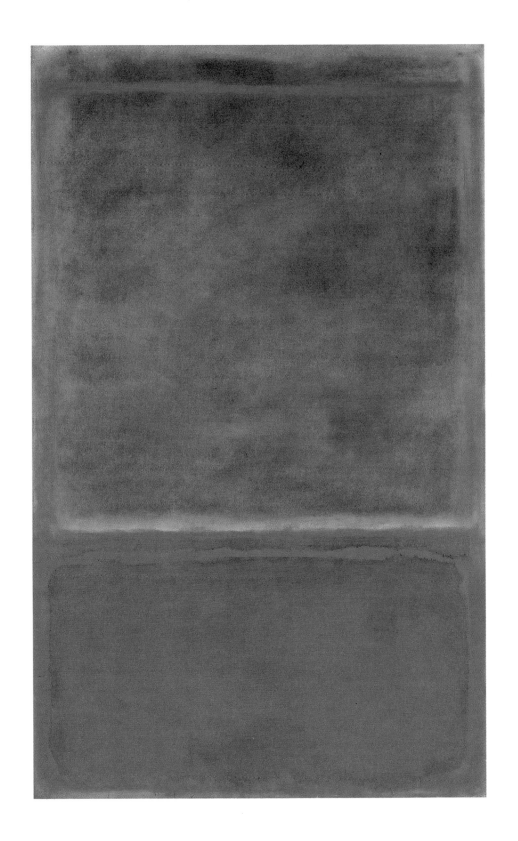

183

WILLEM DE KOONING

b. Rotterdam, 1904

Ashville

1949
Oil on board
65.1 x 81 cm. (25⅝ x 31⅞ in.)
Acquired 1952

Ashville is a misspelling of Asheville, North Carolina, the city where Willem de Kooning bought artist's supplies during the term he taught at Black Mountain College. The title also obliquely identifies the painting as a souvenir of that particular summer in the Blue Ridge mountains, a summer which all the painters, dancers, musicians, writers, and students present remember as a time of unparalleled camaraderie. Josef Albers had come to Black Mountain in the 1930s, bringing his Bauhaus experience to the designing of an environment which would encourage artistic cross-fertilization. By 1949, disparate though the sensibilities of de Kooning, Peter Grippe, John Cage, Buckminster Fuller, and their equally independent-minded students sometimes were, these artists had come to share a sense of mission, a unity of purpose.

There is a meshing of media and forms in *Ashville* very like the atmosphere of temporary alliance the artists felt at Black Mountain. Here, the loopy black line, melded with sensuously applied pastel paint, evokes the agreeable sense of harmonious well-being Matisse associated with *luxe*. There is none of the slashing line or frantically urgent brushwork that began to dominate de Kooning's paintings of tormented women the following year. In *Ashville*, de Kooning reconciles his two great, but often incompatible, talents for working in both a painterly and a linear manner. By the same token, he literally disproves the adage "oil and water don't mix" by drawing in ink washes on paper, then painting with juicy emulsions of pigment. *Ashville* appears in books both on de Kooning's drawings and on his paintings, raising the question, "What is the definition of each?" The work may, in fact, have begun as a drawing. The artist Vivi Rankin, student and friend of de Kooning, remembers a show of similar drawings held in the dining room of Black Mountain College but can't be sure whether or not *Ashville* was among them. Whatever the origins, whatever the label assigned it, *Ashville* is one of de Kooning's most satisfying, most resolved—in short, most beautiful—works.

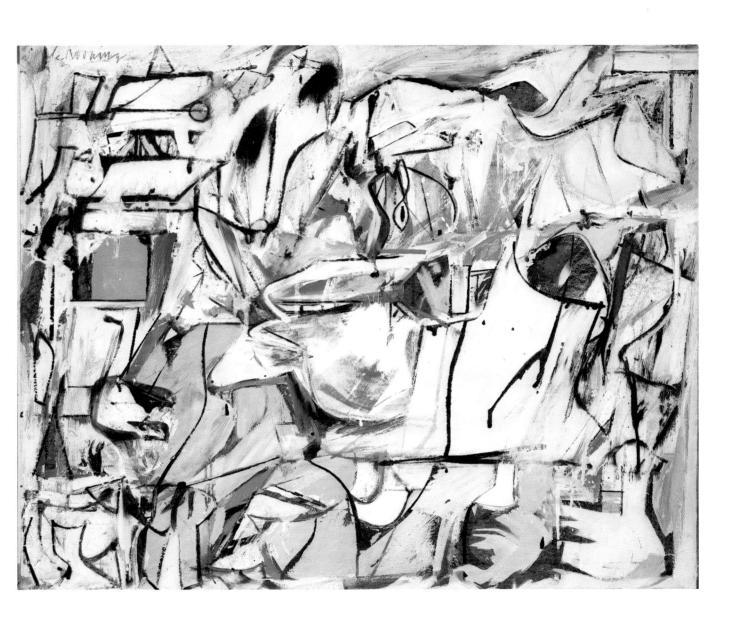

CLYFFORD STILL

b. Grandin, North Dakota, 1904
d. New York, 1980

1950 B

1950
Oil on canvas
212.7 x 171.1 cm. (83¾ x 67⅜ in.)
Acquired 1969

Of the eighteen self-proclaimed "Irascibles" who protested the conservatively selected 1950 "American Painting Today" exhibition at the Metropolitan Museum, no one lived up to the name as fully as Clyfford Still. Apocalyptic in his written and painted prophecies, he was aptly called one of the Four Horsemen (along with Rothko, Pollock, and Newman) by the sculptor Tony Smith. Subsequently, Still renounced his early associates and the entire contemporary art world along with all the "sterile conclusions of western European decadence." In the 1952 Museum of Modern Art *Fifteen Americans* catalogue, he wrote of his need to walk "straight and alone," and in 1961 he removed himself from the maelstrom of New York City to rural Maryland, where he resided for the rest of his life.

The craggy forms and roughened surfaces of Still's canvases have often been interpreted as abstract remembrances of the rugged western landscape Still knew as a youth. He always denied that his work contained any more than a coincidental formal and textural similarity to mountains and precipices; he did talk, however, of the need for man to be measured against the highest peaks.

If any of Still's paintings can be called lyric, *1950 B* fits the description. It was painted during the year in which he began to release himself from the harsh color and dense, overall impasto surface that characterized his earlier work. Here the introduction of purple and bits of bare canvas around the red area and at the lower right allow breathing space in the painting. It is as if Still felt he had finally "crossed the dark and wasted valley and come at last into clear air and could stand on a high and limitless plain."

186

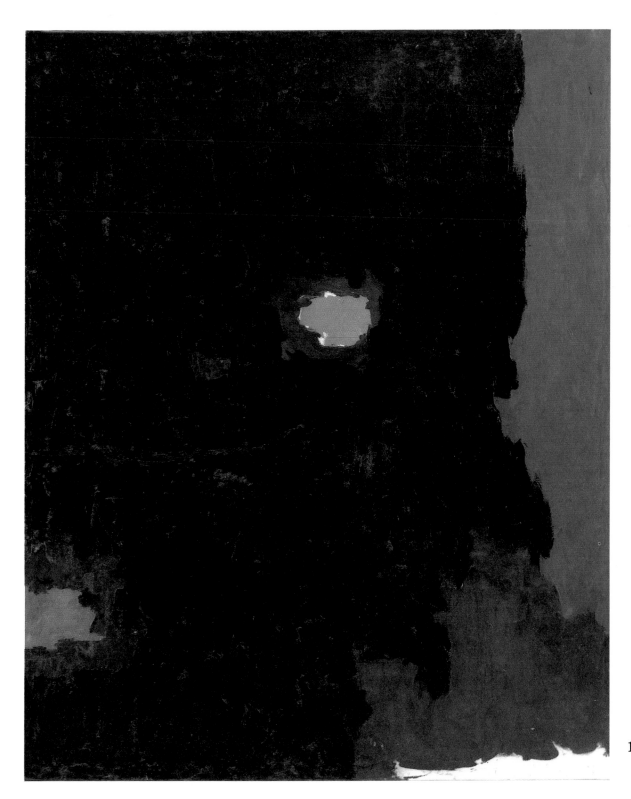

ADOLPH GOTTLIEB

b. New York, 1903
d. East Hampton, Long Island, 1974

The Seer

1950
Oil on canvas
151.8 x 182 cm. (59¾ x 71⅝ in.)
Acquired 1952

The Seer, one of a series of paintings Gottlieb called "pictographs," reflects all of the Abstract Expressionists' fascination with primitive art and Jungian psychology. As Rothko and Gottlieb wrote in a 1943 *New York Times* manifesto, "We assert that . . . only that subject matter is valid which is tragic and timeless. That is why we profess spiritual kinship with primitive and archaic art."

The early pictographs were monochromatic with symbolic forms compartmentalized in black-lined grids which owe a debt to Mondrian. By 1950 Gottlieb had loosened his compositions to emphasize color and a painterly handling of the surface. *The Seer* at the left looks out with a single all-seeing eye and appears again at top center as a visionary interpreting the universal symbols arrayed below. The underlying structure has been almost obliterated.

The Seer highlights a turning point in Gottlieb's career. Soon after its completion, he began working on progressively larger canvases moving inevitably toward the great bursts of floating color for which he was ultimately best known. The artist himself rediscovered the importance of the pictographs during a 1968 retrospective exhibition when, seeing a number of them together on the wall for the first time, he said, "I never realized how powerful they were."

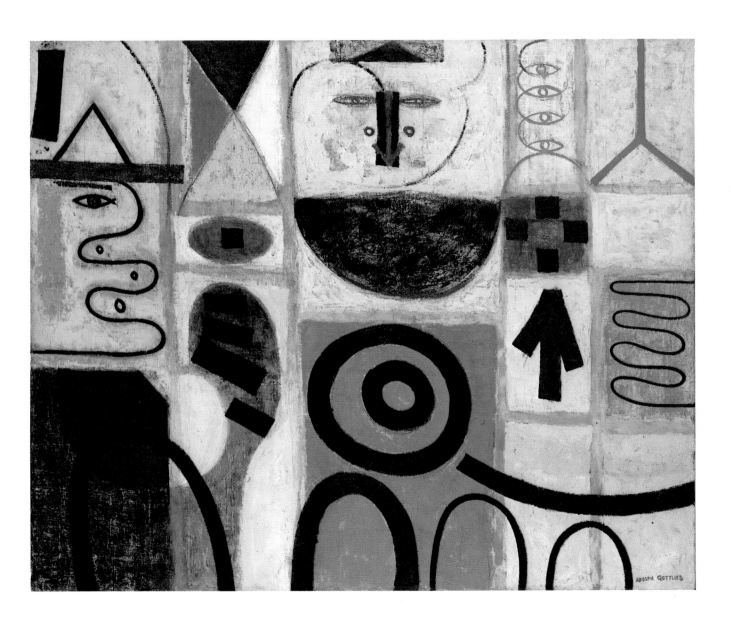

BRADLEY WALKER TOMLIN

b. Syracuse, New York, 1899
d. New York, 1953

Number 9

1952
Oil on canvas
213.4 x 200.7 cm. (84 x 79 in.)
Acquired 1957

Bradley Walker Tomlin had more in common, both temperamentally and aesthetically, with Robert Motherwell and Philip Guston than with any of the other Abstract Expressionist artists. Most notably, they shared a sensitivity to color and a continued admiration for older European art, even as they delved into their subconsciouses to hunt for a new formal means of expression. Tomlin may have learned the technique of automatism from Motherwell, or he may have studied it earlier, at that time in the 1930s when he was attracted to Surrealism. In any case, sometime in the late 1940s, the method led him away from Cubist painting to a linear, calligraphic style of writing which looks as if it might be a decipherable code. The writing then became progressively simplified until, in such canvases as *Number 9*, the painted marks carry no connotations to anything other than pure color and pictorial space.

Contrary to the energetic appearance of the finished painting, Tomlin worked slowly and meticulously, weaving brushstrokes into a tapestry of ingratiating colors. Unfortunately, the pretty color and overall coherent pattern of Tomlin's paintings led to a misunderstanding and to the end of a close friendship he had had with Adolph Gottlieb. Although Gottlieb later admitted to possibly having been a "little wrong," Tomlin remained wounded by the accusation that he was "decorative," which, in the artistic jargon of the time, implied mindlessness. It was no wonder that such a highly cognitive artist as Tomlin took offense; even when he had been most deeply immersed in automatism, he had never made an impetuous mark on the canvas. He elaborated a motif as if he were composing a classical symphony from a few notes, building and relating elements with almost mathematical precision.

Four years after Tomlin's premature death, Guston described him in the catalogue for a Whitney Museum exhibition as a man who was "not at all hesitant, firm, yet not presuming, wondering did he dare continue the already experienced or must he begin all over again? [A man whose] temperament insisted on the impossible pleasure of controlling and being free at the same moment."

190

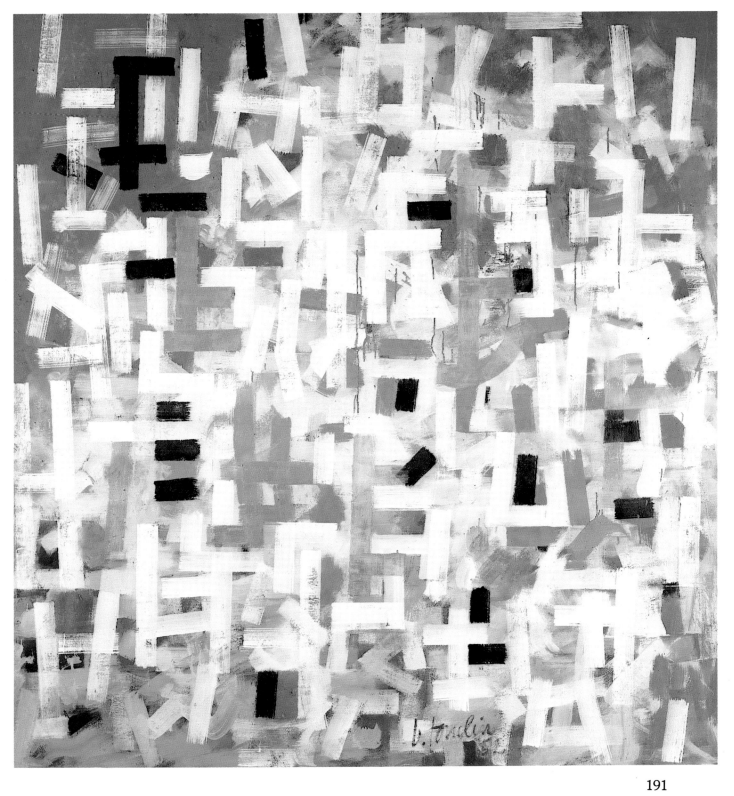

PHILIP GUSTON

b. Montreal, 1913
d. Woodstock, New York, 1980

The Native's Return

1957
Oil on canvas
164.8 x 192.8 cm. (64⅞ x 75⅞ in.)
Acquired 1958

Philip Guston always unabashedly admired Italian Renaissance painting, especially the work of Masaccio, Mantegna, Uccello, and Piero della Francesca. Their influence is obvious in the murals he painted during the 1930s, when he was employed on Federal Arts Projects, and surfaced again during the last years of his life, in his solidly constructed representational paintings. In 1951, however, Guston said, "The desire for direct expression finally became so strong that even the interval necessary to reach back to the palette beside me became too long; so one day I put up a large canvas and placed the palette in front of me. Then I forced myself to paint the entire work without once stepping back to look at it."

This approach to the canvas, and the artist's impatience, may account for Guston's clustering of forms near the center of paintings, at approximately eye level. His color, on the other hand, bespeaks a distant vision of Mediterranean light on bougainvillea growing against whitewashed walls. Guston always quoted and paraphrased from art history and from his own experiences. The title, *The Native's Return*, may refer to the year Guston spent in Italy from 1948–49, implying the artist's identification of himself as a spiritual native of that land. His palette glowed with pinks, blues, and rosy reds on his return—to such an extent that a critic quite accurately called him an Abstract "Impressionist"—until about 1954, when greys and blacks began to impart a brooding atmosphere to his paintings.

The Native's Return comes from a brief period in Guston's career when his sensibility was most closely linked to Bradley Walker Tomlin's lyricism. But, as Tomlin wrote prophetically just before his death, "the simple truth about the matter of links is if they are any good at all they break." Before long, Guston honored the value of his nonbinding link with Tomlin, moving on to a different mode of expression, without rejecting the once-close kinship.

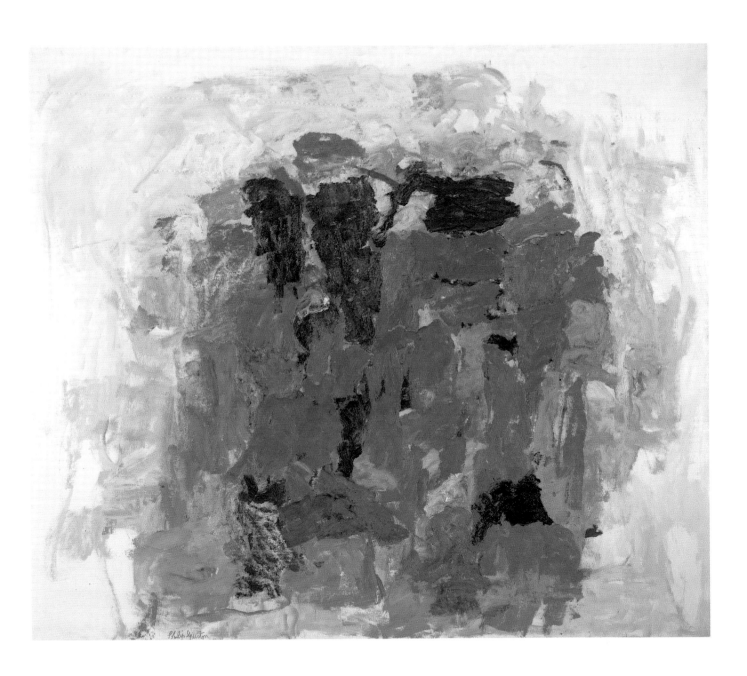

193

ROBERT MOTHERWELL

b. Aberdeen, Washington, 1915

In White and Yellow Ochre

1961
Oil and paper collage
104.1 x 68.6 cm. (41 x 27 in.)
Acquired 1965

Robert Motherwell and Bradley Walker Tomlin were of that minority of Abstract Expressionist painters who found European art of the recent past compatible with their newly asserted Americanness. During World War II, jingoism made the elegance of French art suspect, and the description "late Cubist" applied to Motherwell, had pejorative implications of decadence. Nevertheless, his devotion to Surrealist methods of automatism and images from Symbolist poetry was unswerving.

From the time of his first collaboration with Jackson Pollock, assembling collages in 1943, Motherwell enthusiastically embraced the traditionally French Cubist medium as congenial to both his aesthetic and his working method. The rapidity with which paper could be torn and rearranged allowed many juxtapositions to be considered without long waits for paint to dry. He could also introduce chance as a factor in his design, as had the Surrealists, by dropping paper to the floor and accepting any fortuitous arrangements that happened to occur. But while he accepted chance as a valid means of arriving at a design solution, he qualified its importance: "There is no such thing as an 'accident' really; it is a kind of casualness.... One doesn't want a picture to look 'made' like an automobile.... I agree with Renoir who loved everything handmade."

Over the years, Motherwell's collages reflect the same concerns manifested in his paintings. *In White and Yellow Ochre* followed a series of paintings each titled *Spanish Elegy* and two "monster" canvases in which the central oval image functions as a Cyclops's eye. Here, the ocular form, a torn piece of Russian newspaper printed with theater reviews with a painted "pupil," stares out of the collage, with what Motherwell calls "the monstrous ambiguity of an artist's situation."

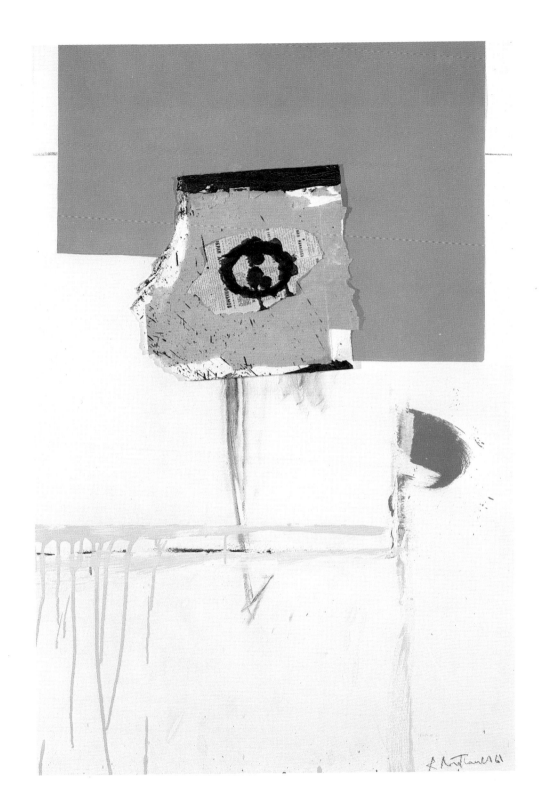

NICHOLAS DE STAËL

b. Leningrad, 1914
d. Antibes, 1955

Fugue

1952
Oil on canvas
80.6 x 100.3 cm. (31³/₄ x 39¹/₂ in.)
Acquired 1952

The affinity between this vibrant, rhythmically structured painting by Nicholas de Staël and Cézanne's late *Jardin des Lauves* (page 81) was noted by Duncan Phillips soon after he acquired *Fugue* in 1952. As in Cézanne's painting, a curious impression of space and light emerges from an ordered patchwork of colors. This manifest interest in evoking effects of space and light, achieved through a nonfigurative arrangement of forms and colors, attests to the emergence of what has been called "abstract impressionism" in post-World War II Parisian painting.

Indeed, although perhaps not to the same degree as in the *Jardin des Lauves,* one has a distinct feeling that a scene from nature has inspired this compact mosaic of perfectly modulated, balanced lozenges of color. De Staël used his distinctive pictorial language to abstract from nature variations of light, form, and color. In recalling a scene, he divested it of the conceptual structures through which the mind habitually filters optical sensations; he wanted to record an unmediated experience of space and light, somewhat in the manner of Monet, who once advised a student:

> When you go out to paint, try to forget what objects you have before you, a tree, a house, a field, or whatever. Merely think, here is a little square of blue, here an oblong of pink, and paint it just as it looks to you . . . until it gives your own naive impression of the scene before you.

In fact, de Staël did not consider his nonfigurative paintings as abstractions and always insisted upon the links between his work and visible reality. Not surprisingly, soon after completing *Fugue,* he began to paint in a simplified, figurative style.

A nonfigurative yet highly evocative painting such as the present work lends itself to a wide range of interpretations. To Duncan Phillips, *Fugue* seemed "a desert city of sunbaked walls . . . in an iridescent sky-blue Morocco, a memory of de Staël's years in the Foreign Legion." The fact that this image can be construed as a "naive impression" of some exotic townscape is due in no small part to the directly associative power of de Staël's masonlike build-up of the paint surface, which is at some points almost an inch thick.

The accumulation of layer upon layer of heavily trowelled paint suggests that de Staël proceeded intuitively, and attempted to recover and recreate a special experience of space and light in the very act of painting itself. This process results in a surface that asserts through the tactile sense the rugged presence of crudely hewn stonework.

R.C.C.

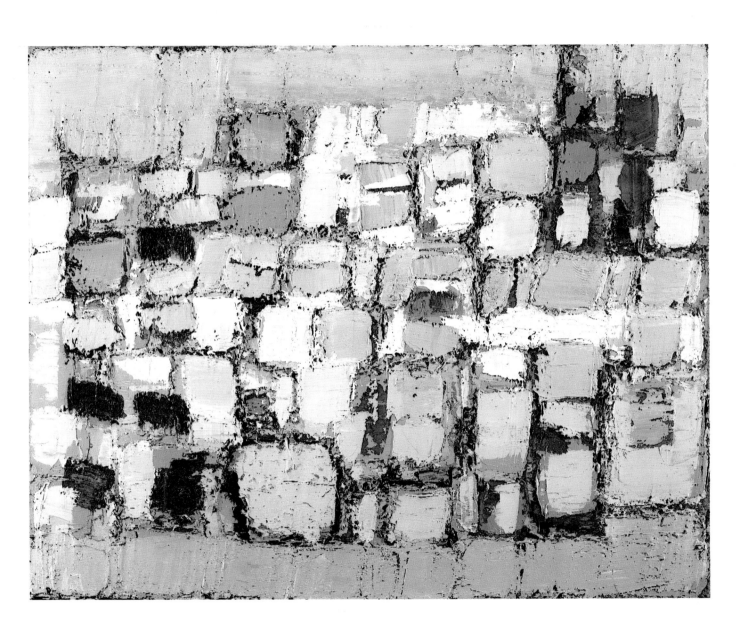

197

SAM FRANCIS

b. San Mateo, California, 1923

Blue

1958
Oil on canvas
122.9 x 88 cm. (48³/₈ x 34⁵/₈ in.)
Acquired 1958

Sam Francis's exuberant atmospheric color paintings of the 1950s bespeak a hedonistic approach that distinguishes his work from the usually harsh, anxiety-ridden canvases of the first-generation Abstract Expressionists, Willem de Kooning and Jackson Pollock. Absent also from Francis's work is evidence of the grave metaphysical concerns that disciplined Mark Rothko's ultimately iconic color fields.

Indeed, Francis's embrace of one of the strongest traditions in French art—a joyous and unrestrained love of color and light as revealed by the works of Monet, Bonnard, and Matisse—was demonstrated by the artist at the outset of his career. In 1950, having obtained a master's degree in art from the University of California at Berkeley, Francis bypassed New York and moved to Paris, where, for almost seven years, he painted, fraternized with European and American artists and critics, and absorbed the impact of such French masterpieces as Monet's *Nympheas* at the Orangerie.

In Paris, Francis evolved his individualistic style in a series of abstractions—radiant color matrices—in which cooler, close-valued, cell-shaped forms coalesce, and are subsumed in a diaphanous haze, through which more irregularly shaped patches of warmer color occasionally burn.

Francis, surely one of the most peripatetic artists of all time, visited Japan in 1957, and the increasingly important role that unpainted white surfaces play in his work no doubt reflects a response to traditional Japanese painting, in which blank areas are often used to create an impression of breadth, space, and luminosity.

In *Blue*, the use of blank areas is most prominent at the corners of the canvas, where they subtly orient the variegated, buoyant mass. This seems to float up, across, and off the upper right-hand corner of the field—an effect enhanced by the fact that the edges of the canvas appear to cut off from view the totality of the soaring, dripping, color phantasm.

R.C.C.

198

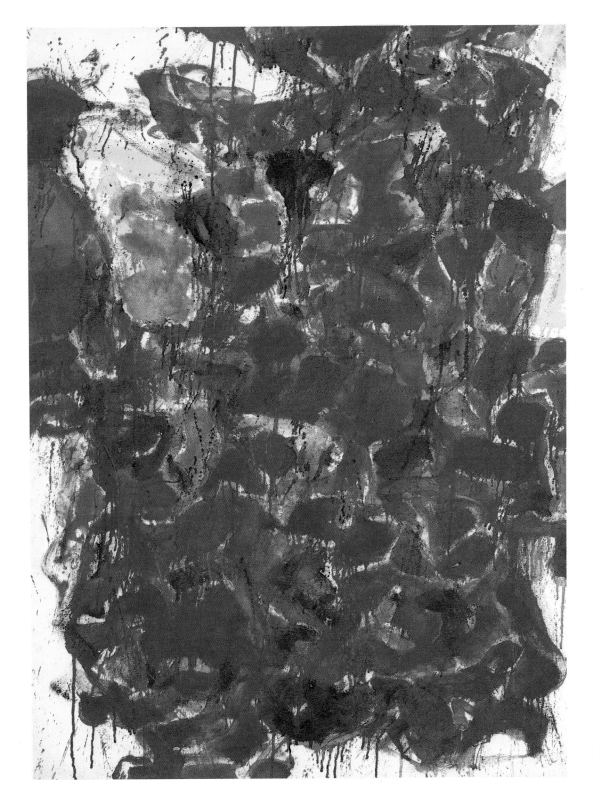

199

MORRIS LOUIS

b. Baltimore, 1912
d. Washington, D.C. 1962

Number 182

1961
Acrylic on canvas
208.3 x 83.9 cm. (82 x 33 in.)
Acquired 1963

When Morris Louis first saw Pollock's drip paintings he was awed: he tried the technique, discarded it, and realized that imitators of pioneer Abstract Expressionists could not sustain the power of the originals.

Striking out in search of a new direction, he was one of a handful of Washington, D.C. artists who believed they had more chance to find an independent path if they blinded themselves to the course of New York painting. Louis, especially leery of being seduced by the juicy paint and bravura drawing of artists like de Kooning, avoided exposure to current exhibitions by staying home in the city that was commonly referred to during the 1950s as "a cultural wasteland." In The Phillips Collection, however, he found an oasis where he could nurture his artistic growth. There, under the tutelage of Bonnard, Renoir, Cézanne, and Matisse, he seems to have realized his own predilection for color as the dominant element in painting. There also, the paintings of Augustus Tack would have shown him at least one way to hold colors in unobtrusive, anonymous forms.

In their own time, these masters had been daring, and even shocking, in their use of unfettered color. Now Louis needed to set color free of arbitrary line, to deny the physical presence of pigment, or distracting composition, in order to carry painting another step forward. Whether or not the darker edges of overlapping color should have the value of line is a fine point.

Although, because Louis never shared secrets, it is impossible to pinpoint exactly when and how he made his discovery, sometime in the late 1950s he found a solution to his dilemma. By staining paint into canvas, he fused image and support. Other than the report of a privileged visitor to his studio that "there wasn't a brush in sight," and the conjecture to his colleague Kenneth Noland that he may have used a putty knife to spread syrupy ribbons of paint, there is no documentation of his working process, and no one knows how the flaring pillars of *Number 182* and paintings like it came into being. Whatever his precise method, he impregnated unsized, or partially sized cotton duck canvas with pure, brilliant acrylic pigments in order to obliterate all distinction between color and support. In other words, instead of following traditional methods of painting construction, in which the canvas is sealed off and then layered with pigments dissolved in a medium, Louis stained the color into the fiber itself. This technical change makes the integrated color appear to hang in the air of its own accord.

Number 182 has always been hung vertically, so that the rocket-like color-thrusts rush upward in a high-velocity trajectory. It is worth noting, however, that Louis gave his permission to hang the series sideways for a different effect; seen as laterals, the ribbons of color are stilled—hanging like vapor trails in the atmosphere.

201

RICHARD DIEBENKORN

b. Portland, Oregon, 1922

Interior with View of the Ocean

1957
Oil on canvas
125.6 x 146.1 cm. (49$\frac{3}{8}$ x 57$\frac{1}{2}$ in.)
Acquired 1958

In 1955, just as Richard Diebenkorn's Abstract Expressionist canvases were gaining recognition and respect, he became apprehensive that the very freedom of the style would lead him to gestural excesses. As he said, "I came to mistrust my desire to explode the picture and super-charge it in some way."

Diebenkorn stabilized his art within a geometric framework by painting what he saw and what he remembered seeing. *Interior with View of the Ocean* takes its yellow triangles from the crisp San Francisco light of his studio; the vertical window opening up the picture space to a glimpse of landscape pays homage to the Matisse painting *Studio, Quai St. Michel* (page 83), which he had studied years before as a Marine stationed near Washington. When the painting was first exhibited at the Oakland Art Museum exhibition of "Contemporary Bay Area Figurative Painting," Diebenkorn said, "I think what is . . . important is a feeling of strength in reserve—tension beneath the calm." Here, the tension is spatial—a sensation of deep and flat space felt simultaneously.

When his figurative paintings first appeared they distressed Diebenkorn supporters as being a retrogressive shift in direction. The artist assured them that he did not rule out a return to abstract painting if the time came when it felt appropriate to him. The time did come in 1967, when he embarked on a series of *Ocean Park* paintings, which are more formal and controlled than the early work. In retrospect, the use of recognizable subject matter to impose order on his compositions seems a right and inevitable part of Diebenkorn's consistent development.

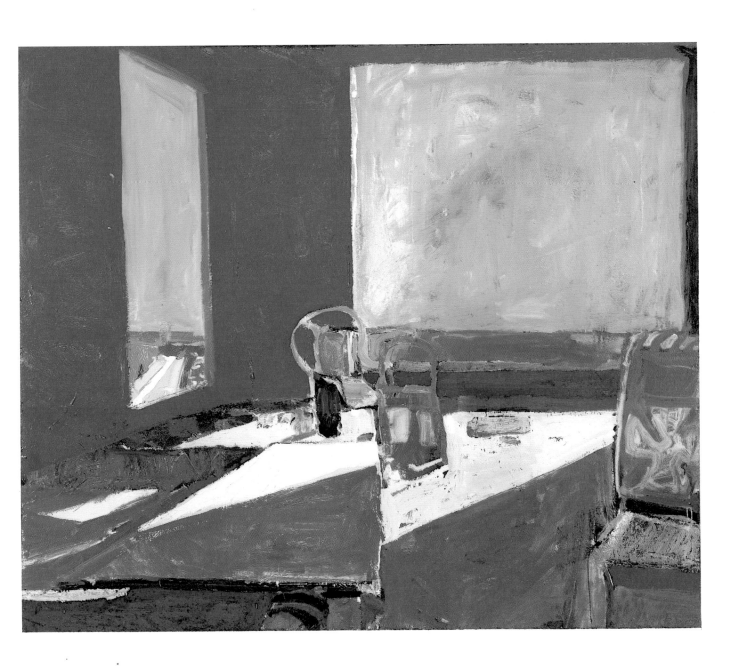

BEN NICHOLSON

b. Denham, Buckinghamshire,
 England, 1894

Zennor Quoit 2

1966
Oil on carved pavatex
123.9 x 267.3 cm. (48¾ x 105¼ in.,
 framed measurements)
Acquired 1967

In an art collection notable for its emphasis on singing color, Nicholson's *Zennor Quoit 2* hums quietly. As the artist explained, "I have the impression that many people think of color as 'bright' color, but what is more beautiful than the natural 'inner' color of wood and stone? At any rate there must be available the full range of color from that of stone or wood to the brightest and most pungent color imaginable." *Zennor Quoit 2*, named for a neolithic passage-grave in Cornwall, evokes the "inner color" of stones and the ritualistic formality of primitive stone construction, suggesting the passage from sunlight, through an antechamber, to darkness.

Nicholson, the most celebrated English painter of his generation, formulated his style on the tenets of Synthetic Cubism, and never deviated far from the standards he had set for himself as a young man as his art moved from illusionary shallow space to shallow relief.

The artist described this work as "very horizontal. It's abnormally long and narrow and for that reason [it is] exciting to try to solve [the compositional problem]." His solution—with white bands like cracks of light crossing the passage, and an almost centered blue rectangle opening up a hypnotically infinite space—has, as does all his work, a sense of inevitability.

It is not surprising that Nicholson remembered having an astonishing feeling of quiet and repose after meeting Mondrian in the 1930s, for the artists shared a passion for equilibrium. As Nicholson said, "I don't want to achieve a dramatic arresting experience . . . but something more enduring."

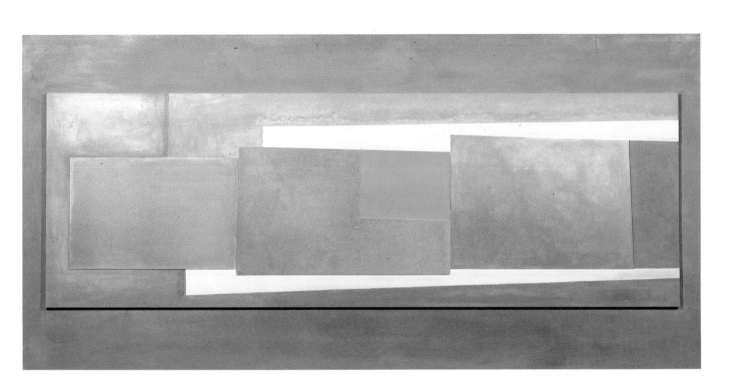

205

FRANK STELLA

b. Malden, Massachusetts, 1936

Pilicia II

1973
Relief collage of mixed media
249 x 279.5 cm. (98 x 110 in.)
Acquired 1974

Frank Stella admits that he has never been "very good at making things come out representationally." By virtue of his age and environment, he grew up concerned primarily with the theory and practice of abstract painting. He first studied the work of Arthur Dove, Mondrian, and Hans Hofmann at the Phillips Academy, Andover. By the time he graduated from Princeton, Stella had absorbed Abstract Expressionist techniques and ideas, and, as he said, had finished imitating "the intellectual and emotional processes of the painters I saw."

The revolutionary black paintings of 1958 to 1960, which, Stella said, "forced illusionistic space out of the painting at constant intervals by using a regulated pattern," shocked even the most adamantly avant-garde critics by their reductive severity. Then, just as they were being accepted, Stella drastically changed his approach to painting.

In 1970, he once again relaxed the rules he had set for himself in the brilliantly colored *Protractor* series, to allow the construction of three-dimensional paintings. *Pilicia II* (the second of the three versions of *Pilicia* based on a 1970 drawing) takes its name from a wooden eighteenth-century Polish synagogue destroyed during World War II. Stella chose the titles for the Polish and Russian village series for several reasons: he sees a relationship between the "interlockingness" of the painting and the elaborate carpentry of the buildings, and, more important, their locations plot the route of Constructivism as it moved from Russia to Germany. He acknowledges that his own development has brought him parallel to the Constructivist aesthetic and to admiration for "the entire moral, artistic and political ambience for which that period in the history of abstraction has come to stand." Formally, Stella's art evolved drastically over a decade from paintings of insistent flat bands of color which deny any sense of depth to literal three-dimensionality. Every few years, almost arbitrarily, he continues to alter not only his style but the norms on which he bases his art. Gabo and his Constructivist friends wrote in their 1920 Manifesto, "The impasse into which Art has come in the last twenty years must be broken." This could almost be Stella's artistic credo.

207

Paintings in the Exhibition

1. Milton Avery (1893–1965)
 Girl Writing, 1941
 Oil on canvas
 121.9 x 81.3 cm. (48 x 32 in.)
 Signed l.l.: "Milton Avery"
 Provenance: Acquired through Valentine Gallery, Inc., New
 York, 1943.
 Reproduced p. 181.

2. Pierre Bonnard (1867–1947)
 The Open Window (*La fenêtre ouverte*), 1921
 Oil on canvas
 118 x 96 cm. (46$^1/_2$ x 37$^3/_4$ in.)
 Signed l.r.c.: "Bonnard"
 Provenance: The artist to Bernheim-Jeune, Paris, 1922; G.
 Besnard, Paris; acquired through Jacques Seligmann &
 Co., Inc., New York, 1930.
 Reproduced p. 71.

3. Pierre Bonnard
 Woman with Dog (*Femme tenant un chien*), 1922
 Oil on canvas
 69.2 x 39.4 cm. (27$^1/_4$ x 15$^1/_2$ in.)
 Signed u.r.: "Bonnard"
 Provenance: The artist to Bernheim-Jeune, Paris, 1923; ac-
 quired from Bernheim-Jeune, 1925.
 Reproduced on cover.

4. Pierre Bonnard
 The Palm (*La Palme*), 1926
 Oil on canvas
 114.3 x 147 cm. (45 x 57$^7/_8$ in.)
 Signed l.r.: "Bonnard 26"
 Provenance: Félix Fénéon, Paris; acquired from de Hauke &
 Co., New York, 1928.
 Reproduced p. 73.

5. Pierre Bonnard
 Nude in an Interior (Nu debout près d'une baignoire; Nu dans un intérieur), ca. 1935
 Oil on canvas
 73 x 50.2 cm. (28³/₄ x 19³/₄ in.)
 Signed u.l.: "Bonnard"
 Provenance: Dr. and Mrs. Frederick B. Deknatel, Cambridge, Massachusetts; to M. Knoedler & Co., Inc., New York, 1951; to Sidney Janis, New York, 1952; acquired from Sidney Janis, 1952.

6. Georges Braque (1882–1963)
 Still Life with Grapes and Clarinet (Nature morte à la clarinette), 1927
 Oil (with addition of sand) on canvas
 54 x 73 cm. (21¹/₄ x 28³/₄ in.)
 Signed l.r.: "G Braque 27"
 Provenance: Acquired from Reinhardt Galleries, New York, 1930.
 Reproduced p. 95.

7. Paul Cézanne (1839–1906)
 Self-Portrait (Portrait de l'artiste), 1878–80
 Oil on canvas
 60.6 x 47.3 cm. (23⁷/₈ x 18⁵/₈ in.)
 Unsigned
 Provenance: Ambroise Vollard, Paris; Theodor Behrens, Hamburg; Julius Meier-Graefe, Berlin; Paul Cassirer, Berlin; Baron and Baroness Leo von Koenig, Schlachtensee; Paul Rosenberg, Paris; acquired from Paul Rosenberg, New York, 1928.
 Reproduced p. 75.

8. Paul Cézanne
 Still Life with Pomegranate and Pears (Vase paillé et fruits sur une table), ca. 1895–1900
 Oil on canvas
 47 x 55.3 cm. (18¹/₂ x 21³/₄ in.)
 Unsigned
 Provenance: Claude Monet, Giverny; Michel Monet; Bernheim-Jeune, Paris; Joseph Stransky, New York, until 1937; acquired through Wildenstein & Co., New York, 1939. Gift of Gifford Phillips.
 Reproduced p. 79.

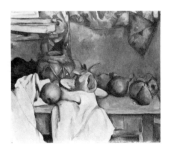

9. Jean-Baptiste Siméon Chardin (1699–1779)
 Bowl of Plums, a Peach, and Water Pitcher (*Jatte de prunes
 avec une cerise, une pêche et un pot à eau*), ca. 1728
 Oil on canvas
 45.1 x 56.8 cm. (17³/₄ x 22³/₈ in.)
 Unsigned
 Provenance: Roberts Collection, London; acquired through
 Wildenstein & Co., New York, 1920.
 Reproduced p. 23.

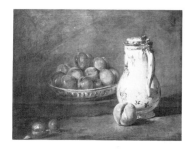

10. John Constable (1776–1837)
 On the River Stour, ca. 1834–37
 Oil on canvas
 61.2 x 79.3 cm. (24¹/₈ x 31¹/₄ in.)
 Unsigned
 Provenance: The artist to his niece, Alicia Whalley; Sir Joseph
 Beecham, London; acquired through Scott and Fowles,
 New York, 1925.
 Reproduced p. 39.

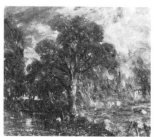

11. Jean-Baptiste Camille Corot (1796–1875)
 View from the Farnese Gardens, Rome (*Vue prise des jardins
 Farnèse*), 1826
 Oil on paper mounted on canvas
 25.1 x 40.6 cm. (9⁷/₈ x 16 in.)
 Stamped l.l.: "VENTE COROT"; dated l.r.: "Mars 1826"
 Provenance: Posthumous Corot sale, 1881, to M. Detrimont,
 Paris; Quincy Adams Shaw Collection, Boston; Mrs. Mal-
 colm Graeme Houghton; acquired through Paul Rosen-
 berg & Co., New York, 1942.
 Reproduced p. 33.

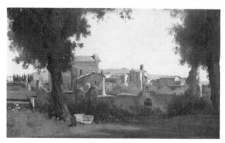

12. Gustave Courbet (1819–1877)
 Rocks at Mouthiers (*Les Rochers de Mouthiers*) ca. 1850
 Oil on canvas
 76.2 x 116.2 cm. (30 x 45³/₄ in.)
 Signed l.l.: "G. Courbet"
 Provenance: Félix Gérard, senior, estate sale, 1905, to Am-
 broise Vollard, Paris; de Rochecouste Collection, Paris,
 1908; Georges Petit, Paris, 1909; acquired through C. W.
 Kraushaar Galleries, New York, 1925.
 Reproduced p. 35.

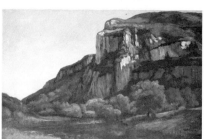

13. Honoré Daumier (1808–1879)
 The Uprising (*L'Emeute*), ca. 1860
 Oil on canvas
 87.6 x 113 cm. (34¹/₂ x 44¹/₂ in.)
 Unsigned
 Provenance: Henry Bing, Paris; Vigier (?), Paris, ca. 1904; H.
 Fiquet, Paris; acquired through Leicester Galleries, Lon-
 don, 1925.
 Reproduced p. 29.

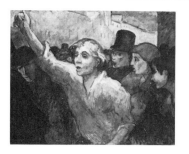

14. Honoré Daumier
 Three Lawyers (*Trois advocats; Trois advocats causant*), ca.
 1870
 Oil on canvas
 40.2 x 33 cm. (16 x 13 in.)
 Signed l.l.: "h. Daumier"
 Provenance: Geoffroy-Dechaume; Henri Rouart, Paris, until
 1912; George Blumenthal, New York; acquired through
 M. Knoedler & Co., New York, 1920.

15. Hilaire-Germain-Edgar Degas (1834–1917)
 Dancers at the Bar (*Danseuses à la barre*) ca. 1884–88
 Oil on canvas
 129.7 x 97.8 cm. ($51^1/_8$ x $38^1/_2$ in.)
 Signed l.r.: "Degas"
 Provenance: First Degas studio sale, 1918; Durand-Ruel, Par-
 is; Ambroise Vollard, Paris; Jacques Seligmann, Paris;
 American Art Association sale to Mrs. W. A. Harriman,
 New York, 1921; acquired through Valentine Gallery,
 Inc., New York, 1944.
 Reproduced p. 55.

16. Ferdinand Victor Eugène Delacroix (1798–1863)
 Paganini, ca. 1832
 Oil on panel
 45.1 x 30.5 cm. ($17^3/_4$ x 12 in.)
 Unsigned
 Provenance: Hermann Collection sale, 1879 to Perreau, Paris;
 Champfleury ca. 1885; Champfleury sale, 1890, to Chér-
 amy; Chéramy sale, 1908, to Dikran Khan Kelekian; Ke-
 lekian sale, 1922, to C. W. Kraushaar Galleries, New
 York; acquired from Kraushaar, 1922.
 Reproduced p. 27.

17. Richard Diebenkorn (b. 1922)
 Interior with View of the Ocean, 1957
 Oil on canvas
 125.6 x 146.1 cm. ($49^3/_8$ x $57^1/_2$ in.)
 Signed l.r.: "RD 57"
 Provenance: The artist through Poindexter Gallery, New York,
 1958.
 Reproduced p. 203.

18. Arthur Garfield Dove (1880–1946)
 Cows in Pasture, 1935
 Wax emulsion on canvas
 51.1 x 71.6 cm. ($20^1/_8$ x $28^3/_{16}$ in.)
 Signed l.c.: "Dove"
 Provenance: The artist through Stieglitz, An American Place,
 New York, 1936.
 Reproduced p. 164.

19. Thomas Eakins (1844–1916)
 Miss Van Buren (*Portrait of Miss Amelia C. Van Buren*), ca.
 1886–90
 Oil on canvas
 113.1 x 81.3 cm. (44¹/₂ x 32 in.)
 Unsigned
 Provenance: Acquired from Miss Van Buren, Tryon, N. C.,
 1927.
 Reproduced p. 131.

20. Sam Francis (b. 1923)
 Blue, 1958
 Oil on canvas
 122.9 x 88 cm. (48³/₈ x 34⁵/₈ in.)
 Unsigned
 Provenance: The artist through Martha Jackson Gallery, New
 York, 1958.
 Reproduced p. 199.

21. Paul Gauguin (1848–1903)
 Still Life with Ham (*Le Jambon*), 1889
 Oil on canvas
 50.2 x 57.8 cm. (19³/₄ x 22³/₄ in.)
 Signed l.r.c.: "P Go"
 Provenance: The artist to Ambroise Vollard, Paris; Maurice
 Cortot, Paris; Etienne Bignou, Paris; Paul Rosenberg,
 New York; acquired from Rosenberg, 1951.
 Reproduced p. 59.

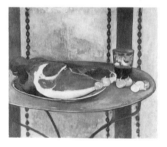

22. Vincent van Gogh (1853–1890)
 Entrance to the Public Gardens in Arles (*L'Entrée du jardin
 public à Arles*), 1888
 Oil on canvas
 72.5 x 91 cm. (28¹/₂ x 35³/₄ in.)
 Unsigned
 Provenance: Prince de Wagram, Paris; Madame Thea Stern-
 heim, Uttwil, Switzerland, from 1909; Frederick Muller &
 Co. sale, Amsterdam, 1919; Karl Sternheim, Reichen-
 berg; Arthur and Alice Sachs, New York; acquired
 through Wildenstein & Co., New York, 1930.
 Reproduced p. 61.

23. Adolph Gottlieb (1903–1974)
 The Seer, 1950
 Oil on canvas
 151.8 x 182 cm. (59³/₄ x 71⁵/₈ in.)
 Signed l.r.: "Adolph Gottlieb"
 Provenance: Acquired through Samuel M. Kootz Gallery,
 New York, 1952.
 Reproduced p. 189.

24. Francisco José de Goya y Lucientes (1746–1828)
 The Repentant Peter, ca. 1820-24
 Oil on canvas
 73.3 x 64.8 cm. (28$^7/_8$ x 25$^1/_2$ in.)
 Signed l.r.: "Goya"
 Provenance: Don Alejandro Pidal, Madrid; Duc de Trévise,
 Paris; acquired through Newhouse Galleries, New York,
 1936.
 Reproduced p. 21.

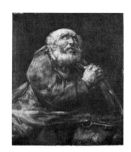

25. El Greco (Domenikos Theotokopoulos) (ca. 1541/47–1614)
 The Repentant Peter, ca. 1600
 Oil on canvas
 93.6 x 75.2 cm. (36$^7/_8$ x 29$^5/_8$ in.)
 Signed (fragmentary and barely visible) l.l.: "Domenikos Theo-
 tokopoulos"
 Provenance: Guillermo de Guillén García, Barcelona; Ignacio
 Zuloaga, Zumaya; Ivan Stchoukine, 1908; Heilbuth Col-
 lection, Copenhagen, 1920; acquired through The Ehrich
 Galleries, New York, 1922.
 Reproduced p. 19.

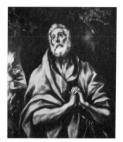

26. Juan Gris (pseudonym of José Victoriano González)
 (1887–1927)
 Still Life with Newspaper (*Nature morte au journal*), 1916
 Oil on canvas
 73.6 x 60.3 cm. (29 x 23$^3/_4$ in.)
 Signed l.l.: "Juan Gris 8–16"
 Provenance: Léonce Rosenberg, Paris; Katherine S. Dreier,
 Connecticut, 1922; acquired from Dreier, 1950, as *Black,
 Grey and White*.
 Reproduced p. 93.

27. Philip Guston (1913–1980)
 The Native's Return, 1957
 Oil on canvas
 164.8 x 192.8 cm. (64$^7/_8$ x 75$^7/_8$ in.)
 Signed l.l.c.: "Philip Guston"
 Provenance: Acquired through Sidney Janis, New York, 1958.
 Reproduced p. 193.

28. Edward Hopper (1882–1967)
 Approaching a City, 1946
 Oil on canvas
 69 x 91.5 cm. (27$^1/_8$ x 36 in.)
 Signed l.r.c.: "Edward Hopper"
 Provenance: Acquired through Frank K. M. Rehn, Inc., New
 York, 1947.
 Reproduced p. 147.

29. Jean Auguste Dominique Ingres (1780–1867)
 The Small Bather, 1826
 Oil on canvas
 32.7 x 25.1 cm. (12⁷/₈ x 9⁷/₈ in.)
 Signed l.r.: "Ingres 1826"
 Provenance: E. Blanc until 1862; Mme Blanc; Haro; Baron
 Mourre sale, 1892; Paul Rosenberg & Co., Paris, to Bar-
 on François de Hatvany, ca. 1911; Paul Rosenberg &
 Co., 1947; acquired from Paul Rosenberg & Co., New
 York, 1948.
 Reproduced p. 25.

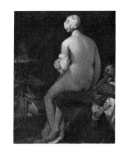

30. George Inness (1825–1894)
 Lake Albano, 1869
 Oil on canvas
 77.1 x 115.2 cm. (30³/₈ x 45³/₈ in.)
 Signed l.l.: "Geo. Inness 1869"
 Provenance: S. M. Nickerson, Boston; acquired through C. W.
 Kraushaar Galleries, New York, 1920.
 Reproduced p. 129.

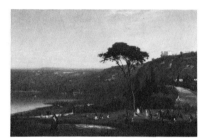

31. Wassily Kandinsky (1866–1944)
 Composition–Storm; originally *Study for Painting with White
 Border* (*Entwurf zu Bild mit weissem Rand*), 1913
 Oil on canvas
 100 x 78.8 cm. (39³/₈ x 31 in.)
 Signed l.r.: "Kandinsky"
 Provenance: Possibly purchased from Der Sturm by Katherine
 S. Dreier, 1920; acquired 1953, Katherine S. Dreier
 Bequest.
 Reproduced p. 107.

32. Paul Klee (1879–1940)
 Arab Song (*Arabisches Lied*), 1932
 Gouache on unprimed burlap
 91.1 x 64.8 cm. (35⁷/₈ x 25¹/₂ in.)
 Signed u.r.: "Klee"; Klee notation: Y3
 Provenance: Acquired from Karl Nierendorf, New York, 1941.
 Reproduced p. 109.

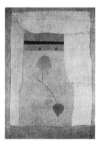

33. Karl Knaths (1891–1971)
 Pine Timber, 1952
 Oil on canvas
 127 x 101.1 cm. (50 x 40 in.)
 Signed l.r.c.: "Karl Knaths"
 Provenance: Acquired through Paul Rosenberg & Co., New
 York, 1952.

34. Oskar Kokoschka (1886–1980)
 Lyon, 1927
 Oil on canvas
 97.1 x 130.2 cm. (38$^1/_4$ x 51$^1/_4$ in.)
 Signed l.l.: "OK"
 Provenance: Paul Cassirer, Berlin; to private collection, Berlin,
 ca. 1927; acquired 1949.
 Reproduced p. 103.

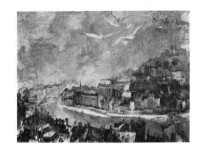

35. Willem de Kooning (b. 1904)
 Ashville, 1949
 Oil on board
 65.1 x 81 cm. (25$^5/_8$ x 31$^7/_8$ in.)
 Signed u.l.: "de Kooning"
 Provenance: Acquired from Vincent Melzac, Virginia, 1952.
 Reproduced p. 185.

36. Roger de la Fresnaye (1885–1925)
 Emblems (La Mappemonde), ca. 1913
 Oil on canvas
 88.9 x 200 cm. (35 x 78$^3/_5$ in.)
 Unsigned
 Provenance: Georges de Miré, Versailles; Jacques Seligmann
 & Co., New York; acquired 1939.
 Reproduced p. 91.

37. Morris Louis (1912–1962)
 Number 182, 1961
 Acrylic on canvas
 208.3 x 83.9 cm. (82 x 33 in.)
 Unsigned
 Provenance: Acquired through André Emmerich Gallery, Inc.,
 New York, 1963.
 Reproduced p. 201.

38. George Luks (1867–1933)
 Otis Skinner as Colonel Bridau in "The Honor of His Family,"
 1919
 Oil on canvas
 132.1 x 111.8 cm. (52 x 44 in.)
 Signed l.l.: "George Luks"
 Provenance: Commissioned by Duncan Phillips, 1919; ac-
 quired through C. W. Kraushaar Galleries, New York,
 1920.

39. Edouard Manet (1832–1883)
 Ballet Espagnol, 1862
 Oil on canvas
 61 x 90.5 cm. (24 x 35⁵/₈ in.)
 Signed l.r.: "éd. Manet 62"
 Provenance: The artist to Durand-Ruel, Paris, 1872; acquired
 from Durand-Ruel, New York, 1928.
 Reproduced p. 43.

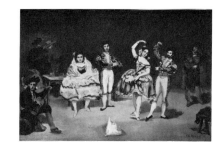

40. Franz Marc (1880–1916)
 Deer in the Forest I, 1913
 Oil on canvas
 101 x 104.8 cm. (39³/₄ x 41¹/₄ in.)
 Signed l.r.: "M"
 Provenance: The artist's widow to Katherine S. Dreier, 1927;
 acquired 1953, Katherine S. Dreier Bequest.
 Reproduced p. 105.

41. John Marin (1870–1953)
 Maine Islands, 1922
 Watercolor on paper
 42.5 x 50.8 cm. (16³/₄ x 20 in.)
 Signed l.r.: "Marin 22"
 Provenance: The artist through Alfred Stieglitz, The Intimate
 Gallery, New York, 1926.
 Reproduced p. 158.

42. John Marin
 Back of Bear Mountain, 1925
 Watercolor on paper
 43.2 x 50.8 cm. (17 x 20 in.)
 Signed l.l.: "Marin 25"
 Provenance: The artist through Alfred Stieglitz, The Intimate
 Gallery, New York, 1927.

43. John Marin
 Mt. Chocorua, 1926
 Watercolor on paper
 42.5 x 54.6 cm. (16³/₄ x 21¹/₂ in.)
 Signed l.r.: "Marin 26"
 Provenance: The artist through Alfred Stieglitz, The Intimate
 Gallery, New York, 1928.

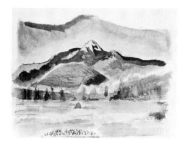

44. John Marin
Street Crossing, New York, 1928
Watercolor on paper
66.3 x 54.9 cm. (26^1/$_8$ x 21^5/$_8$ in.)
Signed l.r.: "Marin 28"
Provenance: The artist through Alfred Stieglitz, An American
 Place, New York, 1931.

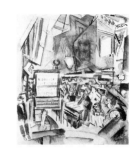

45. John Marin
Fifth Avenue and Forty-Second Street, 1933
Oil on canvas
71.1 x 92 cm. (28 x 36^1/$_4$ in.)
Signed l.r.: "Marin 33"
Provenance: The artist through Alfred Stieglitz, An American
 Place, New York, 1937.
Reproduced p. 159.

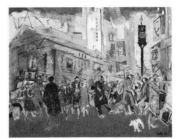

46. Henri Matisse (1869–1954)
Studio, Quai St. Michel (*L'Atelier du Quai St. Michel*), 1916
Oil on canvas
148 x 116.8 cm. (58^1/$_4$ x 46 in.)
Unsigned
Provenance: Private collection, London; Gargoyle Club, Lon-
 don; Lord Kenneth Clark, London; acquired from Pierre
 Matisse Gallery, New York, 1940.
Reproduced p. 83.

47. Joan Miró (b. 1893)
The Red Sun (*Le Soleil rouge*), 1948
Oil on canvas
91.1 x 71.1 cm. (35^7/$_8$ x 28 in.)
Signed on back: "Miró/1948/LE SOLEIL ROUGE"
Provenance: Acquired from Pierre Matisse Gallery, New York,
 1951.
Reproduced p. 177.

48. Amedeo Modigliani (1884–1920)
Elena Pavlowski (*Hélène Povolotzka*), 1917
Oil on canvas
64.8 x 48.9 cm. (25^1/$_2$ x 19^1/$_4$ in.)
Signed l.r.: "Modigliani"
Provenance: Pavlowski Collection, Paris; Pierre Matisse,
 1947; acquired from Pierre Matisse Gallery, New York,
 1949.
Reproduced p. 119.

49. Piet Mondrian (1872–1944)
 Painting No. 9 (Composition in Black, White, Yellow, and Red), 1939–42
 Oil on canvas
 79.4 x 74 cm. (34¹/₄ x 29¹/₈ in.)
 Signed l.l.c.: "PM"; dated l.r.: "39/42"
 Provenance: The artist to Katherine S. Dreier, Connecticut, 1942; acquired 1953, Katherine S. Dreier Bequest.
 Reproduced p. 169.

50. Claude Monet (1840–1926)
 On the Cliffs, Dieppe (Sur la falaise, Dieppe), 1897
 Oil on canvas
 61.5 x 100 cm. (25⁵/₈ x 39³/₈ in.)
 Signed l.r.: "Claude Monet 97"
 Provenance: The artist to Durand-Ruel, Paris, 1898; Durand-Ruel Collection until 1955; through Galerie Charpentier to M. Fellion, Paris, 1955, and directly thereafter to World House Galleries, New York; acquired from World House Galleries, 1959.
 Reproduced p. 47.

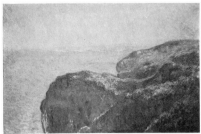

51. Adolphe Monticelli (1824–1886)
 Bouquet, ca. 1875
 Oil and encaustic on wood panel
 69.2 x 49.5 cm. (27¹/₄ x 19¹/₂ in.)
 Signed on the right: "Monticelli"
 Provenance: Delpiano, Cannes; acquired from Paul Rosenberg & Co., New York, 1961.
 Reproduced p. 37.

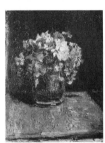

52. Giorgio Morandi (1890–1964)
 Still Life (Natura morta), 1953
 Oil on canvas
 20.3 x 39.7 cm. (8 x 15⁵/₈ in.)
 Signed l.r.: "Morandi"
 Provenance: Acquired from Curt Valentin Gallery, Inc., New York, 1954.
 Reproduced p. 123.

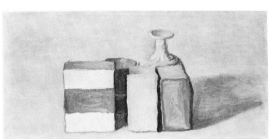

53. Robert Motherwell (b. 1915)
 In White and Yellow Ochre, 1961
 Oil and paper collage
 104.1 x 68.6 cm. (41 x 27 in.)
 Signed l.r.: "R Motherwell 61"
 Provenance: The artist through Marlborough Gallery, New York, 1965.
 Reproduced p. 195.

54. Ben Nicholson (b. 1894)
Zennor Quoit 2, 1966
Oil on carved pavatex
123.9 x 267.3 cm. (including frame) (48³/₄ x 105¹/₄ in.)
Unsigned
Provenance: The artist through Marlborough Gallery, London, 1967. Gift of Marjorie Phillips and Laughlin Phillips.
Reproduced p. 205.

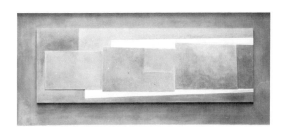

55. Georgia O'Keeffe (b. 1887)
Ranchos Church, ca. 1930
Oil on canvas
60.9 x 91.4 cm. (24 x 36 in.)
Unsigned
Provenance: The artist through Alfred Stieglitz, An American Place, New York, 1930.
Reproduced p. 165.

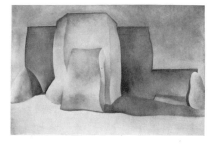

56. Marjorie Phillips (b. 1894)
Night Baseball, 1951
Oil on canvas
61.3 x 91.8 cm. (24 ¹/₈ x 36 ¹/₈ in.)
Signed l.l.: "Marjorie Phillips 51"
Provenance: Acquired from the artist, 1952.
Reproduced p. 149.

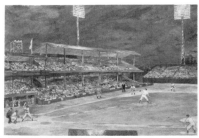

57. Pablo Picasso (1881–1973)
The Blue Room (*The Tub: Early Morning; La Toilette*), 1901
Oil on canvas
50.6 x 61.6 cm. (19 ⁷/₈ x 24 ¹/₄ in.)
Signed l.l.: "Picasso"
Provenance: Wilhelm Uhde, Paris; Etienne Bignou, Paris; Alfred Gold, Berlin; Reid & Lefevre, Ltd., London, 1926; Wildenstein & Co., Inc., New York, 1927; acquired from Wildenstein, 1927.
Reproduced p. 67.

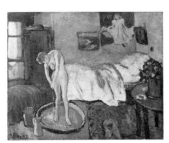

58. Pablo Ruiz Picasso
Bullfight (*Course de taureaux*), 1934
Oil on canvas
50 x 65.4 cm. (19 ³/₄ x 25 ³/₄ in.)
Signed l.l.: "Picasso/Boisgeloup 27 juillet XXXIV"
Provenance: Acquired from Valentine Gallery, New York, 1937.

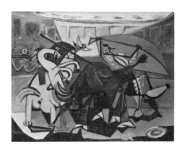

59. Horace Pippin (1888–1946)
 Domino Players, 1943
 Oil on composition board
 32.4 x 55.9 cm. (12 ³/₄ x 22 in.)
 Signed l.r.: "H. PIPPIN./1943."
 Provenance: Acquired from The Downtown Gallery, New
 York, 1943.
 Reproduced p. 151.

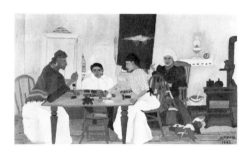

60. Jackson Pollock (1912–1956)
 Collage and Oil, 1951
 Oil and paper collage on canvas
 127 x 88.9 cm. (50 x 35 in.)
 Signed l.r. (partially obscured): "Jackson Pollock"
 Provenance: Lee Krasner; acquired from Sidney Janis Gallery,
 New York, 1958.
 Reproduced p. 179.

61. Maurice Prendergast (1859–1924)
 Ponte della Paglia, Venice, 1898–99 and 1922
 Oil on canvas
 71.1 x 58.4 cm. (28 x 23 in.)
 Signed l.l.: "Prendergast"
 Provenance: The artist through C. W. Kraushaar Galleries,
 New York, 1922.
 Reproduced p. 153.

62. Pierre Puvis de Chavannes (1824–1898)
 *Marseilles, Gateway to the Orient (Marseilles, porte de l'Ori-
 ent),* 1868
 Oil on canvas
 98.1 x 146.4 cm. (38 ⁵/₈ x 57 ⁵/₈ in.)
 Unsigned
 Provenance: Durand-Ruel, Paris; Baron Denys Cochin, Paris;
 Cochin sale, 1919, to Bernheim-Jeune, Paris; Meyer
 Goodfriend Collection, New York; Goodfriend sale,
 1923; acquired through C. W. Kraushaar Galleries, New
 York, 1923.
 Reproduced p. 41.

63. Odilon Redon (1840–1916)
 Mystery (Le Mystère), undated
 Oil on canvas
 73 x 54 cm. (28 ³/₄ x 21 ¹/₄ in.)
 Signed l.r.: "Odilon Redon"
 Provenance: Mme. Redon; acquired through C. W. Kraushaar
 Galleries, New York, 1925.
 Reproduced p. 65.

64. Pierre Auguste Renoir (1841–1919)
The Luncheon of the Boating Party (*Le Déjeuner des canotiers*), 1881
Oil on canvas
129.5 x 172.7 cm. (51 x 68 in.)
Signed l.r.: "Renoir 1881"
Provenance: Durand-Ruel, Paris, 1881; sold to M. Balensi, December, 1881; sold back to Durand-Ruel (Collection), April 1882; acquired from Durand-Ruel, 1923.
Reproduced p. 53.

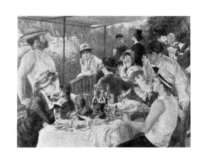

65. Mark Rothko (1903–1970)
Green and Maroon, 1953
Oil on canvas
231.8 x 139.1 cm. (91 $^1/_4$ x 54 $^3/_4$ in.)
Signed on back: "Mark Rothko/1953"
Provenance: The artist through Sidney Janis Gallery, New York, 1957.
Reproduced p. 183.

66. Georges Rouault (1871–1958)
Christ and the High Priest (*Christ et docteur*), ca. 1937
Oil on canvas
49.5 x 34.3 cm. (19 $^1/_2$ x 13 $^1/_2$ in.)
Signed u.r.: "G. Rouault"
Provenance: Ambroise Vollard; acquired from Bignou Gallery, New York, 1940.

67. Henri Rousseau (1844–1910)
The Pink Candle (*La Bougie rose*), 1905–08
Oil on canvas
16.2 x 22.2 cm. (6 $^3/_8$ x 8 $^3/_4$ in.)
Signed l.l.: "H. Rousseau"
Provenance: Galerie Bignou, Paris; Workman Collection, London; Reid & Lefevre, London; acquired from M. Knoedler & Co., Inc., New York, 1930.
Reproduced p. 101.

68. Albert Pinkham Ryder (1847–1917)
Moonlit Cove, ca. 1880–90
Oil on canvas
35.9 x 43.5 cm. (14 $^1/_8$ x 17 $^1/_8$ in.)
Unsigned
Provenance: Mrs. Alexander Morton; acquired through Frank K. M. Rehn, New York, 1924.
Reproduced p. 135.

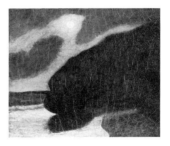

69. Alfred Sisley (1839–1899)
 Snow at Louveciennes (*Jardin à Louveciennes, effet de neige*),
 1874
 Oil on canvas
 55.9 x 45.7 cm. (22 x 18 in.)
 Signed l.r.: "Sisley 74"
 Provenance: Kirkpatrick, London; Zygomalas, Paris; Alexan-
 der Rosenberg, Paris; acquired from Paul Rosenberg,
 Paris, 1923.
 Reproduced p. 49.

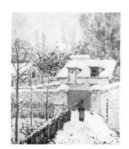

70. John Sloan (1871–1951)
 The Wake of the Ferry II, 1907
 Oil on canvas
 66 x 81.3 cm. (26 x 32 in.)
 Signed l.l.: "John Sloan 1907"
 Provenance: Acquired from C. W. Kraushaar Galleries, New
 York, 1922.
 Reproduced p. 145.

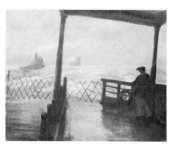

71. Nicolas de Staël (1914–1955)
 Fugue, 1952
 Oil on canvas
 80.6 x 100.3 cm. (31 $^{3}/_{4}$ x 39 $^{1}/_{2}$ in.)
 Signed l.l.: "Staël"
 Provenance: The artist through Theodore Schempp & Co.,
 New York, 1952.
 Reproduced p. 197.

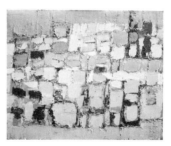

72. Augustus Vincent Tack (1870–1949)
 Time and Timelessness (*Spirit of Creation*), 1944
 Oil on canvas
 88.9 x 210.8 cm. (35 x 83 in.)
 Signed vertically l.l.: "Augustus Vincent Tack"
 Provenance: Acquired from the artist, 1948.

73. Bradley Walker Tomlin (1899–1953)
 Blossoms (*Number 8*), 1952
 Oil on canvas
 167.7 x 122 cm. (66 x 48 in.)
 Signed u.l.: "B. Tomlin 52"
 Provenance: Acquired from Betty Parsons Gallery, New York,
 1955.

74. John Henry Twachtman (1853–1902)
 Emerald Pool, ca. 1895
 Oil on canvas
 63.5 x 63.5 cm. (25 x 25 in.)
 Signed l.r.: "J. H. Twachtman"
 Provenance: Acquired from Ferargil Galleries, New York,
 1921.
 Reproduced p. 137.

75. Edouard Vuillard (1868–1940)
 Woman Sweeping (Femme balayant dans un intérieur),
 ca.1892
 Oil on cardboard
 45.7 x 48.3 cm. (18 x 19 in.)
 Signed l.r.: "E Vuillard"
 Provenance: Bernheim-Jeune, Paris, 1916; Josse Bernheim,
 1918; acquired from Jacques Seligmann & Co., Inc., New
 York, 1938.
 Reproduced p. 69.

Index of Color Plates by Artist